Design for Hackers

Reverse-Engineering Beauty

David Kadavy

WILEY

A John Wiley and Sons, Ltd, Publication

Design for Hackers

This edition first published 2011

© 2011 Kadavy, Inc.

Registered office

John Wiley & Sons, Ltd, The Atrium, Southern Gate, Chichester, West Sussex, PO19 8SQ, United Kingdom

For details of our global editorial offices, for customer services and for information about how to apply for permission to reuse the copyright material in this book please see our website at www.wiley.com.

The right of the author to be identified as the author of this work has been asserted in accordance with the Copyright, Designs and Patents Act 1988.

Wiley also publishes its books in a variety of electronic formats. Some content that appears in print may not be available in electronic books.

Designations used by companies to distinguish their products are often claimed as trademarks. All brand names and product names used in this book are trade names, service marks, trademarks or registered trademarks of their respective owners. The publisher is not associated with any product or vendor mentioned in this book. This publication is designed to provide accurate and authoritative information in regard to the subject matter covered. It is sold on the understanding that the publisher is not engaged in rendering professional services. If professional advice or other expert assistance is required, the services of a competent professional should be sought.

Trademarks: Wiley and the Wiley Publishing logo are trademarks or registered trademarks of John Wiley and Sons, Inc. and/ or its affiliates in the United States and/or other countries, and may not be used without written permission. iPhone, iPad and iPod are trademarks of Apple Computer, Inc. All other trademarks are the property of their respective owners. Wiley Publishing, Inc. is not associated with any product or vendor mentioned in the book. This book is not endorsed by Apple Computer, Inc.

A catalogue record for this book is available from the British Library.

978-1-119-99895-2

Set in 11pt Adobe Garamond Pro by Wiley Composition Services

Printed in the United States by CJ Krehbiel

About the Author

DAVID KADAVY is president of Kadavy, Inc., a user interface design consultancy with clients including oDesk, PBworks, and UserVoice, and mentor at the 500 Startups seed fund. Previously, David led the design departments of two Silicon Valley startups and an architecture firm, taught a college course in typography, and studied ancient typography in Rome while earning his BFA in graphic design at Iowa State University. David's design work has been featured in *Communication Arts* magazine, and he has spoken at the South by Southwest (SXSW) Interactive conference. David blogs about design and entrepreneurship at kadavy.net and can be reached on Twitter at the handle @kadavy or by e-mail at david@kadavy.net.

To my parents, Reed and Marilyn Kadavy,
for encouraging me to follow my curiosity.

Credits

Some of the people who helped bring this book to market include the following:

Editorial and Production

VP Consumer and Technology Publishing Director
Michelle Leete

Associate Director–Book Content Management
Martin Tribe

Associate Publisher
Chris Webb

Publishing Assistant
Ellie Scott

Development Editor
Elizabeth Kuball

Copy Editor
Elizabeth Kuball

Technical Editor
Jason Simanek

Editorial Manager
Jodi Jensen

Senior Project Editor
Sara Shlaer

Editorial Assistant
Leslie Saxman

Marketing

Associate Marketing Director
Louise Breinholt

Marketing Executive
Kate Parrett

Composition Services

Compositor
Indianapolis Composition Services

Proofreader
Susan Hobbs

Indexer
Slivoskey Indexing Services

Acknowledgments

It seems strange that I should even have the privilege of putting my name on the front of this book, as it is a product of the work, talent, and inspiration of so many people. I have merely synthesized and filtered stimuli and processed it as best I could with the point of view that I have formed over the years.

More than anyone, I would like to thank my acquisitions editor, Chris Webb, for having the vision and guts to publish a book that another publisher dismissively referred to as "ambitious." I would also like to thank my editor, Elizabeth Kuball, for her invaluable guidance and skill in turning what can sometimes be an incoherent mess into writing that I am truly proud of. I also want to thank my technical editor, Jason Simanek; I'm so grateful that our kindred yet complementary minds were finally able to collaborate, and I'm so glad that you were up for the challenge when it arrived.

The content of this book has been reviewed by a few enthusiastic reviewers who selflessly donated their time and intelligence for no more payment than what I presume to be a premature satiation of their curiosity and what follows. So, thank you Chris Duesing, Zack Gilbert, Jacob Rus, and Paul Stamatiou.

A great deal of useful knowledge is still locked up in libraries around the world, but the incredible amount of information and visual resources freely available on the Internet made writing this book much easier. So, thank you to all the great contributors to the Internet, from Wikipedia contributors, to bloggers, to photographers and illustrators who make their work available under a Creative Commons license on Flickr, Wikimedia, or anywhere else.

The viewpoint I present in this book is, in part, thanks to the influence of my professors at Iowa State University. Thank you to Arthur Croyle, who was the best teacher I could have had to teach me about the origins of typography in Rome. Thank you also to Gary Tartakov, whose lectures shared a socioeconomic viewpoint on design and art history like none other. Thank you to Paula Curran, whose methodical approach to design problems was an inspiration.

The content and point of view of this book are also a product of the influence of artists, authors, designers, architects, teachers, and entrepreneurs, as well as anyone, anywhere, ever, who has had the bravery to truly explore what he or she had to offer the world. I will certainly leave out someone deserving of mention, but here is my attempt: Jan Tschichold, Robert Bringhurst, Malcom Gladwell, Seth Godin, Tim Ferriss, Steve Jobs, Vincent van Gogh, Dave Eggers, Jane Austen, and Mies van der Rohe. Thanks to all of you, to the first person to ever discover how to start a fire, and to anyone who ever did anything novel and creative thereafter and taught someone else about it.

This book probably never would have been written were it not for an unlikely chain of events that brought me the privilege of living and working in Silicon Valley during one of its most exciting periods. That time exposed me to the most creative cowboys and cowgirls I've ever encountered, so thank you to all of you and to everyone I ever met who was like you but didn't happen to live in Silicon Valley. So, thank you to Jeff Cannon and Jon Stevenson for getting me there. Also, thank you to Vinnie and Kristine Lauria, Noah Kagan, Paul Bragiel, and Ramit Sethi for being inspiring in your own ways. I would have put all of you in the preceding paragraph, but because I know you personally, that would have been weird.

Thank you to Ryan Halvorsen, Joe Avella, and Matt Taets for being inspiring friends at all the right times. Thank you to Ziad Hussain for saying one statement that became the impetus for this book.

Finally, thank you to you, who is standing there, or sitting there, or lying there, reading this book or receiving these ideas and concepts as brain input through some not yet invented device. The presence of your eyeballs (or synapses), the beating of your heart, the encouraging words – or the constructive criticism – you have provided through blog comments, tweets, e-mails, or taking the time to see me in person have powered me through what has been the biggest project of my life thus far. I'm so thrilled to share this with you, and I'm blown away by your willingness to receive it. Thank you so, so much.

Contents

Introduction

WHEN I WAS in grade school, handwriting was my worst subject. I had terrible handwriting. It looked like a woodchuck had barfed a bunch of twigs onto a piece of paper. So, each quarter, when I was sent home with my report card, it was full of A's and B's... and one C-, in penmanship.

Never having been one to blindly accept convention, I asked why it even mattered if I had decent handwriting. It's probably no surprise that I thought handwriting was "stupid," even "a waste of time." I was too young to respect the merits of something at which I had no hope of succeeding (though seriously, grading on penmanship is stupid and a waste of time).

No matter how many times I asked, I was always told the same thing: "When you grow up and get a job, you'll need to be able to communicate clearly. You need good handwriting to communicate clearly."

Thank goodness computers took over. My handwriting is still terrible. Oh, I can *draw* letters, but I certainly can't *write* them.

Today I understand that at the root of my educators' intentions was something valuable: Clear communication is critical to success. Luckily for me, I rarely have to rely upon my handwriting to communicate clearly. I can simply type an e-mail, make a slide presentation, or write a book, and it will be rendered in crisp, beautiful typography. Many of these letterforms were perfected over 500 years ago, and they still carry words with strength and clarity today.

Additionally, I have spent years studying the subtleties of visual communication. I passed countless boring Nebraska days as a child, drawing in my room. I got my degree in graphic design, while exhausting the university library's supply of typography and design books – skipping keggers so I could conduct experiments with typography and geometry. I studied the very origins of modern typography in the ruins of the ancient Roman Empire. I've even discussed the hidden meaning of something as simple as a brick or a piece of wood, while working at an architecture firm. Finally, I've implemented the

fruits of all this practice and analysis in the fast-paced environment of Silicon Valley startups. Design and visual communication is so deeply embedded in my brain that I'm hardly aware of its presence. My handwriting still sucks, though.

Design as Literacy

One evening, I was "moworking" in a cafe with my friend Ziad, coding some design tweaks to the WordPress template for my blog. Ziad always has a way of saying abstract things that break my concentration and split my brain wide open, and this evening was no exception: "Design is this mysterious thing. The people who know it can't seem to explain it. It's like if you want them to teach you something about design, they just chalk it up to talent."

Ziad's comment did strike me as interesting, but the true weight of it took about a year to sink in. First came the realization that someone who wasn't a designer by trade would actually *want* to learn about design. Being able to design was something I had taken for granted. It was a great skill to have, especially when creating my own apps or participating in weekend hackathons, such as Django Dash or Rails Rumble. I could create this perception of quality, this value, out of thin air. But, not being much of a back-end coder, I was envious of the fact that my design wasn't worth a thing without the magic robot words behind it, which developers knew how to create.

Second, I realized that design skills are a new kind of literacy. The whole reason why I had suffered the consequences of poor handwriting was because handwriting was a part of communication. The only reason that I could write anything at all was that I was literate.

This idea sounds very simple, but it's pretty novel in the scope of human history. Most people today know how to read and write, but even just a couple hundred years ago, this was not the case. For people to learn how to write, they had to know how to read. For people to learn how to read, they had to have access to writing. To have access to writing, someone with the ability to read and write would have to produce something with writing in it, like a book.

But books have only recently been affordable to common people in the civilized world. Johannes Gutenberg printed the first book, the so-called "42-line Bible" (see Chapter 3) in 1455. Books very rapidly dropped in price over the

next hundred years, but before Gutenberg's Bible, books had to be written by hand. So, it's no surprise that few people, aside from the clergy, knew how to read or write.

Today's world is, of course, vastly different. Not only can most of us read and write, but we don't even have to worry about our handwriting. Desktop publishing, and even the ability to publish on the Internet, is available to the majority of people in the industrialized world.

Not only can we publish our words, but we can design them. We have access to thousands of fonts. We can change colors and sizes of fonts with a few clicks. We can edit and publish photos and illustrations alongside our words.

We're all modern-day printers. We can create flyers, postcards, and PowerPoint presentations complete with animations. We can create blogs, posters, and even coffee mugs.

But few of us are design literate. Sure, matters of design taste are starting to creep into our world. There are backlashes over ugly fonts, such as Comic Sans (see Chapter 3). Much like having poor handwriting, not having design literacy results in miscommunication. Fonts, colors, layout, and the proper use of white space all affect how our message is conveyed, and nearly all of us have the ability to manipulate these factors. The world is in need of design literacy.

The Hacker Attitude

No group stands to gain more from design literacy than hackers do. No, I don't mean computer geeks who break into networks and steal passwords. I don't even necessarily mean software developers. I mean the renegade group of entrepreneurially minded people who are transforming the way we live, work, and interact.

Though the term *hacker* originated at MIT in the 1960s and was used to refer to a particular group of computer and software enthusiasts, to many, the term has a broader meaning. An article by Eric Steven Raymond entitled "How to Become a Hacker" (`www.catb.org/~esr/faqs/hacker-howto.html`) presents five tenets of the hacker attitude:

> The world is full of fascinating problems waiting to be solved.

> No problem should ever have to be solved twice.

> Boredom and drudgery are evil.

> Freedom is good.

> Attitude is no substitute for competence.

In short, a hacker values knowledge and learns whatever he needs to learn to achieve his vision. In today's world, that often means learning at least a little coding, but the hacker attitude can be applied to problem solving of all kinds.

People who live by the hacker attitude are curious. They do whatever it takes to achieve their visions. They're entrepreneurial. They value skills and knowledge over titles and experience.

At the forefront of the hacker movement is the Hacker News community (`http://news.ycombinator.com`), a news aggregation site contributed to by followers of Paul Graham's Y Combinator entrepreneurial incubator program. The program tends to fund small teams of hackers who have used their skills and hacker attitude to build cool products that solve problems: UserVoice (`www.uservoice.com`) democratizes customer support; Reddit (`www.reddit.com`) democratizes news; Dropbox (`www.dropbox.com`) provides an easy, automatic backup solution; and AirBNB (`www.airbnb.com`) turns extra bedrooms into places for travelers to stay.

Hackers are the scribes of the modern world. They build products and businesses that not only communicate, but that users interact with and use to communicate with each other. Armed with a laptop, an idea, and a few hours to code, a hacker can build something that reaches millions.

Hackers are able to accomplish so much in so little time because they come from a community that's built upon sharing knowledge. They benefit from billions of collective hours that these members of this community have invested in writing software, manuals, and other tutorials with which to empower one another.

They can learn whatever it is that they need to learn to solve the problem at hand. If they run into a coding problem, they can do a quick Google search or

read a manual. If their business takes off and they have to do accounting or bookkeeping, they can find more of what they're looking for on the Internet or read a book from the library.

The Gap in Design Knowledge

The one subject that is exceedingly frustrating for hackers to try to learn is design. Hackers know that in order to compete against corporate behemoths with just a few lines of code, they need to have good, clear design, but the resources with which to learn design are simply hard to find. They might hire a designer to help them out, but good designers are expensive and, when you're bootstrapping a startup, you just don't have the money to spend.

The main reason for the difficulty in learning design is probably that designers tend to have difficulty articulating the process through which they make decisions. Many designers are, in fact, born with some degree of innate talent and interest in design, and, through countless hours of practice and experimentation, they've developed their particular approach to design. As a result, much of the design advice that exists is either too simple or too complicated. Have you ever heard anyone tell you simply to "use white space," for example? If you don't get it, she may just shrug her shoulders and say that she was just born knowing how to design.

But the truth is, there really is a thought process – a decision-making framework – behind design. The nuances of white space, for example, are actually influenced by geometric proportion, which I'll discuss in Chapter 5. Chunks of white space are a part of compositional forces, which I'll explain in Chapter 6. Finally, white space can be instrumental in making clear what information is most important, as I'll explain in Chapter 7.

With this book, I hope not just to provide you with simplistic rules about design, but to expose the methodical thought framework that I've developed from years of experimentation and analysis – a thought framework that I implement even as I collaborate with a team of developers on launching a product in a single weekend, or create a design solution for a client with limited funding. By "reverse-engineering" the design process, I hope to provide you with knowledge that can sustain you across a variety of situations.

If you want to learn to create great design yourself, if you want to gain design literacy, there simply is no way to do so with lists of rules. Instead, I want to provide you with a new set of eyes through which you can see the world anew. After reading this book, you still may not be totally satisfied with the very next design that you create. But the next time you see a design you like, you'll see it in a new way. You'll notice how the font choices are appropriate to the subject matter. You'll see how the proportions between various parts of the design relate to one another. You'll notice how the designer achieved clarity in differentiating pieces of information. And you'll see how the colors relate to one another to communicate and emote.

This is my tiny contribution to the collective billions of hours the hacker community has invested, and I'm looking forward to sharing it with you.

Part I: Understanding Design

chapter **I**

Why Design Matters

GIVEN THAT YOU'RE reading this book, you probably don't need much convincing that design is, in fact, important. Good design has clearly been fundamental to the success of many of the world's largest companies, and interest in and awareness of design has exploded during the past couple decades. But exactly what kind of impact can design have? More important, what really defines the bounds of design?

Skillful use of good design can create experiences that are emotionally moving. At the same time, good design – through improved communication and clarity – can make things easier to use. The characteristics of good design can bring increased credibility to your company and ultimately influence the decisions of your customers. Skillful use of good design can affect emotions, build credibility, and earn trust. Finally, good design can actually make things easier to use. But to really achieve these results, you have to understand design holistically.

I witnessed firsthand the power of design in one of the world's oldest functioning buildings. While I was studying the origins of modern typography in Rome, my studio was just a few blocks from the Pantheon. I spent hours sitting inside the building and people-watching. I'm not normally entertained by watching people, but inside the Pantheon, watching people is a different experience than it is elsewhere. Why? Because people-watching in the Pantheon gives you the opportunity to see the reactions of people who are walking into the building for the very first time.

The reaction of a person walking into the Pantheon for the first time – though different for everyone – follows a predictable pattern: He walks through the doors, in a hurry, guidebook in hand and comfortable sneakers on his feet. Then, once he looks up, everything about his demeanor changes. He begins walking in slow motion. His head falls back limply on his neck, as if he were a child seeing fireworks for the first time. His jaw drops, and at some point, a "wow" and a sigh of amazement manage to escape his mouth. He may lift a camera to his eyes – in an attempt so feeble as to be entertaining – hoping that he may later relive the experience at will.

This is why I loved to people-watch in the Pantheon. I had experienced what they were going through myself, and – although the Pantheon amazes me to

this day – there's something magical about seeing what is little more than a pile of stone, arranged in a certain way, have this affect on grown adults.

What Design Really Is

Steve Jobs once said, "In most people's vocabularies, design is a veneer. It's interior decorating. It's the fabric of the curtains of the sofa. But to me, nothing could be further from the meaning of design. Design is the fundamental soul of a human-made creation that ends up expressing itself in successive outer layers of the product." It's this layering, the interconnectedness of these different factors, that manifests itself in the impact of the Pantheon.

The emotional reactions that I witnessed over and over in the Pantheon are exactly as intended. The Pantheon, the current design of which was commissioned by Emperor Hadrian in 126 AD, was built to be the temple of all the gods of Ancient Rome. So, it's fitting that walking into the building would be an awe-inspiring experience. If it's good enough for Venus, the goddess of love and beauty, it's bound to be pretty amazing to you and me. This intention behind the design of the building – the impact it was meant to have – is definitely one of the "layers" that Steve Jobs was referring to.

The way that the interior of the Pantheon achieves this reaction is through conceptually representing the heavens. Emperor Hadrian wanted those who entered the Pantheon to be awe-struck. This is the house of the gods, after all. The interior does this by being in the form of a perfect sphere – it is as tall as it is wide, taking the form of a semicircular dome on top of a cylinder. At 142 feet, it remains the tallest unreinforced concrete dome in the world – nearly two millennia after its creation. At the very top of this dome, a 30-foot wide *oculus* (hole) projects a beam of sunlight into the building, lighting the interior. This is how the Pantheon has such an impact. Upon entering, you're enveloped by another world, complete with its very own "sun" (see Figure 1-1).

Part of the impact of the Pantheon comes from the relationship between this incredible spatial experience and the materials used to create it. To achieve this form, the Pantheon pushes the limits of the materials from which it is built, which helps explain why a dome of this height hasn't been created with the same technology since. So much reinforcement is needed to keep this dome

standing that the walls of the dome are 20 feet thick at the base of the dome and only 4 feet thick at the edge of the oculus.

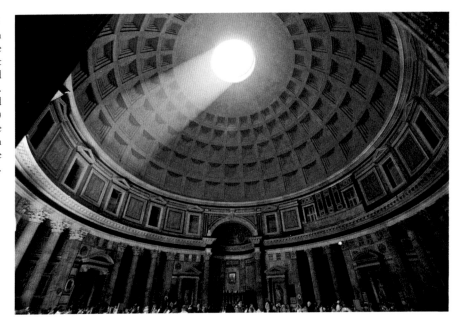

To better manage the weight of the concrete, hard and durable basalt was added to the mix for the foundations, with the mix gradually getting lighter, until pumice rock was used toward the oculus. This way, the base of the dome has the weight and strength to support the rest of the dome, while the upper parts of the dome are thin and light, reducing their load upon the base.

To make the dome material even lighter, a series of recessed squares, or *coffers,* are formed within the dome. These coffers, which exist by engineering necessity, contribute to the impact of the interior. They rhythmically radiate from the oculus, creating visual interest, while contrasting with the smooth concrete that immediately surrounds the oculus.

In concert with these technical considerations, the designers of the Pantheon had to make some aesthetic choices as well. Because the floor is too large to be made with one piece of marble, it's made up of various pieces. This marble is laid out in a pattern of basic circular and square forms, which are in geometric harmony with the rest of the interior.

The marble used within the Pantheon was in different colors, as well, so care had to be taken to ensure that there was harmony and beauty in how the various colors of marble interacted with one another.

All these factors worked together and were considered so masterfully that the Pantheon is one of the most influential buildings in the history of architecture. From St. Peter's (just down the road from the Pantheon, in Vatican City) to the U.S. Capitol building, the dome of the Pantheon has inspired the design of buildings all over the world.

This careful marriage of all the "layers" of design are what makes a design beautiful, timeless, and, ultimately, successful in reaching its goals. The intentions of a design work together with the limitations of the technology used to create the design, as well as with harmonies of form, geometry, and color. All these pieces, all these layers, are inextricably linked with one another, forming the whole of what truly is design.

What Design Is Not

Like Steve Jobs said, many people think of design as some kind of afterthought – the upholstery on a couch, the logo on a business card, or the visual look of a button on a website. In pursuit of understanding design, many are led down the fruitless path of approaching design with this definition in mind. They may try to learn how to create a particular visual effect, repeatedly refer to lists of do's and don'ts, or try adding visual elements to a design that do little but create clutter.

To keep yourself creating good design, you need to learn how to understand all the layers that create great design. To create great design: Don't draw ponies.

Chances are, when you were in grade school, there was a kid in your class who everyone thought of as a good artist. His big secret was, he only knew how to draw one thing. In my third-grade class, there was a girl who could draw ponies. She drew beautiful ponies. They had big, juicy eyes and long, flowing manes. They had smooth, powerful muscles, and looked as if they could leap off the page. The other kids in class would crowd around her as she drew pony after beautiful pony. Then, one day, someone asked her to draw a portrait. "Draw a picture of me!" he said. The girl looked scared. "Yeah, draw him," the

other kids cheered. So, reluctantly, she tried to draw the boy. As you can probably imagine, the resulting drawing looked nothing like the boy at all. His eyes were lifeless, flattened footballs. His hair was a random mess of scribbles. "I'm not very good at drawing people," she said, sheepishly. Everyone seemed disappointed, but they still wanted to believe that she was a good artist.

I was too young to figure it out then, but eventually I got it. All the ponies the girl drew were essentially the same. Most of them had the same pose. The heads were at the same angle. Maybe the front hoof of each of the ponies was pulled up, as if the pony were ready to begin a gallop. She probably had just learned to draw a pony from one, maybe two angles – maybe from a picture in a magazine – and just repeated that over and over again. She was really good at drawing ponies this way.

But the pony-drawing girl didn't conceptually understand ponies. She didn't understand the "layers" that make up a pony. Hey, she was in third grade, so that's okay. But she didn't understand pony anatomy, where all the muscles really were, or how they might change shape as the pony changed poses.

The drawing of her classmate didn't look right because she didn't know human anatomy, either. She didn't understand the way that tear ducts are on the inner part of the eye, or the way that an eyelid is constructed, or exactly how they tuck underneath the eyebrow ridge. She didn't understand how individual hairs on a person's head interact with each other and clump together. She didn't understand technically how these things worked, she didn't understand how a viewer perceives these things, and she didn't understand how to use a pencil and paper to bridge the gap between these two worlds.

Of course, she didn't understand these things – she was in third grade. Probably, someday, she progressed as an artist, or maybe today she's the most famous artist in the pony world.

The point is that to truly be adept at designing something, you have to understand how it works. You have to understand the nature of what you're building, how what you're building is perceived, and how you can use your tools to make your vision happen. Otherwise, you aren't designing. You're creating a veneer. You're drawing ponies. Don't draw ponies.

The Layers of Design

It's important to understand the layers that make up a design, because getting those layers to work together is the key to creating designs that look good, that solve problems, and that ultimately influence your users.

On the web, more than anywhere else, using the layers of design appropriately is critical to success. People are exposed to more information today than ever before, and there just isn't enough time or attention for us to process all of it. So, we use shortcuts to decide what is deserving of our ever-more-precious attention.

In psychology, these shortcuts are called *heuristics*. Heuristics help us solve complex problems and make complex decisions by using "rules" that are either programmed into us by evolution or learned from our own experiences.

If you see a pair of shoes that you're considering buying, you'll immediately make a judgment on whether this brand of shoes is for you. How does the way it's constructed affect the look of the shoes? Do the colors appeal to you? Is it your style? You use heuristics based upon how similar these shoes are to shoes that you've had past experiences with.

These heuristics are in heavy use as people make decisions on the web. We make split-second judgments about how much we trust a news site to give us accurate information, how much we trust an e-commerce site to process our payments securely, or whether we believe a nonprofit will use our money wisely.

It turns out, in all these cases, design is the single most important heuristic we process when deciding whether a site is credible.

The factors that influence design are countless, with fuzzy boundaries. You could ask a dozen different design experts what factors manifest themselves in a piece of design, and although you'd get a dozen different sets of answers, they would all pretty much cover the same things. Here are some of the layers of design that I'll talk about in this book.

How design affects credibility on the web

In a study done at Stanford University, B. J. Fogg and his colleagues presented participants with two websites and asked them to rank the sites' credibility, as well as provide comments about what they based their rankings upon.

When the results were processed, Fogg found that design had an overwhelming influence in participants' ratings of the credibility of the websites in the study. An incredible 46 percent of all comments about the credibility of the sites were related to design. Participants said trustworthy sites were "more professional looking," had a "higher-quality look and feel," or "just [looked] more credible." Some participants even went so far as to specifically mention the color schemes or choices of fonts in sites that looked credible to them.

Although well-designed sites enjoyed high credibility ratings, sites that were poorly designed were viewed as less credible. Participants didn't trust a site if it was "not very professional looking," if the "design [was] sloppy," or if it looked "like it was put together in five minutes."

But just as drawing a pretty pony doesn't make you a good artist, creating a pretty website doesn't make you a good designer. Participants were skeptical of sites that looked inappropriately polished, giving negative comments suggesting that certain sites looked as if they were "designed by a marketing team."

The design of a site has to be appropriate, and considering all the layers that make a good design is critical in creating effective designs.

Aside from the visual look of sites being important to their perceived credibility, the results of Fogg's study also suggested that some of the more subtle aspects of design also were extremely important. Comments about the information design and structure of the sites in the study were the second most common, comprising over 28 percent of all the comments processed. Participants praised some sites for being "well organized," while criticizing other sites because the "information [was] badly presented."

So, together, the visual look of a site – along with the way the information was organized – accounted for nearly 75 percent of all comments about whether participants trusted a site or not. Moreover, the participants' comments were sensitive to design that was inappropriate for the site in question.

Users know when you're drawing ponies, so to create successful design, you need to understand how the layers of design interact.

Purpose

Every piece of design has a purpose or an intention. The Pantheon was built as a temple of the gods, the iPod was built as a portable device for playing music, and every website or application you create has its own set of purposes.

The purpose of a design is wrapped up with economic factors as well. The forms of letters have been influenced throughout time by the need for efficiency in communicating language (see Chapter 3). As I'll explain in Chapter 2, and as demonstrated by the skeptical comments toward inappropriately polished design in Fogg's study (see the earlier sidebar), these economic factors help dictate the quality of design that a particular artifact should have.

The purposes and intentions of a design interact with the characteristics and needs of a user. In Chapter 2, I'll explain how you can better account for these characteristics when developing the structure of your design. In Chapter 9, I'll talk about how you can account for cultural color considerations.

Every user needs to be able to access information clearly, and this communication is the very foundation of design. In Chapter 3, I'll explain the differences between various fonts in historical context. In Appendix A, I'll explain how these historical considerations affect the mood that a typeface conveys. In Appendix B, I'll show you how some of the tiniest typographic details can have dramatic effects on the information being communicated. Most important, in Chapter 7, I'll illustrate how you can attach the appropriate amount of importance to various pieces of information within your designs.

Medium and technology

Every piece of design is created by a particular set of materials, with certain methods of construction that influence the design. The limitations of creating a concrete dome caused the Pantheon to feature recessed coffers throughout the dome; the latest MacBook Pro is created from a single piece of aluminum, a production consideration that influences its design; and, as I'll talk about in Chapter 4, designs created with HTML and CSS tend to have certain characteristics that lend themselves to the capabilities and limitations of that technology.

In Chapter 4, I'll go into more detail on how the technologies behind the Internet have created design trends, such as the Web 2.0 look. In Chapter 3, I'll explain how the limitations of the pixel have made some of the longest-lived typeface designs incompatible with use on the web. In Chapter 8, you'll learn about how the technologies with which we represent colors can influence our color choices designing across mediums or when choosing colors for information graphics. In Appendix A, I'll explain how the various technologies used to create letters have, over time, led to new styles of typefaces.

Aesthetic decisions

Working in concert with design intentions and characteristics of medium and technology are the aesthetic considerations of design. When you hear it called that, it probably brings to mind a lot of what people think of design as – the veneer of design. But in many ways, the aesthetic decisions of design are invisible.

The geometric relationships between things in a design are not something you can see, but they make a huge impact on the visual harmony, the sense of organization of content, and the overall "clean" feeling of a design. I'll talk about these hidden geometric relationships in Chapter 5, and I'll talk about how these geometric relationships work with other hidden principles of design in Chapter 6.

The colors we use in designing are, of course, visible. But designers make some important though invisible decisions when working with colors. After explaining how we perceive colors with our visual system, and how we represent colors with various technologies (Chapter 8), I'll explain how colors can influence our emotions, I'll explain how colors interact with one another, and I'll present some common formulas for choosing colors that go well together (Chapter 9).

Conclusion

By gaining an understanding of all the various factors that affect design, you can create designs with emotive power, clarity, and beauty. Throughout the rest of this book, I'll break down all these factors, so you can see the world through new eyes. Let's get started, shall we?

chapter 2
The Purpose of Design

DESIGN IS THE manifestation of many different "layers" that make up a product. So, something that might just appear attractive or pretty isn't necessarily going to be a "good" design. Good design is sensitive to these many layers that influence the final design of a product. What is often misunderstood as design – things such as the pattern of a fabric, or even the graphic styling of a button on a website – don't come close to encompassing the definition of design. Visual characteristics are certainly components of design, but they are products of many factors.

The bounds between design and other related disciplines are fuzzy, but for the purposes of this book, I'll be talking primarily about visual design. Visual design concerns itself with the visual look – or the "beauty" – of a product. Visual design, as the name implies, is mostly associated with things that you see, such as the arrangement of design elements, the look of typography, or the choice of colors, but these things are all affected by some pretty concrete things, such as product goals, culture, or technology.

I'll be talking about all of these factors in greater detail later in the book. In Chapters 3 and 4, I'll explain how culture and technology have influenced, throughout history, the shapes of typography and design. In Chapters 5 and 6, I'll explain how hidden geometric and compositional forces create a sense of order and visual interest in a piece of design. In Chapter 7, I'll break down how these factors can work together to create a sense of ordered visual importance within your design layouts. In Chapters 8 and 9, I'll explain how our perception of colors, and the ways that we organize and represent colors with various technologies, interacts with our cultural and cognitive responses to colors. Finally, in the appendices, I'll cover some of the details of typographic expression through various font styles and through subtle details of typographic etiquette.

By understanding a "reverse-engineered" view of these various factors, you'll be well equipped to approach design with a lucid understanding of what makes a design attractive. Visual design will no longer be a mysterious and seemingly arbitrary production of innately gifted individuals. Like the exposed structural elements of the Golden Gate Bridge, you'll begin to see the framework of decisions that produce beautiful, timeless, or sometimes just-good-enough design work.

But this knowledge won't come in the form of quick tips, top-ten lists, or simple rules for good design. Effective forms of these are rare, and they just don't get you that far. Instead, I hope to provide you with a new set of eyes – eyes that see things you've never noticed before. You'll notice the subtle curves that make one font seem serious and another seem playful (see Appendix A). You'll start seeing the hidden geometric relationships that make one vast expanse of white space enliven a design, while another leaves it feeling dead (see Chapters 5, 6, and 7). You'll stop seeing colors as a pure mystery and start to understand how they interact, changing the prominence and meaning of one another based upon their relationships (see Chapter 9). You may even be able to tell your friends – with no visual reference – how the color #8989FC differs from #89CCFF (see Chapter 8).

I'll provide this new set of eyes with guidelines whenever possible. Some rules of visual design happen to exist by their own merits. But mostly, I hope to provide a foundation on which to grow. You'll have a visual vocabulary with which to interpret designs that you think are beautiful – or not so beautiful. You'll be as fluent in breaking down the design of the latest startup's landing page from TechCrunch as you are in interpreting a Monet at the Guggenheim. But to get started in understanding these various facets of visual design, you need to have some understanding of the factors that surround and shape visual design.

Visual Design and Its Relation to User Experience Design

Within the context of designing websites or applications, visual design is a component of the discipline of user experience design. User experience design concerns itself with anything relating to a user's interaction with a product. User experience design attempts to make products memorable and easy to use and incorporates a number of different disciplines, including usability.

Figure 2-1 is a view of visual design's relationship with other disciplines within user experience design (in the context of websites and applications). As you can see, visual design is intertwined with the content and usability of a product. Naturally, the content of a product is what a visual designer is really trying to

illuminate, while usability considerations – which strongly influence visual design – ensure that the end-user will be able to use the product effectively.

FIGURE 2-1
Visual design is a
component of
user experience
design and is
influenced by
other disciplines
and components
of user
experience
design.

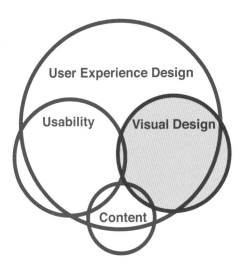

This diagram is very simplified, and many other related disciplines overlap with these disciplines and fall within user experience design. Disciplines such as interaction design, human-computer interaction, information architecture, cognitive psychology, and human factors all play some part in user experience design. Although I discuss products of other disciplines such as architecture and industrial design in this book, they, too, are outside the scope of my concern as I analyze the relationship between user experience design and visual design.

The basics of user experience design

The user experience design of a product essentially lies between the intentions of the product and the characteristics of your user. The foundations of user experience really shape a product, ultimately providing constraints for visual design decisions.

If I were to design a hammer, my intentions for that hammer would be that it would be used for hammering nails and maybe removing nails from time to time. I would then make some assumptions about the user of the hammer. Hopefully, my budget would allow for a little research to help me form these

assumptions. I'd assume that the user has a working hand, so I would design a handle. I would take into account that a pretty good amount of force is required to drive a nail into wood, so I'd make the head of the hammer pretty heavy and hard. Sometimes it's hard to accurately hit a nail on the head, so I'd make the head of the hammer big enough to be a little forgiving but small enough that it wouldn't be too heavy to swing with some degree of control.

So, now I'd have the basic form of a heavy object on a stick. But there would still be room for improvement. Through testing of a prototype, I might notice that the head of the hammer tends to twist if I don't hit the nail perfectly, so I'd be careful to balance the weight evenly. Now, not only do I have a head for striking the nail, but I also have a trailing portion of the head for balancing the weight of the striking portion of the head. This is a perfect opportunity to incorporate, right into the trailing part of the hammer head, a mechanism for removing nails.

I may experiment with different materials, ultimately finding that a steel head offers the desired durability at the right price. For the handle, I might find that wood is sufficiently cheap and lightweight and provides decent shock absorption.

Through this process of considering my intentions for the product and the needs of the user, I would have the basic design of a hammer. The hammer is such a well-designed device for driving and removing nails that, when you have a hammer in your hand – as the old saying goes – "everything looks like a nail."

But even more complex considerations may be driving the design of my hammer. Maybe a competing company has come out with a similar hammer, and I need to find some way to differentiate my hammer and make it better. Through talking with my customers, I may find that some of them complain about feeling discomfort after driving nails with my hammer all day, so I might try different materials, such as fiberglass, looking for optimal shock absorption. I might find that some customers have trouble maintaining their grip on the hammer, so I might try incorporating a rubber grip and molding the handle to better fit the human hand.

This whole process that I've gone through to create this hammer fits within the realm of user experience design. Not only have I designed a solution for my

customers, but I've optimized that solution according to their needs and improved the competitive health of my business.

The visual design of one product versus another

These considerations affect the visual design of hammers only somewhat. If you search for "hammer" on www.homedepot.com, you'll get a hundred different results. This may sound like a lot, but there are many different types of hammers for many different situations. There are classic hammers, for driving and removing nails; there are ball-peen hammers, for shaping metal; and there are shingling hammers, for installing and removing shingles. There are even items that are hardly hammers at all, such as mallets, which have much larger, blunt heads, and post drivers, for driving fence posts into the ground. There are hammers that compete with each other in materials (some of them milled entirely of steel) or price (some are only $2, while others are $50).

But you'll see a very modest degree of variety in the visual design of hammers. Contrast this with shoes, another very simple invention, with a very simple purpose, for which there is tremendous variety in terms of visual design. Zappos.com sells over a thousand different *brands* of shoes, each with a wide variety of styles. Sure, there are different shoes for different situations, just as there are different hammers for different situations, but many of the different styles of shoes are available in several different colors.

Clearly, there is a difference in the importance of visual design when selling shoes compared to when selling hammers. There are a variety of explanations for this discrepancy. For one, shoes wear out. Even if a person owned only one pair of shoes at a time, each person would go through dozens of pairs of shoes over a lifetime. Hammers tend to last longer – depending on how much you use a hammer, it might last your whole life. Also, shoes are something we use every day. Many of us may not even own a hammer.

But there's a fundamental difference in the way that we interact with shoes: Shoes are much more closely attached to our personal identities. We wear them directly on our bodies, and we walk around with all the world seeing our shoes. Shoes are part of fashion, and although fashion is fleeting and, by its very definition, arbitrary, it's the primary reason we have such a wide variety of shoe designs and not quite so many different hammers.

Visual design has emerged as an important element in selling shoes. There are only so many ways, try as they might, that shoe manufacturers can innovate the shoe. They can try different materials and different styles. They can put bubbles of air in them or add tall heels to them. They can change the thickness of the soles or even design them to go around each toe, individually. Ultimately, whether consumers are willing to admit it or not, visual design is an important consideration when they're choosing a pair of shoes. When choosing hammers, however, visual design is clearly not such an important consideration for consumers. The market has naturally demonstrated this.

Sometimes a Visual Design Is Just Good Enough

I demonstrate the varying importance of visual design from one product to the next to point out that, as much as I love design, and as much as you probably love design, a compelling visual design is not always necessary to create a successful product. Whether a product needs to be visually compelling to compete is up to market forces.

Take for example, craigslist (`www.craigslist.org`), which has single-handedly put hundreds of newspapers and classified ad companies out of business. The visual design of craigslist is ugly (or just nonexistent) to the point of legend. Many attempts have been made to add a more attractive front-end to craigslist, or to suggest a redesign of craigslist, but the design of craigslist has remained bare bones, with only periodic, small tweaks. Meanwhile, craigslist still pulls in an estimated $150 million a year.

The success of craigslist can be attributed to the fact that it functions very well and addresses a tremendous pain point in the market. It used to be that if you wanted to find a roommate, or sell your car, or find a date, you had to pick up a phone. Like some sort of a caveman, you called and talked to a human being in a giant office building at a giant newspaper and paid money to place an ad. Oh, and you had to pay by the line, so your ad had to be short if you cared at all about money. Then you waited. If you were lucky, your ad would be placed the next day and you'd start receiving calls. After you had found your roommate, or sold your car, or found a date, you would keep receiving calls – sometimes for weeks afterward – because your ad would still exist, and you couldn't take it down.

But craigslist eliminated all this and created a product that worked better. Most amazingly, its product was, and still is (for most categories), free. It's no wonder that craigslist didn't need a beautiful design. In fact, the sloppy design of craigslist evokes its community-driven, anti-corporate, grass-roots ethos. By using this sloppy, community-driven site, people are giving a middle finger to all those polished corporate newspapers that took their money for so many years.

Sometimes Visual Design Is Your Advantage

But, of course, craigslist is an exceptional case, and its market share is being eroded by a variety of services that specifically target various categories within craigslist. Services such as AirBNB (www.airbnb.com), TaskRabbit (www.taskrabbit.com), and oDesk (www.odesk.com) all provide solutions that are more tailored to the needs of their specific vertical markets and incorporate much more attractive visual design.

There is no better example of a company that enjoys a heavier advantage thanks to its design than Apple. In 1997, Steve Jobs – upon returning to the company after a 12-year absence – discovered the under-appreciated design laboratory of Jonathan Ives. Since then, Apple has released innovative products with great design time and time again, enjoying tremendous success. It's grown to be the largest tech company in the world, at as much as 100 times its own size in 1997.

Apple has accomplished this success by releasing one great product after another, but it owes its growth to one product above all others: the iPod. Before the iPod, contact with the elegance of Apple's design was reserved for its relatively small group of extremely dedicated followers. It was as if they all had one great hammer that everyone else thought was "too expensive." But the iPod made available a very good Apple product at a price point that was more accessible.

The iPod has played a big role in Apple's stock outperforming Microsoft's stock by over 3,000 percent since the day the iPod was released. Windows-equipped computers had 98 percent market share in the personal computer market then; today, Apple has tripled its market share to just over 7 percent, and the introduction of the iPad brought Apple an almost immediate 95 percent share of the tablet market.

At the time the iPod came out, most people were using their computers for many of the same things they use them for today: surfing the web and creating

documents. Since Microsoft Office was such a dominant software program, so important to doing business, getting people to switch to a Mac was nearly impossible. So, Apple went for a more emotional point by attacking music.

"Music is a part of everyone's life. Everyone. Music has been around forever. It will always be around," Steve Jobs said as he introduced the iPod in 2001. People had been listening to music on their computers for a few years at that time, but the portable digital player market was just emerging. Many of the players that were on the market at the time of the iPod's introduction were bulky, difficult to transfer music to, and had interfaces that were "unbelievably awful," as Steve Jobs put it. Apple had an opportunity to get one of its products into the hands of consumers more easily than it could a personal computer, and it seized that opportunity with the iPod.

Since the introduction of the iPod, 300 million iPods have been sold and the iTunes Store has sold over 10 billion songs (at an 88 percent market share in 2006). Apple showed consumers what great products it made and, through building that trust, started to sell more personal computers, with its market share tripling. Apple's tremendous distribution of digital music has been a big part of music stores going out of business, and Apple was finally in a position to kill the CD completely with the introduction of the Flash-storage MacBook Air in October 2010.

Many factors played into Apple's success, but none of it would have been possible were it not for Apple's dominant product design. Although Apple had introduced style to computing with the multicolored iMacs (which was a bit like designing a really pretty hammer), now Apple had an opportunity to introduce fashion where it really mattered: in a music device that people carried around next to their bodies.

Music is an inherently emotional thing – it's very personal. Combine that with the fact that a portable music player is something people carry with them, in public, and it's almost like a fashion accessory. Because of this, great design was critical to winning the portable music player battle. Much as people associate their identities with their preference in music, so to would their choice of music player affect the way they felt about themselves. Today, everyone recognizes the iconic white Apple ear buds.

Apple didn't win in the portable music market, and achieve the dominance it enjoys today, by beating out the competition on storage size or features – the iPod wasn't groundbreaking on either of these criteria. The main factor upon which it differentiated itself was design. So, Apple was able to triple its market share with the help of a beautiful little item that it sold.

Reverse-Engineering the Twitter User Experience

Twitter's user experience (see Figure 2-2) does a great job of handling various use cases. In this section, I go into a very simple "reverse-engineer" of the Twitter user experience. You can be sure that Twitter went into far more depth than this in redesigning its service. But I want to give you an overview of the kind of structured thinking that takes place in the user experience design process.

NOTE	I can't stress enough that there is no right way to do user experience design, especially when you're working independently on a small project. What's important is that you learn how to think about user experience, find a process that works for you, and turn your vision into reality.

FIGURE 2-2
The latest design of Twitter provides a user experience that handles the user's needs very well.
Reproduced by permission of Twitter, Inc.

User personas

Twitter has a wide variety of users across every age group, lifestyle, and culture, but for our purposes, we'll just imagine the prototypical Twitter user: a tech-minded guy who's on the cutting edge of anything that's going on in the "hivemind."

User personas are little "sketches" of potential users that you can use to guide decisions as you develop and design. The complexity of user personas can vary depending upon your project's budget and complexity. On larger projects, you'll take great care to form personas that fit as nearly as possible the characteristics of members of various target markets and audiences. If you're working in a collaborative situation, give each of your personas a name, like "Betty" or "Bob," and sometimes even a picture of what you imagine the person looking like. This gives you a more specific image of a user when you're discussing the project with your teammates. Then you can identify what each of your personas needs from your product. Through this process, you can start to hone solutions that really fit your audience.

Plenty of user experience resources recommend some very complex personas. I'll just demonstrate with a very *simple* persona. You can create a decent persona in a matter of minutes.

> Name: Mike
>
> Occupation: Ruby on Rails web developer/entrepreneur
>
> Quote: "I want to use Twitter to have intelligent conversations with intelligent people, and to promote and get feedback for my many web products. Sometimes, when I'm troubleshooting something, I like to ask people on Twitter to see if they have any advice."
>
> Needs: Keep track of conversations; easily scan lots of tweets

So, there you have it: Mike is a smart web developer, who is experimenting with different startups. He wants to stay in touch with everything that's going on in the tech and entrepreneurship world (as well as in other news). He wants to connect with other smart people to have discussions and get (and probably provide) a little help from time to time. Chances are, you know a Twitter user similar to Mike. Hey, you might even be a little like Mike yourself.

You can see that even with just a few words, we already know quite a bit about our typical user, and quite a few things about how he would like to use our product. He's tech-savvy, so he can probably figure out a somewhat complex interface. Also, he wants it to be easy to have conversations and to promote products.

Use cases

Use cases (sometimes called *user stories*) help you more efficiently solve some of the most important issues and uses that your users typically have. Use cases may turn out to be very similar to, or exactly the same as, the user needs that you list in your user personas. A use case is essentially an imaginary situation that you anticipate your users will encounter regularly. By really sketching out this situation, and thinking about the situation in conjunction with your user personas, you can think in a very focused manner about solutions that will work well for a given situation.

Twitter, by its very nature, is a bit disorganized. Little messages of 140 characters or less come streaming in, and there isn't much structure to organize them. Sure, you can choose who to follow or even organize people into lists, but ultimately, it's just one big stream of messages. The messages can have so much other stuff attached to them, though: A tweet can mention another Twitter user, be retweeted by another user, or be one of many in a conversation. Additionally, the essential content of a tweet may be a link to a piece of media, such as an image or a video, or have location data attached to it that shows where the user doing the tweeting is located.

The trick for managing all this chaos is enabling the user to scan all these tweets, while still being able to quickly – and without interrupting the current flow of reading – access all the rich data that relates to each tweet. The paradox is that trying to put any of this rich data into the stream of tweets would destroy the casual convenience with which a user can scan tweets in his stream. So, a solution had to be created that would enable the user to access this data, while still allowing the user to scan his stream of tweets.

To really understand how best to allow all this, it's helpful to create a few use cases that outline how a user might consume a tweet, and what considerations are at play in that particular case. Following is one such use case.

This case refers to situations where you see a tweet that begins with an @Reply, and you wonder what the person who wrote the tweet is replying to. You may have seen a tweet in your Twitter stream at some point that said something to the effect of "@username I have that problem all the time. I prefer to just use Firebug." Naturally, you have no clue what that person is talking about unless you can see what he's replying to. So, you might sketch up a case that looks something like this:

Case: What's this in reply to?

Description: Mike sees a tweet that says "@username But startups love extrapolating exponential growth curves." Mike wants to know what the tweet is in reply to. The tweet may be a part of a conversation, so it would be nice to have some mechanism through which users can see all the tweets within that conversation. Additionally, Mike may not be familiar with the user who is mentioned in the tweet, so it would be nice to provide some information on that user.

User quotes: "Hmmm, sounds like an interesting conversation is going on. I wonder what they're talking about. Also, who is this @username person?"

Requirements: Display tweet(s) that this tweet is in reply to; display tweet(s) that replied to this tweet; display information on the user mentioned in this tweet.

Just from this simple use case — and there clearly could be many more — you can begin to understand why Twitter is laid out the way that it is. When you click on a particular tweet, a sort of "tweet information pane" pops out to the side, displaying information relevant to that tweet. For the preceding use case, you can see that listing all the tweets in a conversation on this pane covers the user's needs. Additionally, simple biographical information related to a user can be displayed in this same pane. Mike (from our user persona) can still scan his Twitter stream on the left side, while the tweet information pane stays static (see Figure 2-3).

FIGURE 2-3
The tweet
information
pane, which
slides out when
an individual
tweet is selected,
provides relevant
information on a
specific tweet,
while allowing
the user to
continue to scan
his stream.
*Reproduced by
permission of
Twitter, Inc.*

Just by thinking about these most common use cases, a solution has emerged that can be used for many other less common use cases. The tweet information pane can display media (such as an image or video) that is related to a tweet. This feature keeps users on the Twitter domain and allows them to get to the meat of what a particular tweet is really about.

Wireframes

From this information, and a little more focused thinking, you can start to sketch out the "skeleton" of the front-end of the Twitter application. Usually, this part of the process is called *wireframes,* because it's a simple layout with no design flair to it. It gives you and your team an idea of where everything in the application is going to be.

Wireframes also can vary greatly in complexity, depending upon your project. Some people use mockup software such as Balsamiq to create functional prototypes. Other people like to draw wireframes in a vector drawing application

such as Adobe Illustrator or OmniGraffle. Some developers like to go straight to code and build wireframes from HTML and some simple CSS; this approach has the added advantage of creating something you can use in the next phase of the project. Others simply draw really rough and simple sketches (see Figure 2-4) or do some combination of all the above.

FIGURE 2-4
A very simple sketch can be enough to get your ideas ready for further development.

What matters when wireframing is that you have some way to express your ideas without getting too caught up in minute and as-of-yet inconsequential details such as fonts and colors.

Knowledge Applied

Visual design is intertwined with the other disciplines of user experience design. Because successful design relies upon sensitivity to the interconnectedness of these disciplines, it's important to have an understanding of user experience design when working on a project. The structured thinking of the user experience design process ensures that you're meeting the needs of your user and produces the basic shape of your application, which strongly influences your visual design.

Here are a few things to keep in mind when integrating user experience with your visual design:

> You don't always need a great visual design to be successful. Be sensitive to the needs of your users, how they interact with your product, and how your product fits into the competitive landscape.

> Great visual design depends upon great user experience design. Use some form of a user experience design process early on in your project. User personas, use cases, and wireframes all help you focus on the critical aspects of user experience before getting caught up in details.

Part II: Medium and Form

Medium and Form in Typography

UNDERSTANDING THE RIGHT tools for the job is always important to the hacker. You know better than to use the `font` tag for typographic control and tables for layout (unless economic considerations say otherwise, as in Chapter 2). Instead, you use CSS. It has taken a while, but web standards are finally such that content and style can be separated in this way. Understanding these technologies and their intended uses enables you to make wise decisions such as this. You probably hardly even recognize it as a decision – it's just the way you do things.

Just as a hacker knows to separate HTML from CSS, a skilled designer can pick the right font for any situation in an instant. Thousands of hours of manipulating typography (making subtle changes that alter the hierarchy of a document) and thousands of hours spent admiring typefaces and understanding and studying their differences makes the trained designer able to picture a typeface as readily as your mother could picture your face.

Knowing the right font to use takes an understanding of the emotional response your audience will have to it. But an understanding of this emotional response stems from an understanding of the tools, people, and philosophies that are behind the letterforms. Not understanding these factors makes choosing fonts a guessing game.

In this chapter, I'll explain how tools have shaped one of the most important elements of design: typography. I'll show you how a mediocre font can become a terrible font when not used as intended. I'll demonstrate how closely linked language is to typography, outlining how the visual representations of ideas and things have evolved into our modern alphabet. I'll show you how, throughout time, tools and technology have shaped new letterforms that remain closely tied to the letters that came before. Finally, I'll demonstrate why some of the longest-lived typefaces are incompatible with much of today's technology.

The Tragedy of Misuse: Why You Hate Comic Sans

The most exaggerated and memorable example I can give for what can occur when the true intention of a font isn't fully understood by its users is the story of Comic Sans.

Everyone loves to hate Comic Sans. The childlike handwriting font is so infamous, there is a movement to try to ban it. Mention its name to the common layman (aside from a preschool teacher), and you'll likely get a chuckle. Mention it to a trained designer, and you'll get a look of disgust. But what exactly makes Comic Sans so horrible?

To illustrate the poor fundamentals of Comic Sans, I'll compare it to Helvetica, which is such a beloved typeface that there's a movie about it: *Helvetica* (2007). Check it out!

First, I should acknowledge that comparing these typefaces is a bit like comparing apples to oranges. They convey completely different moods. Helvetica looks strong and serious; it's perfect for signage. Comic Sans is usually used in situations where the user wants to look playful and casual; it's better suited for preschool classrooms.

But they have their similarities as well. They both have relatively unmodulated strokes, meaning that the thickness of the strokes on the type doesn't change throughout the stroke. Figure 3-1 shows how Helvetica's form differs from Garamond's form, which has a modulated stroke. Comic Sans also has an unmodulated stroke, like Helvetica.

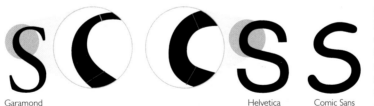

Garamond

Modulated Stroke Unmodulated Stroke

Helvetica Comic Sans

FIGURE 3-1
Both Helvetica and Comic Sans have unmodulated strokes, whereas Garamond's stroke is modulated.

This modulation is a result of Garamond's form being derived from that of scribed letters. Before printing was available in the West, scribes lettered Bibles beautifully and patiently by hand, using a flat-tipped pen, held at a fixed angle, which influenced the form of those letters and resulted in a modulated stroke. As printing was developed, the letters created mimicked scribed letters, and, although they eventually developed their own forms, printed letterforms almost exclusively had modulated strokes until sans-serif type was popularized in the early 1800s. The forms of most sans-serif typefaces are not influenced by drawing tools.

Though the strokes of Helvetica's letterforms are unmodulated, some adjustments are made to improve its legibility. In Figure 3-2, notice how the stroke on Helvetica gets thinner where the shoulder meets the stem on this letter *n*. This helps to give the letter a more even visual weight.

FIGURE 3-2
Helvetica makes adjustments where strokes meet to better manage visual weight.

Stem Shoulder Heavy Area

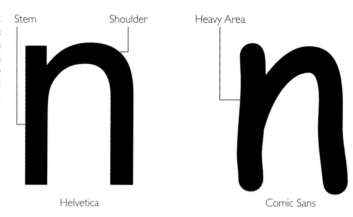

Helvetica Comic Sans

If you squint your eyes while looking at Figure 3-2, you'll notice that there is a disproportionately heavy area where these strokes meet on Comic Sans, while Helvetica's weight is more evenly distributed.

The ironic thing about this distinction is that Comic Sans is actually influenced by a drawing tool: a round, felt-tipped pen or marker. But the stroke of this tool is unmodulated. Meanwhile, the letterforms of Helvetica are rationalized from predecessors, without apparent influence of a drawing tool.

This mismanagement of visual weight is the main issue that makes reading Comic Sans an unpleasant experience. Evenness of weight, or *texture,* is important to the legibility and readability of typography. Letters or blocks of text that are free from disproportionately light or heavy spots allow the letterforms themselves to shine through and be read easily.

Figure 3-3 shows how a block of text set in Helvetica differs in texture from a block of text set in Comic Sans. I've blurred both blocks of text and bumped up the contrast so you can experience an objective form of squinting and identify areas that are excessively light or dark.

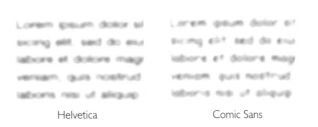

Helvetica Comic Sans

FIGURE 3-3
Helvetica creates
a more even
texture when set
in body text than
does Comic
Sans, which has
dark and light
patches.

First, notice the general variation of lightness and darkness in the lines of type. Helvetica is a more uniform gray, while Comic Sans varies widely, with some very dark spots scattered throughout the body of text. The most obvious anomalies are the letters *e* and *t,* the former of which appears like a blood stain a number of times in the example, and the latter of which languishes like a dead tree. The Comic Sans *e* appears darker than the other letters because its overall visual weight is mismanaged. Figure 3-4 compares Comic Sans with Garamond and Helvetica, so you can get some idea of why Comic Sans is characteristically irregular.

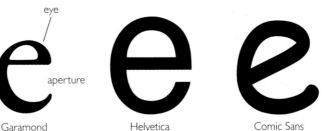

Garamond Helvetica Comic Sans

FIGURE 3-4
The stroke
modulation
of Garamond
allows for it to
have a small
eye and large
aperture.

Garamond's *e* features a very large aperture and a small *eye* (the *counter* – or negative space – in a lowercase *e*), but its stroke modulation keeps it balanced. The extreme heaviness of the stroke toward the lower-left of the *e* is balanced out by the large aperture, and the tiny eye is balanced out by the very thin bar that closes out the eye. Note that all these samples are the same point size but vary in size visually because of differing x-heights (the height of a lowercase *x*).

Helvetica maintains balance by compensating for its absence of stroke modulation by having a larger eye and a smaller aperture. Comic Sans, however, by virtue of its handwriting-based style, has a tilted eye to its *e,* giving it both a

small eye and a large aperture. Because there is no stroke modulation to Comic Sans, it can't compensate for this lack of balance and, thus, utterly fails.

But poor management of visual weight within the letterforms themselves isn't the only characteristic that makes Comic Sans uneven in body text. The *letterfit* (consideration given to the letterforms to allow them to be set together in an even manner) of Comic Sans is very poor. The letterfit of Helvetica allows for it to inherently have decent kerning tables. *Kerning* is the distance between two letters, and good fonts have parameters (or *kerning tables*) set for just about every letter combination in which the font may eventually be set. But if the letters themselves aren't designed with consideration given to how the letters will relate to one another, producing good kerning tables is impossible.

In Figure 3-5, you can see that Comic Sans has an awkward gap between the *f* and the *o,* but this pairing can't simply be more tightly kerned, because it would create an area of tension – from too close proximity – between the crossbar of the *f* and the *o.* You can see similar problems throughout the typeface, but this is one of the better examples.

pet fox pet fox

poor letterfit/kerning

Helvetica Comic Sans

This problem could have been avoided if the right-hand portion of the crossbar of the *f* weren't so long (notice that it's shorter on Helvetica). One way to compensate for these poor pairings would be to space the letters out a bit on the whole, to allow for relatively tighter pairings for problem areas such as those I've described. But this isn't feasible in most computer applications, and it would do little to make up for the other blunders of Comic Sans.

The typographic fundamentals of Comic Sans are very poor as used in high-resolution situations. But Comic Sans was never intended to be used in this manner, and that's part of why it's considered such a bad font.

Comic Sans was originally designed to be used in the talk bubbles of a program called Microsoft Bob. The font wasn't completed in time to actually make it into the program, but it lived on to eventually ship with Windows 95 – and that's when the font really got ugly.

Once the font was in the hands of Windows 95 users, there was no telling how people would use it. It was printed on bake-sale flyers, birthday-party invitations, and even business cards. But remember, this typeface was designed to be used on-screen, and in 1994, when the typeface was designed, most computers for personal use (and Windows 95) didn't have *anti-aliasing* (the technology that makes fonts look smooth on-screen). Without anti-aliasing, fonts look jagged, as if they were made of LEGOs. This isn't the end of the world, as long as the typeface is designed accordingly. In Figure 3-6, notice how much better the *e* of Comic Sans distributes its visual weight when aliased.

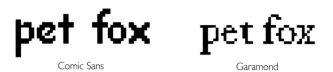

Comic Sans

Garamond

FIGURE 3-6
Comic Sans was originally designed to be displayed aliased.

In fact, as Figure 3-7 demonstrates, when compared to Garamond, which wasn't originally designed for the screen, Comic Sans fares quite well in terms of readability.

Mr. Bennet was so odd a mixture of quick parts, sarcastic humour, reserve, and caprice, that the experience of three and twenty years had been insufficient to make his wife understand his character. Her mind was less difficult to develope. She was a woman of mean understanding,

Comic Sans

Mr. Bennet was so odd a mixture of quick parts, sarcastic humour, reserve, and caprice, that the experience of three and twenty years had been insufficient to make his wife understand his character. Her mind was less difficult to develope. She was a woman of mean understanding, little information, and uncertain temper. When she was

Garamond

FIGURE 3-7
When aliased at 12px, Comic Sans is more readable than Garamond.

So, the story of Comic Sans is not that of a really terrible font, but rather of a mediocre font used incorrectly on a massive scale. Windows 95 was the first operating system to really hit it big. Just as computers were starting to pop up in nearly every home in the United States, Windows 95 was installed on most of those

computers and, with it, Comic Sans. So, now, nearly every man, woman, child, and bake-sale organizer found himself or herself armed with publishing power unlike civilization had ever seen – and few of them really had any design sense.

Comic Sans rode the wave of desktop publishing

It used to be that if you lost your kitten and wanted to make a poster, the most efficient way to make a flyer would be to draw one up with marker, cut out a picture of the cat, and go down to the nearest supermarket to make copies of it at 15¢ apiece. Then you posted them in your neighborhood and, like a caveman, you called the newspaper and placed an ad to help find your kitten.

But with Windows 95, a personal computer, and a printer, you could use Microsoft Word to make your lost kitten poster and print it out at home. And, wow! You could use any font you wanted. What's that? You don't know anything about fonts? Of course not, because you've never had this power before. So, guess what font makes you think about your lost kitten?

This is a monumental moment in history – right up there with the invention of printing. Common people suddenly had the power to typeset and print documents. No big deal for a while – some people got to enjoy making their own Christmas cards, birthday party invitations, and so on, and the small audiences of their families and co-workers suddenly had to put up with some ugly, clip-art-riddled Christmas cards.

But then, gradually, over the next decade, the Internet got more and more popular, and that publishing power got even stronger. Instead of flyers posted in break rooms, Comic Sans was showing up on websites and even as the default font for many people's e-mails. Now, anyone could write a message that could be read by millions, in Comic Sans. This actually happened when Cleveland Cavaliers owner Dan Gilbert wrote a letter regarding the dramatic departure of LeBron James… and used Comic Sans, resulting in a media storm over the poor font choice.

Comic Sans is at the disposal of nearly everyone with a computer. But that doesn't mean that we'll always have to be subject to its awkward forms. The spread of Comic Sans – a pretty bad font – is the result of the spread of an inarguably good technology. Just as the advent of movable type eventually led to a spread of literacy, the advent of personal publishing should lead to the spread of design literacy – and with it, a populace too informed to stoop to using Comic Sans.

The Shackles of the Typographer:
The Unalterable Word

Throughout the history of typography, the forms of letters have been derived from the media and tools with which they were rendered. Since an organized grid of pictographs was scrawled into a tablet of clay in Sumer over 5,000 years ago, the written word has been a song of language, tools, and media, choreographed into a dance inextricably linked to the build, flexibility, and spirit of its performers.

One of the most important principles consistent with every good piece of design is that the designer has shown a mastery of her medium. In any medium – whether it's a block of marble, steel and glass, or pixels – the designer has to work with strengths and limitations. Work with these characteristics, and the design stands a chance of being good; work against them, and the design has no chance.

Apple's lead designer, Jonathan Ive, knows this. In an interview with Core77 (www.core77.com), he said, "(T)he best design explicitly acknowledges that you cannot disconnect the form from the material – the material informs the form…."

The blinding sheen of Michelangelo's *David* is made possible by the hardness of the marble with which it was carved. Furthermore, Michelangelo had to work with a piece of marble that had been abandoned by a less-skilled sculptor – he had to fit the form of David into the malformed block the previous sculptor had left behind. But the resulting forward lean of the statue contributes to its imposing presence.

Architectural design has always been strongly influenced by building materials and technology. When architects began using steel-reinforced concrete frameworks in their buildings, it allowed them to reach heights that previously hadn't been imagined. Chicago's Monadnock Building, the tallest building constructed with load-bearing brick walls, stands at only 215 feet. The walls at the base of the building are 6 feet thick just to bear the load. Meanwhile, Dubai's Burj Khalifa, which was built with steel-reinforced concrete, is more than half a mile tall.

In industrial design, Apple's products perfectly exude the qualities of their materials. The unibody aluminum MacBook Pro features uninterrupted flat surfaces and sharp edges that communicate its solidity. The iPhone 4 – with its touch-screen surface – is essentially two pieces of glass tied together by a metal ribbon. The smoothness of transitions between its surfaces expresses its simplicity.

Typography also is influenced by materials and technology. But, more than any art form, typographic form is inextricably linked with language. "Language just happened, it was never planned," sang Conor Oberst of the band Bright Eyes. This isn't precisely true, but it hints to the fact that there is fluidity in the way that language evolves – so slowly, and with each innovation so dependent upon what came before it, that the progression seems invisible.

Aside from living during the era of one of mankind's most massive innovations in the way that information is shared, you probably haven't seen dramatic changes in language in your lifetime.

You might ask your friend, "how r u," through a text message, all while sifting through a stream of 140-character-or-less tweets, which are flurried with #hashtags.

Books once took years not only to write, but to be reproduced. They were affordable only to the extremely wealthy and privileged, and very few people knew how to read them at all. But today, literacy rates are higher than ever, and a Wikipedia entry can be updated in a moment.

So much has changed in the way language is conveyed and consumed, but in the Western world we've been using some derivation of the Roman alphabet for hundreds of years.

In typography, as in the design of the iPad, form cannot be disconnected from material. Form also can't be disconnected from language. Jan Tschichold, one of the most outspoken and opinionated typographers of the 20th century, stated this well in *The Form of the Book:*

> Since typography appertains to each and all, it leaves no room for revolutionary changes. We cannot alter the essential shape of a single letter

without at the same time destroying the familiar printed face of our language, and thereby rendering it useless.

In short, more dramatic words: "the typographer is chained more than any other artist by the unalterable word...."

So, no matter what the material, no matter what the decorative expression, an *x* will consist of two lines (or at least the visual suggestion of two lines) that cross one another. The same restriction applies to all the letters in our modern alphabet, and all typography must submit to this limitation.

By understanding this concept, you'll hopefully see typefaces with new eyes. All typefaces are different shapes of meat on the same bones. This "skeleton," which hasn't changed for hundreds of years, is a product of civilization, economy, and culture.

The Formation of Our Alphabet

The "unalterable word" is a product of thousands of years of innovation of the written language, starting with the first representations of things and ideas. Some of the earliest known drawings are cave paintings in Lascaux, France, from 15,000 BC to 10,000 BC (see Figure 3-8). These impressive renderings can hardly be considered writing, but they do represent objects – in this case, animals – and, thus, qualify as a form of visual communication. Drawings such as these were abstracted further – so that they could be rendered more quickly – into *pictographs* (drawings that represent things) and *ideographs* (drawings that represent ideas or concepts). Petroglyphs, such as those in Figure 3-9, date as far back as 12,000 BC and consist of pictographs and ideographs.

The first known organized writing occurred in Mesopotamia, considered by some historians to be the "cradle of civilization." The advent of the domestication of plants and animals for food not only freed up time for spawning innovations beyond merely achieving subsistence, but also made necessary some form of record-keeping. Farmers had to keep records on agricultural practices, and the formation of government and commerce called for the recording of tax payments.

FIGURE 3-8
These cave
paintings in
Lascaux are some
of the earliest
known drawings.

FIGURE 3-9
Petroglyphs such
as these consist
of pictographs
and ideographs,
which are some
of the earliest
forms of written
language.
*Jrbouldin (http://en.
wikipedia.org/wiki/
User:Jrbouldin)*

The earliest of such records are clay tablets that have been scrawled with a stylus into an organized grid of pictographs (see Figure 3-10). As more record-keeping was necessary, and the profession of the scribe was born, efficiency was improved by developing a writing system that consisted of vertical columns, so that a scribe would not smear the clay as he rested his hands on the tablet.

FIGURE 3-10
Pictographs were scrawled or impressed into clay tablets, such as this one, to keep agricultural records.
Jim Kuhn (http://www. flickr.com/people/ takomabibelot/)

As pictographs were further abstracted and efficiency improved, the sharp stylus was replaced by a wedge-shaped one, which was now directly pressed into the clay rather than dragged through it. Several singular indentations were made to form each pictograph, greatly simplifying the process of writing.

This organized method of writing, called *cuneiform,* is a pure example of the influence of medium on form. In looking at one of these clay tablets, you can clearly see the consistency of form created by the wedge-shaped stylus. Innovation drove economy to drive the use of this tool, and all these factors danced together to choreograph these forms (see Figure 3-11).

FIGURE 3-11
The forms of the
cuneiform on
this clay tablet
are directly
influenced by the
wedge-shaped
stylus that
was used to
create them.

The Birth of Our Letters

Early writing systems – such as cuneiform, Egyptian hieroglyphics, Cretan
pictographs, and Chinese calligraphy – were complex and difficult to learn.
Eventually, the western world settled on a smaller set of characters from which
evolved our modern alphabet (see Figure 3-12).

As the Latin alphabet was adopted, writing – thanks to its newfound simplicity –
became more widespread. The formative period of this lettering occurred
during the Roman Empire, and in the course of that civilization, typography
was created with brush and paint on walls, with pen and ink on papyrus, and
chiseled into stone through painted-on guidelines.

Cretan pictographs · Phoenician · Early Greek · Classical Greek · Latin · Modern English

FIGURE 3-12
Just one example of how a letter (the letter *A*) evolved throughout time.

The Twitter of the Roman Empire

The remains of the ancient city of Pompeii are like a time capsule of Roman civilization. Pompeii was a lively and active city of the Roman Empire. It was a center of art and culture and was home to gladiatorial battles a century before the Colosseum in Rome hosted its famous battles. But the entire city was buried under volcanic ash in AD 79, with the eruption of Mount Vesuvius.

The city of Pompeii was frozen in time that day and wasn't rediscovered for over 1,500 years. Today, the ruins are still being excavated, revealing things about life in the Roman Empire that historians would never have learned otherwise. The streets, the floor plans of the villas, and the frescoes on the walls all remain as they were that fateful day nearly two millennia ago.

You may have already seen the plaster molds that have been made of the victims of the eruption. Human-shaped voids in the ash tell tales of Pompeii's inhabitants crouched against walls, covering their faces, couples embracing, or entire families huddled together in their last moments.

Less haunting, and more telling of the day-to-day life in Pompeii, are the hundreds of instances of vernacular street graffiti throughout the city. Messages were written on walls throughout the city, like an ancient version of Twitter. The graffiti consists of cheers and jeers of current leadership, claims of sexual prowess, or simply "I made bread."

This graffiti is written mostly in rustic capitals and square capitals (see the nearby sidebar, "Notable letters of typographic history"), using a flat brush. The letters were optimized for speedy writing and made with as few strokes as possible, while still maintaining some standard of aesthetics. The end of a brush stroke, if the brush is simply lifted, looks awkward, so serifs were added to the letters to give them a clean look and enhance readability (see Figure 3-13).

FIGURE 3-13
Graffiti in
Pompeii clearly
shows the
influence of the
brush.
*Gastev (http://www.
flickr.com/photos/
gastev/)*

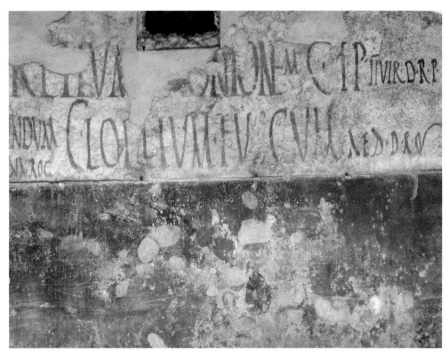

The height of Roman typography

The influence of the brush even found its way into lettering carved in marble, such as in the base of Trajan's Column, which is considered the height of Roman typography. Though there is subtlety in the lettering that, as Apple CEO Steve Jobs has said of calligraphy, is "beautiful in a way that science can't capture," the general "skeleton" of the letters is based upon the square, the triangle, and the circle (see Figure 3-14).

FIGURE 3-14
The theoretical
underpinnings of
Roman capitals:
the square, the
circle, and the
triangle.

The spaces within and between the letters also are carefully considered, to maintain an even texture and allow the letterforms themselves to shine through. The marble was painted first with a brush. Because the brush was flexible and held at a fixed angle, the letterforms have strokes that vary in thickness. After the lettering was applied to satisfaction, it was masterfully chiseled into the marble (see Figure 3-15).

FIGURE 3-15
The lettering on the base of Trajan's Column is influenced by the brush.
A History of Graphic Design, 3rd Edition, Meggs, 1998, John Wiley & Sons, Inc. Reprinted with permission of John Wiley & Sons, Inc.

Even though the serifs on Trajan's Column were probably influenced by the qualities of the brush, in some Roman inscriptions, it's likely that the chisel was the source of the serif. Figure 3-16 shows an inscription inside the Amphitheatre of Pompeii, which predates the lettering on Trajan's Column. Although it's believed that inscriptions such as these – despite having awkward letter widths and spacing – were actually painted onto the stone before chiseling, the tiny spur serifs on this inscription are clearly a result of little cleanup strikes from the chisel, rather than finessed detailing of a brush.

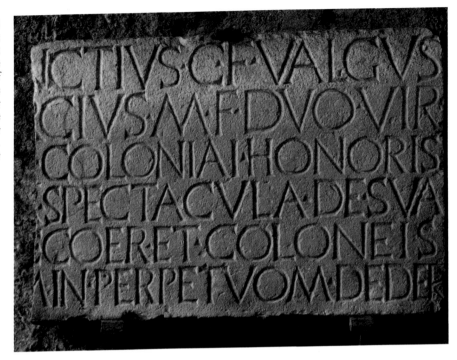

Notable letters of typographic history

The forms of letters have changed throughout time, strongly under the influence of the media in which they were created. Here are some notable milestones of typographic history. To learn more about the different categories of typefaces, and about choosing and pairing fonts for any occasion, turn to Appendix A.

> **Square capitals:** The form of square capitals is influenced by the pen with which they are created. This was the popular writing of the day amongst the Romans.

NIMARTISQ'DOLOSETD
CHAODENSOSDIVVMN
NEQVOCAPTAEDVMFV

A History of
Graphic Design,
3rd Edition,
Meggs, 1998,
John Wiley &
Sons, Inc.
Reprinted with
permission of
John Wiley &
Sons, Inc.

> **Rustic capitals:** Rustic capitals are similar to square capitals but are optimized to require fewer strokes of the pen and to use less paper (because paper was extremely expensive at the time). So, rustic capitals are more condensed than square capitals are, and the letters are simplified a bit.

IOCEANISPRETOSPEDEREPPVL
DEMSIDUSFVGIENSVBIPISCIS
ORTIIBERNASCAELODESCEN

A History of
Graphic Design,
3rd Edition,
Meggs, 1998,
John Wiley &
Sons, Inc.
Reprinted with
permission of
John Wiley &
Sons, Inc.

> **Trajan's Column:** Lettering similar to that on Trajan's Column can still be seen throughout the city of Rome, but this type is considered the height of Roman typography. Though the forms transcend geometry, the letters follow the basic shapes of the square, triangle, and circle, with great consideration given to the balance between the letters themselves and the negative spaces within and between the letters. It wasn't available in modern times until Carol Twombly adapted it in 1989. (*Categorization: serif, humanist*)

IN A WORLD

continued

continued

> **Half uncials:** These are an altered version of the full uncials, which had been around since Greek times. You see the beginnings of ascenders and descenders in this lettering, such as in the *d* and the *q*.

A History of Graphic Design, 3rd Edition, Meggs, 1998, John Wiley & Sons, Inc. Reprinted with permission of John Wiley & Sons, Inc.

> **Carolingian minuscule:** Throughout the Middle Ages, which followed the fall of the Roman Empire, scripture fell into disarray. There was no standardization of lettering, so books were produced with varying degrees of quality in their letterforms. After Charlemagne once again unified Europe, he standardized lettering that should be done by the scribes. The resulting Carolingian minuscule was the birth of what we today consider "lowercase." It could be scribed relatively quickly and used less paper.

> **Textura:** In Northern Europe, textura (or Gothic or blackletter) became popular among the scribes. Because it was so condensed, it used less paper, and the repetition of vertical strokes created a very even texture and rhythm in the resulting text blocks.

*Typographic
Design:
Form and
Communication,*
2nd Edition,
Carter, Day &
Meggs, 1993,
John Wiley &
Sons, Inc.
Reprinted with
permission of
John Wiley &
Sons, Inc.

> **Gutenberg:** When Gutenberg produced the world's first printed Bible, he tried to make it look as though it had been scribed in textura. It took him at least 16 years to perfect the technology and cut the letters.

Kelly
McCarthy
(http://www.
flickr.com/
people/kelly
mccarthy/)

> **Jenson:** Nicholas Jenson created one of the first typefaces that was really influenced by the inherent nature of punchcutting type. The printers of the incunabula mistook scripture in Carolingian minuscule for ancient Roman scripture and tried to copy its forms. But penned letters have some sharp corners that don't lend themselves well to the punchcutting process, and these areas would create a buildup of ink that would result in blotting when printed. *(Categorization: serif, humanist)*

Itaq; equis Romã petũt. R
cóuiuio &luxu deprehédũt

continued

continued

> **Garamond:** This timeless typeface made a further departure from scripted forms and has lived on as one of the most readable typefaces available for printed media. *(Categorization: serif, humanist)*

Source:
Arminiuzz

Quandoquidem fi nihil
;,nihil denique diuinius

> **Baskerville:** John Baskerville strove for crispness, innovating a new, smoother paper, and recasting his type after each printing to retain the sharp contrast between thick and thin in his letterforms. *(Categorization: serif, realist)*

The BOOK of
Common Prayer,

> **Bodoni:** Bodoni really explored the form of type, ignoring the influence of the pen and, instead, geometrically rationalizing the forms. Where the strokes sharply go from thick to thin, they're rounded with geometric precision. The self-consciousness of this typeface's design makes it perfect for the many fashion magazines in which it is commonly used. *(Categorization: serif, geometric)*

Charlie Bites

> **Slab-serif:** As the proliferation of advertisements, posters, and flyers called for more decorative typefaces, Vincent Figgins introduced the first slab-serif (or Egyptian) font under the name Antique.

ABCDEFGHIJ KLMNOPQR STUVWXYZ&,:;.- £1234567890

A History of Graphic Design, 3rd Edition, Meggs, 1998, John Wiley & Sons, Inc. Reprinted with permission of John Wiley & Sons, Inc.

> **Sans-serif:** Though some sort of sans-serif lettering was used as early as the Etruscans, the first widespread use of sans-serif type was in the early 1800s. It quickly became popular in advertising posters and handbills. Typefaces such as Bodoni and slab-serif typefaces had mostly abandoned the influence of a drawing tool, but sans-serif type shed one of the oldest influences of drawing tools: the serif.

W CASLON JUNR LETTERFOUNDER

A History of Graphic Design, 3rd Edition, Meggs, 1998, John Wiley & Sons, Inc. Reprinted with permission of John Wiley & Sons, Inc.

> **Decorative type:** As printing spread, and commerce grew with the industrial revolution, advertisements such as posters and handbills became popularized. In order to stand out, printers experimented with a variety of effects such as outlined type, three-dimensional letters, plant-like flourishes, ornamental and stylized serifs, and decorative textures within the typefaces themselves. Many of these were cut in wood, not cast in lead. (*Categorization: display*)

continued

continued

A History of Graphic Design, 3rd Edition, Meggs, 1998, John Wiley & Sons, Inc. Reprinted with permission of John Wiley & Sons, Inc.

> **Art Nouveau:** Inspired by the Arts and Crafts Movement's return to organic forms, and freed from the limitations of typesetting by stone lithographic technique, Parisian poster artists such as Alphonse Mucha (originally from Morovia, now part of the Czech Republic) integrated illustration and typography. Today's fast pace of business and the technological limitations of the web make typography of this nature impractical. jQuery plug-ins such as Lettering.js are attempting to bring similar typographic control to the semantic web. (*Categorization: display*)

> **Futura:** Paul Renner's Futura broke down letters into the most basic geometric forms that it could. Typefaces with such intense geometric influence render poorly at body copy sizes on today's screens. Pixels are relatively incompatible with perfectly circular forms. *(Categorization: sans-serif, geometric)*

Numa Numa

> **Helvetica:** This font, which was modeled off of Akzidenz Grotesk, was an instant hit and has achieved such ubiquity that there is an entire movie about it. *(Categorization: sans-serif, realist)*

Bubb Rubb

> **Chicago:** The first notable font for the screen, Chicago was used throughout the Macintosh operating system. Though it looked hideous when printed out, its forms work with perfectly with the screen – it's letters are mostly composed of heavy vertical strokes that are easily rendered with pixels. *(Categorization: sans-serif)*

Rick Roll

> **Adobe Garamond:** Robert Slimbach, of Adobe, adapted this classic to current technology nearly 400 years after Claude Garamond's time. *(Categorization: serif, humanist)*

Spaghetti Cat

continued

continued

> **Georgia:** Designed by Matthew Carter, specifically to work with the limitations of the screen, Georgia is arguably the most readable serif font for web use. *(Categorization: serif, realist)*

I Like Turtles

> **Arial:** Designed in 1982 by Robin Nichols and Patricia Saunders, Arial is a nearly perfect imitation of Helvetica, but adjustments have been made to make it more compatible with screen technology. Arial is arguably the most readable sans-serif font for web use. *(Categorization: sans-serif, realist)*

Cuppy Cakes

> **Comic Sans:** Thrust into the hands of millions of kindergarten teachers, this was the first font to achieve widespread infamy even among those not trained in design. To learn more about this font's story, see "The Tragedy of Misuse: Why You Hate Comic Sans," earlier in this chapter. *(Categorization: sans-serif, display)*

Leeroy Jenkins

The Type That Has Lived On

Although the lettering from Trajan's Column is available for use in electronic form, most of us have enough typographic sensibility not to use it for all the body copy of our blogs. Some form of these perfect capitals live on today in most serif typefaces, but the lowercase portion of our alphabet comes from the Carolingian minuscule.

The Carolingian minuscule was established in approximately AD 800 as a standard script to be used throughout Europe by Emperor Charlemagne. The script was eventually replaced throughout Europe by the Gothic blackletter, only to be revived during the Italian Renaissance.

The invention and spread of printing

The first printed book in history, which is widely regarded to be the most significant single invention ever, was Johannes Gutenberg's so-called "42-line Bible." It took Gutenberg at least 16 years to perfect his methods and cut and set the type for these Bibles, only to be bankrupt at the time of their printing.

Besides the fact that he was pioneering a new technology, the arduousness of Gutenberg's task must have had something to do with the fact that he was creating letters that nearly perfectly mimicked textura (also known as blackletter or Gothic) script, which was popular at the time. The pages of Gutenberg's Bible (see Figure 3-17) have an incredibly even texture throughout, but later printers learned to create forms that were more suitable to this groundbreaking innovation.

FIGURE 3-17
A page from Gutenberg's so-called "42-line Bible."
Kelly McCarthy (http://www.flickr.com/people/kellymccarthy/)

As printing spread throughout Europe in the late 1400s, a period of time known as the *incunabula* (Latin for "cradle"), printers began to take their inspiration from the Carolingian minuscule in designing their letters. But the challenges presented by creating movable type brought about entirely new forms.

Though the first few fonts that were inspired by the Carolingian minuscule attempted to completely replicate scribed lettering, printers very quickly found that *punchcutting* (the process they used to create their type) lent itself to new forms, which are still used in much of today's printed material.

Punchcutting: The cradle of the unalterable word

Type designers today have nearly no restrictions, aside from the "unalterable word," to guide the shapes of their letters. But the forms of that unalterable word mostly emerged during the incunabula. Printers that had sprouted up throughout Europe were scrambling to print books and find markets that would have demand for the spoils of this new innovation.

Printers quickly found that the process of creating lead fonts for printing was far different from scribing letterforms. The tedious process of punchcutting instead yielded new forms.

To create a letter of type, founders poured lead in a copper *matrix* (mold) that could be used repeatedly for creating identical slugs of type. The indentation of the copper matrix was created with a *punch,* which was the product of the process of punchcutting (see Figure 3-18).

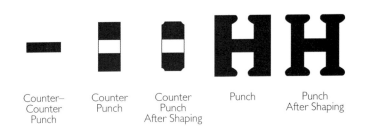

FIGURE 3-18
Punchcutting involved cutting and punching a series of steel shapes to eventually punch a copper matrix.

Counter–Counter Punch Counter Punch Counter Punch After Shaping Punch Punch After Shaping

To start the punchcutting process, a type designer had to create a counter-punch, or even a counter-counter-punch. For example, to create a crossbar for an *H* a punchcutter would first have to file down a steel counter-counter-punch that had the positive shape of the crossbar, much like "—." This would then be punched into a counter-punch, thus creating a negative form of the crossbar of the *H.* Then that counter-punch would be filed down and hardened so that it could punch the negative spaces on either side of the crossbar of the *H,* defining the edges of the serifs on these interiors. This counter-punch would then be punched into a punch. The result would be a raised crossbar, with the impression of the counter-forms surrounding it. Then, the outer edges of the *H,* such as the outer serifs, would be formed through additional filing with fine tools. Once this punch was cut, it would be driven into a sheet of copper to create a *matrix.* Lead would be poured into this matrix numerous times to create multiple instances of the same letter.

If the printer wanted to have more than one type size, he would have to repeat this entire process over again for each size, something that was as much a fortuitous limitation as it was a pain (see Chapter 7).

Naturally, with this process, making an exact replica of text that had been scribed was much more difficult than creating an adaptation of such forms, and the latter is exactly what happened.

Additionally, the designer had to consider the final application of his type design. Once all the type was set for each individual page, ink was spread over the surface of the letter and impressed into the paper upon printing. The thickness of ink in this situation, and the natural "bleeding" of excess ink out to the edges of the letters, made some of the sharp angles that would have resulted from exact replicas of scribed letters impractical. Additionally, creating counter-punches with some of these sharp edges also would've been difficult.

Venice and the Renaissance

As printing was spreading across Europe, Venice became one of the main hotbeds of printing. The incunabula coincided with the Renaissance, so Venice, a center of trade and commerce, was full of wealthy intellectuals with a fascination for ancient Greek and Roman culture.

It was from this fascination with ancient Rome that Nicholas Jenson (not to be confused with the Dutch font Janson) created type whose forms are still in use today. He mixed the smooth lines of the lettering from Trajan's Column with the lowercase forms of the Carolingian minuscule to create type the modern reproduction of which is still one of the best Renaissance Serif typefaces there is.

France and Garamond

Though little happened in France to contribute to the first several decades of printing, the environment created by King Francis I's patronage of the arts brought about one of the greatest typefaces of all time.

Claude Garamond's type, today known simply as Garamond, took cues from Italian printers' designs such as Jenson's, but created a more even texture on the page through a tighter letterfit and smoother forms with even more influence from the process of punchcutting.

Throughout history, Garamond has been misattributed to many incarnations of type originally designed by Jean Jannon. Today's most popular reincarnation of Garamond, Robert Slimbach's Adobe Garamond, holds true to the form of Garamond's original type. But, Garamond's design may have been strong influenced by Antoine Augereau, under whom Garamond apprenticed, and Geoffry Tory, with whom Garamond worked.

Whatever the origin of Garamond's design it became so popular that it is credited for replacing textura throughout Europe, except for in Germany. This popularity is due, in part, to the extraordinary quality of the typeface, but Garamond had some advantages of distribution as well, both fortunate and unfortunate. He was the first to establish an independent type foundry for selling cast type to printers. But also, because he died penniless, his widow sold his punches and matrices, making his type more widely available.

Garamond Today: Why You Don't Use Garamond on the Web

Today, Garamond is still regarded as one of the best typefaces in existence. Having been around for nearly 500 years, it's still a go-to typeface for designers

looking for something sophisticated and readable that creates a pleasant texture in body copy.

A version of Garamond was used in 1984 to announce the release of the Macintosh. Garamond has been used in countless books and publications, from Dr. Seuss to *Harry Potter*. The literary journal of author Dave Eggers's McSweeny's publishing house has gone so far as to vow to only use Garamond throughout its entire lifetime.

In the early 1990s, the advent of the personal computer and the massive innovation of the Internet created a revolution in the way that information in shared. Anyone with a personal computer had never-before-seen publishing power, and anyone with an Internet connection had access to read that published material.

But this presented a new challenge in the conveyance of information. The browsers that translate the language of the web, HTML, could display only fonts available on the computer accessing the document. Along with many other layout challenges, designers creating for the web (though there were few at this time) had almost no control over the fonts their audience would see.

The birth of the "web font"

But Microsoft, which was exploding in influence in the early 1990s, came to the rescue. Starting with Windows 3.1, a collection of fonts became widely distributed that were later to be included in Microsoft's 1996 Core Fonts for the Web project, which made freely available a number of screen fonts so that there would be some cohesion to the fonts available for Internet usage.

Among the fonts included in the Core Fonts for the Web project were many that are still popular for web use today, including Arial, Comic Sans (tragically), Georgia, Times New Roman, and Verdana.

Today, a web designer knows which of these fonts are likely to be available to her audience, and she plans accordingly. CSS even allows her to list multiple fonts, so she can have a next best choice for her preferred font.

But this isn't enough for many designers, nor is it enough for their clients. There are sophisticated design preferences and branding guidelines to be

adhered to, and naturally, a number of different methods have been used to work around this limited palette of fonts.

A designer can use images, but then the information is locked away from the semantic structure of HTML (aside from what may be included in the `alt` attribute). He can use a Flash-based replacement like SIFR, but growing mobile platforms such as iOS don't support Flash. Other font embedding means, such as Cufón, Typekit, and Google Font API, are starting to look promising.

The real reason to stick with the old standby web fonts has nothing to do with the availability of those fonts on your audience's computers and everything to do with the fonts themselves. Much as Carolingian minuscule wasn't right for punchcutting, beautiful classics such as Garamond just aren't compatible with today's displays (at body copy sizes).

A great leap

The introduction of the pixel as a consideration for the type designer brought a fresh departure from standard letterforms that hadn't been seen since the art of punchcutting bore the forms of Garamond. The display of the first Macintosh operating system, introduced in 1984, not only was similar to creating forms out of LEGOs, but also was only a 1-bit display, so each pixel could either be black or white, and that's it.

Such intense restrictions meant that the old standby letterforms – Garamond included – couldn't be used effectively. So, Apple commissioned Susan Kare to create the Chicago font for the Macintosh operating system (see Figure 3-19).

Obviously hideous when printed out or used at large sizes, the Chicago font did a great job of making the best of what little it had to work with. The heavy verticals in each letterform work with the rectilinearity of the pixels and create a strong sense of rhythm that is reminiscent of the textura in which Gutenberg's Bible was printed. These heavy verticals were connected with thin strokes of pixels that ultimately defined the letters. The typeface was also heavy enough to be displayed in alternating black-and-white pixels, to create a gray appearance for disabled menu items in the interface.

FIGURE 3-19
The Chicago
font made good
use of the pixel
and a black-and-
white palette.
Apple

As computing power increased, so did the capabilities of displaying larger numbers of colors, which meant that the subtleties of letterforms could be more readily transferred into pixels through a process called *hinting*. The first personal computer fonts, such as Chicago, were simply bitmaps and could be displayed only at one size. Newer fonts used technologies such as TrueType to actually create outlines of the types and control kerning pairs. Computers with enough power could then use this TrueType information to show the fonts in multiple sizes and print smooth characters on printers.

Bridging the gap

As computing power increased, so did the number of colors available, and more subtle typographic forms could be brought to the computer screen. This brought about a new breed of typefaces that were neither awkward and chunky like Chicago, nor subtly finessed like Garamond.

No type designer's fonts have reached more eyeballs in this category, nor are created with more mastery, than those of Matthew Carter. Carter has designed typefaces that are current standards on the web, including Verdana, Tahoma (Verdana's slimmer brother), and Georgia.

If you were looking for an alternative to Garamond for use on the web, you'd find no better choice than Georgia. Just as Garamond's story starts centuries ago, Georgia's story of its compatibility with the screen starts almost exactly 300 years before its design, in 1692.

As muddled and confusing as typeface classifications can be (see Appendix A), Georgia is considered to be a transitional typeface. The first transitional typeface ever created was the Romain du Roi. Louis XIV formed a committee to create a new type for the royal printing office. The new letters were to be designed scientifically, so instead of relying on more calligraphic forms as Garamond did, they used a grid of 2,304 squares to guide their design (see Figure 3-20). It's as if transitional typefaces were made to be displayed in pixels from the beginning.

Because Georgia is related to the Romain du Roi, it has a natural advantage when displayed on-screen. Transitional typefaces, such as Georgia and the Romain du Roi have a vertical axis. Notice in Figure 3-21 how the thin parts of the *o* on Georgia are vertically aligned with one another, whereas with Garamond, they are not. This vertical orientation, a product of the grid that Transitional typefaces were bore from, is part of what makes Georgia more compatible with the screen.

Also, Georgia has sharp serifs, whereas Garamond, which is an old style typeface with a humanist structure, has subtly modeled serifs. Look at that little curve on the bottom of Garamond in Figure 3-21. Details like this get lost when reproduced on-screen at small sizes.

If you go to `www.designforhackers.com/moire.html` (Adobe Flash required) you can see an example of how today's screens are incompatible with subtle curvilinear form. As the concentric circles on the animation change in size, you notice how a moiré pattern dances across your screen. This shortcoming is what makes many typefaces that were designed before the digital revolution display poorly at body copy sizes.

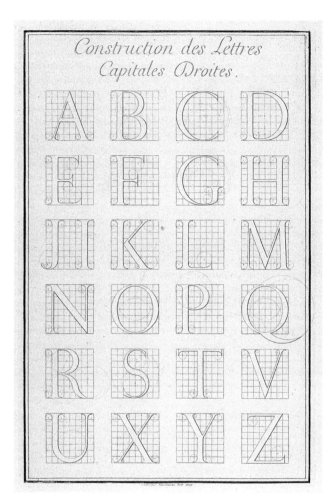

FIGURE 3-20
The letters of the Romain du Roi were designed on a grid of 2,304 pixel-like squares.

A History of Graphic Design, 3rd Edition, Meggs, 1998, John Wiley & Sons, Inc. Reprinted with permission of John Wiley & Sons, Inc.

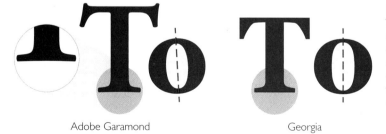

Adobe Garamond Georgia

FIGURE 3-21
The vertical axis and sharp serifs of Georgia give it an advantage over Garamond when displayed on-screen.

Figure 3-22 shows just what I mean by that. Georgia reads better on-screen primarily because it has a higher x-height and, as a result, a larger eye and other counters. This prevents letters such as *e* from becoming muddled and illegible and makes the letters actually look larger.

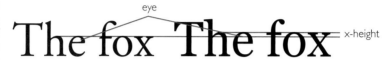

Technologies such as Typekit and Google Font API are making it more feasible for web developers to overcome the font availability hurdle, promising to one day make it easy for a designer to use whatever font he chooses. Meanwhile, more advanced screen technologies such as the iPhone 4's 326 ppi Retina display promise to one day bring web typography to the resolution of paper. The only way for a designer or developer to ensure that she's making the right font choice is for her to develop an understanding of the font's intentions and the limitations of the screen technology – or whatever medium in which the design will finally be conveyed.

Limitations can be embraced – even parodied

When a new medium presents limitations, instead of trying to compromise, some designers innovate by embracing the limitations. In the late 1990s and early 2000s, many designers who were working in Flash used very small typefaces that crisply displayed pixel-for-pixel. "Pixel fonts," such as those in Figure 3-23 from Craig Kroeger's Miniml (`www.miniml.com`), were designed to be used at specific sizes with no anti-aliasing. Kroeger and other pixel font designers explored nearly every conceivable letterform that could be produced at sizes as small as 4 pixels in height.

In the early 2000s, taken by the beauty of these tiny pieces of art – and with much younger eyes – I forced many clients to request that I "make it bigger" when I used these fonts.

Fonts 4 pixels high may seem absurd, but some have dared to take pixel experimentation even further by creating subpixel fonts, such as Miha Zajec's Flea's Knees (see Figure 3-24), which is a mere 3 pixels high, and – though

beautiful – has, as Zajec admits in the Typophile forum post in which he introduces the font (`www.typophile.com/node/61920`), little practical application other than perhaps use in a 16-pixel favicon. Subpixel fonts actually use the red, green, and blue stripes that make up each pixel on LCD displays as if the stripes themselves were pixels.

```
ceriph 07  56
ABCDEFGHIJKLMNOPQRSTU

ceriph 07  63
ABCDEFGHIJKLMNOPQRS

ceriph 07  64
ABCDEFGHIJKLMNOPO

ceriph 07  65
ABCDEFGHIJKLMNOPQRSTU

ceriph 07  66
ABCDEFGHIJKLMNOPQRS
```

FIGURE 3-23
Pixel fonts, like these from `www.miniml.com` embraced the limitation of the pixel.

FIGURE 3-24
Subpixel typefaces exploit the red, green, and blue stripes within the pixels on LCD screens to render tiny type.

Knowledge Applied

From its beginnings, typography, more than any other art form, has been bound not only by the characteristics of language, but also by the properties of the medium in which the typography is created. Today's most popular letterforms don't depart very drastically from those created in the early days of printing, but the technologies of the web call for the use of fonts that are created with the web's unique limitations in mind. As technology improves, it

promises to once again make classic letterforms relevant. The only way for a hacker to be sure she's using a font correctly in a particular situation is for her to develop an understanding of where the typeface comes from and the technologies and mediums that influenced its forms.

Although there's no substitute for lots of understanding and practice, here are a few guidelines that will help improve your understanding of design moving forward:

> Learn about the different types of typefaces, paying special attention to who designed them and how technology influenced the design. Read Appendix A for more on this.

> On today's screens (about 100 ppi to 150 ppi), stick with web-standard fonts at sizes below 30 px.

> Feel free to use custom fonts from Typekit, Cufón, or other technologies at sizes above 30 px, but be sure that you understand the font and how best to pair it. Read Appendix A for more on this.

> Avoid using fonts designed for the screen in print applications.

Technology and Culture

AS DISCUSSED IN Chapters 1 and 2, design is a product of many "layers." The purpose of a piece of design sets the foundation upon which these layers are built. As illustrated in Chapter 3, the medium with which a particular typeface is created interacts with the alphabet to create letters that have differing qualities. And, as I'll talk about more in Appendix A, certain philosophies and cultural factors further evoke particular moods in various type styles.

Aside from the medium in which a particular design product is created, the very world within which the designer lives has a tremendous influence on the form that she creates. The most successful designs, those that set trends and eventually stand the test of time, express – and sometimes change – the spirit of their time. The very best designers are either actively aware of this influence or surrender their process to its gentle hand.

The product of this confluence of medium, technology, and culture is what most people recognize as a "style." It manifests itself as art movements or design trends. To the viewer, it may be all about the "look," but this "look" is a product of many factors. If a designer were to simply try to copy a "look," he would likely end up doing little more than creating the veneer to which the Steve Jobs quote in Chapter 1 refers. To really create a design that belongs in its time and place, a designer must yield his process to the influences of his world.

How Trends Are Created

Any significant design trend, or any significant artistic movement, has been a reaction to – and embrace of – technological and cultural forces. Wars, famines, the rise and fall of leaders, demographic trends, inventions, and other world events and innovations all create opportunities for designers to approach the ordinary in an extraordinary way. This is how style is born and how trends are set.

The birth of Impressionism

The artistic movement of Impressionism is no exception to this rule. This groundbreaking style paved the way for modern art and remains the most popular and imitated style in painting.

When many people think of Impressionism, they think of paintings that are colorful but, simply put, blurry. But it wasn't that the Impressionists had impaired vision or even lacked artistic skill. There were particular technological and cultural factors that inspired the Impressionist movement.

In 1860s Paris, a group of bohemians, later to be known as the Impressionists, gathered at Café Guerbois in Paris. Édouard Manet, Claude Monet, and other soon-to-be-famous artists discussed ideas, art, and politics. France had undergone a series of revolutions over the previous hundred years, and it was just about to experience yet another revolution, as the political influence of the elite classes dwindled and that of the middle class grew.

This growing middle class was increasingly enjoying a biannual art event held in Paris, known simply as the Salon. The Salon was organized and sponsored by the French government's Academy of Arts, and – because Paris was the center of the art world – this event was the biggest event in art. Jurors chose thousands of paintings to be displayed, and the paintings were crowded onto every inch of the exhibition hall that was available.

For the previous hundred years or more, paintings in the neoclassical style had prevailed at the Salon. Neoclassical art usually depicted scenes from ancient Greek or Roman history or mythology, painted as realistically as possible. For example, Jacques-Louis David's *The Oath of Horatii* (see Figure 4-1) shows the three sons of the Horatii family vowing to defend Rome to the death.

So, in the Parisian art scene, around the time of the birth of Impressionism, there was a very scholarly approach to art: classical themes depicted with perfect perspective and perfect brushwork. The growing middle class was basking in the reflective glory of ancient Greece and Rome, all the while enjoying their newfound capitalist freedom. It was all a little out of place, as this scholarly approach to art was left over from the days when the elite classes ruled Paris. But with the 1863 Salon, this all changed.

Impressionism and the middle class

For some unknown reason, the jury for the 1863 Salon rejected far more paintings than usual. The art community and public were so outraged over these rejections that the French government decided to hold an exhibition of all the rejected works, known as the *Salon des Refusés.*

Ironically, the very public that came to this exhibition looking for cutting-edge artwork, was shocked at one particular painting. Manet's painting, *Luncheon on the Grass* (see Figure 4-2), flew in the face of the sense of propriety that the middle class valued. To at least one art critic, this painting was little more than "a young man's practical joke."

The main issue they took with the painting was the presence of the nude in the foreground. This was paradoxical because the Salon was, like any large art exhibit, full of paintings of nudes. But those nudes were likely idealized Roman or Greek goddesses, whereas Manet's nude was a model in the Paris art scene. Instead of being sprawled out with eyes averted – as she might have been had

this been a painting of the Roman goddess Venus – she is seated in an unflattering position and glaring right at the viewer, with no sense of self-consciousness or submissiveness.

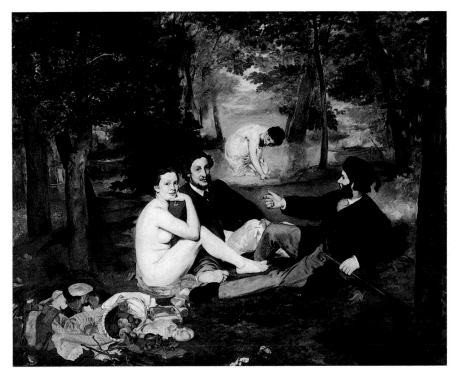

FIGURE 4-2
Édouard Manet's
Luncheon on the Grass (1863),
with its everyday
subject matter
and unrefined
brushwork,
marked the
birth of
Impressionism.

Almost as controversial as the subject matter of this painting was the technique with which it was rendered. The brush strokes are clearly visible, and, in some places, the painting looks like nothing more than a sketch. The sense of perspective is off as well, with the bathing woman in the background looming slightly larger than she should be. The whole scene has a sense of flatness.

Impressionism and photography

Impressionism developed further as it began to gain acceptance, and this "sloppy" style of painting was both a reaction to, and an inspiration of, the advent of photography, which was gaining popularity as an artistic medium. The "slice of life" subject matter of Impressionism lent itself to the immediacy of photography, resulting in compositions that looked as if they were mere

snapshots from a camera, such as in Gustave Caillebotte's *Paris, A Rainy Day* (see Figure 4-3). Instead of being carefully arranged within the painting, the people in this piece are caught in motion, entering and exiting the edges of the canvas.

FIGURE 4-3
The suspended action of Gustave Caillebotte's *Paris, A Rainy Day* (1877) makes it look as if it were a photographic snapshot of a Paris street.

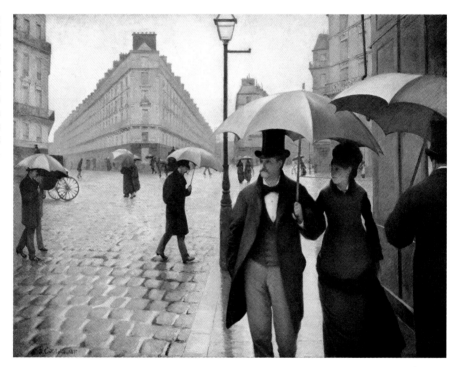

Now that photography could capture life realistically, painters were free (if not pressured) to explore new ways of expressing themselves with paint. By the late 1880s, Impressionism, now very popular and common in the Salon, gave way to Post-Impressionism. The flat compositions and exposed brushwork of Impressionism evolved into more in-depth study of the interaction between individual brush strokes of color and the eyes of the viewer. You probably need only glance at Vincent Van Gogh's famous *Starry Night* (see Figure 4-4) to get some idea of what I mean. (I talk more about how the Impressionists and Post-Impressionists explored color in Chapter 9.)

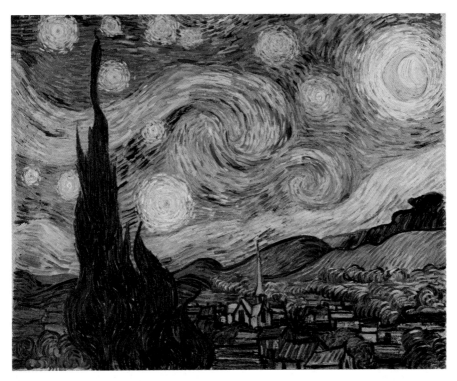

FIGURE 4-4
The Post-Impressionists further broke down brushwork and color interaction, such as in Vincent Van Gogh's *Starry Night* (1889).

Impressionism and modern art

The work of the Impressionists and Post-Impressionists paved the way for modern art. It transformed painting from a method of representation into a method of conceptual and perceptual exploration. Artists continued to find new ways to represent the physical world; make social commentary; and explore the qualities of paint, brush, and canvas.

Art has continued to evolve beyond Impressionism, but go to any art fair today, and you'll likely see artists of varying degree of skill painting in a style that is visually similar to Impressionism. Some of the paintings may actually be attractive, but none of them has the same cultural import and relevance as the paintings that truly originated from the technological and cultural forces of Paris in the late 19th century.

REMEMBER In order for a piece of art or design to really be relevant and important, it has to be sensitive to the technological and cultural factors present within the world in which the piece is created. Doing otherwise will result only in the creation of a veneer.

Web 2.0 graphics

Time will tell what art and design produced today will stand the test of time and go down in history as historically significant, but it's safe to assume that it will be art that is a product of technological and cultural influence. One such artistic style, believe it or not, may well be that associated with the Web 2.0 movement.

The Web 2.0 movement gathered momentum around 2005 and is typically understood to encompass web applications that enable information sharing between multiple users. Services such as Flickr, Blogger, Delicious, and YouTube all benefit from what their users produce. This user-generated content contributes to the overall value of the service. The more photos that are added to the photo-sharing site Flickr, the more it grows into a repository where you can easily find photos on nearly any subject. Many of the photos in this book, for example, are from Flickr.

But Web 2.0 sites also are known for their graphic style – lots of gradients, reflective surfaces, and rounded corners. The graphic style of Web 2.0 has been so ubiquitous in the past decade that various sites have popped up – as jokes – for automatically generating Web 2.0 logos and graphics. The Web 2.0 Logo Creator in Figure 4-5 (now defunct) was one such example. It created a logo with gradients in the letters, with an optional reflection of itself underneath.

It's true, plenty of very laughable Web 2.0–style graphics were created around 2005, but this is mostly because, like the modern-day "Impressionist," the creators of the graphics were copying the "look" rather than understanding the forces that brought the style into existence.

FIGURE 4-5
The Web 2.0
style has been so
overused that
sites like the
now-defunct
Web 2.0 Logo
Creator parodied
the style.
*Copyright © 2006
Alex P*

How Apple started the Web 2.0 style

To understand where the Web 2.0 style comes from, we have to rewind to the Macworld Expo in January 2000, where Steve Jobs introduced Mac OS X and its revolutionary Aqua interface. The crowd oohed and ahhed as he introduced features such as Genie, which "sucked" operating system windows into the Dock – like a genie into a lamp – when he minimized them. But one of the most striking departures of the interface from the status quo was the overall look of the interface. "One of the design goals was when you saw it, you wanted to lick it," Jobs said.

The most interesting part about Jobs's comment was that, secondarily, the interface was really inspired by candy. As shown in Figure 4-6, Aqua was designed to complement the colorful translucent hardware Apple produced at the time, such as the Bondi iMac. While designing the iMac, Apple's design lead, Jonathan Ives, had spent hours in a candy factory searching for inspiration in the lickable translucence of the sweets produced there.

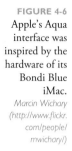

FIGURE 4-6
Apple's Aqua
interface was
inspired by the
hardware of its
Bondi Blue
iMac.
*Marcin Wichary
(http://www.flickr.
com/people/
mwichary/)*

The desire to have this sort of compelling physical quality in the interface is deeply rooted in the culture for which Mac OS X was being produced. Graphical computer interfaces (GUIs), after all, have always mimicked the physical world through interface metaphors. We drag around "windows" as if they were pieces of paper on our "desktop," while occasionally dragging a "document," into the "trash." Most computer users take these things for granted, but when Xerox first developed the GUI, representing bits of data with representations of physical objects was a groundbreaking concept.

Apple took these interface metaphors to new heights with the Aqua interface (see Figure 4-7). It went beyond representing reality, into representing a fantastical hyper-reality. Check boxes, radio buttons, and other buttons within Aqua glow – like droplets of dew – with a luminescence that you could imagine in your dreams, but that you have never witnessed in reality. Window edges and menu bars are modeled with impossibly gentle smoothness and cast soft shadows underneath them as they float in the virtual space of the desktop.

FIGURE 4-7
Mac OS X's
Aqua interface
represented
interface
elements in
fantastical
hyper-reality.

It wasn't necessarily that nobody had ever before imagined an interface of such lush graphical splendor, but rather that rendering an interface with such detail hadn't previously been technically feasible. Apple built a technology called Quartz, built upon OpenGL, which – through PDF technology – enabled the rapid display of interface elements that incorporated transparency, path-based shapes, and shadows, while rendering them at device-independent subpixel precision. Aqua's predecessor, the Platinum interface (see Figure 4-8), relied instead upon QuickDraw, which drew shapes within the interface with raster graphics, represented by solid pixels.

FIGURE 4-8
The Platinum
interface of Mac
OS 9 relied upon
QuickDraw
technology,
which made
impractical
drawing an
interface as
sophisticated
as Aqua.

Apple rode so lightly on the cutting edge that users complained the interface was too cumbersome for the computers of the day. But, eventually, computing power caught up, and now other operating systems represent a similar hyper-reality in their interfaces.

How Aqua influenced the web

Designers have preferred the Macintosh since its release, so they were naturally influenced by this revolutionary Aqua interface. A colleague of mine at the time

preferred Microsoft Windows, and he looked over my shoulder and drooled at my Mac's "inspiring" interface. (He later made the switch to Mac.) But the 2001 commercial release of Mac OS X was a little too early to have meaningful influence on web graphics.

At that time, only 37 percent of Internet users had the capability to display 16 million colors, and – more important – broadband Internet speeds were just beginning to make their way into homes. So, many users were not equipped to even enjoy the amount of color depth such graphics would require, and – with load time of websites being critically important – even if they could, they would have had to wait just a little too long to download them.

In addition to these display restrictions, building such graphics with HTML and CSS was incredibly difficult, if not impossible. Web developers were still dealing with the unpredictable rendering bugs of Internet Explorer 5, and Internet Explorer 6 was just being released. Web designers were mostly restricted to using the square corners that CSS1 yielded (if they were using CSS at all) and solid blocks of color to fill spaces.

But renegade web designers were determined to achieve their visions. In 2003 and 2004, blogs such as A List Apart (`www.alistapart.com`) shared their elaborate hacks that would create effects such as drop shadows and rounded corners (see `www.alistapart.com/articles/cssdropshadows`), while remaining cross-browser compatible and minimizing the load time of graphics.

These new techniques still fell slightly short of creating the type of hyper-realism that Aqua depicted. OpenGL simply has some capabilities that go beyond those of CSS. But clearly, designers had been inspired to strive for interfaces and graphics that had a sense of dimension that went beyond the simple capabilities of CSS.

How Aqua met Web 2.0

Finally, designers could create graphics for the web that mimicked reality. Unfortunately, though, many designers worked for large corporations where they didn't get the opportunity to experiment with new techniques, or had conservative clients who were reluctant to try designs that were anything unlike the rectilinear designs that were commonplace at the time.

Fortunately for some of these designers, the Web 2.0 revolution was coming. Frameworks such as Ruby on Rails and Django, both released in 2005, were making it easier than ever for developers to create web applications that would bring Internet users the social experiences that they craved.

Small teams of young developers flocked to Silicon Valley to start companies and try to secure funding. These teams included designers (myself included) who were eager to try out their new bag of tricks.

These small teams could call all the shots themselves. Some of the developers on these teams had quit their jobs at big companies, while others were straight out of college – or had even dropped out. Still others had fallen victim to the recent economic downturn and couldn't find jobs anyway. All of them were excited to build things on their own terms.

Silicon Valley in 2006 had the atmosphere of a really geeky frat party – or maybe even 1860s Café Guerbois. Some companies, such as Meetro (a now defunct location-based instant messaging service), were composed of a dozen developers living and working in a three-bedroom apartment in Palo Alto. Developers and designers got together at an all-night "hackathon" called SuperHappyDevHouse, just to talk about ideas and build "mashups." PBwiki (now PBworks), a hosted wiki provider turned online collaboration tool, was one startup that emerged from such jam sessions. You can see from the August 2006 screenshot of PBwiki's home page in Figure 4-9 that it used plenty of gradients, three-dimensional elements, and highlights in its design.

This youthful exuberance was evident in the cultures of the companies. Playful alert messages, such as "oops" and "hooray" became commonplace. You can still see this developer-driven attitude in Google's Gmail (see Figure 4-10). The casual atmosphere, the playful web copy, and company mottos such as Google's "do no evil" all evinced liberation from the stuffy corporate culture that had previously prevented developers from innovating.

Web 2.0 was all about making the web social, friendly, and humanized. And the type of juicy, friendly-looking graphics that were inspired by the Aqua interface had just the right tone to convey that.

As with any Silicon Valley boom, few of these startups were successful. But those that were were wildly so. YouTube was acquired by Google for $1.65 billion, Yelp has upended Zagat as the go-to place for restaurant reviews, and Facebook was recently valued at over $50 billion. The winners of the Web 2.0 boom have transformed the way that people interact and have won over even the mainstream.

Not every Web 2.0 startup used juicy buttons, gradients, and drop shadows, but the popular aesthetic has lived on and evolved. Those most successful in taking cues from the Web 2.0 style haven't directly copied it as a visual style, but instead have embraced the ability to create a hyper-real interface, which usually involves some form of gradients, rounded corners, and dimensional

characteristics on buttons. Zappos.com (see Figure 4-11) recently abandoned its sharp corners and flat colors for a friendlier and more dimensional graphic style.

FIGURE 4-11
Zappos.com recently updated its design to one that features more rounded corners, gradients, and other dimensional qualities.
Reproduced by permission of Zappos Retail, Inc.

Form shapes technology, this time

In Chapter 3, I talked a lot about how tools have shaped form over time, but this is one case in which form began to shape the tools. The CSS3 specification has a number of properties that make it easy to create gradients, rounded corners, and drop shadows, directly in CSS, all without having to create a single graphic. It's even possible to make buttons that closely mimic Aqua buttons (see Figure 4-12) using only CSS3.

SEO Is Design

As I explained in Chapter 2, the bounds of where design ends and other disciplines begin can be quite fuzzy. The growing influence of design has called for designers to have wider and wider skill sets. When designing something that conveys information, such as a blog or other website, or when designing anything, the main thing that the designer is trying to do is communicate information. Because of this central premise around which design is built, it's critical that a skilled designer for the web understand SEO best practices.

Design – more specifically, the design of typography – has always been about the conveyance of information. Ensuring that the right audience gets that information is part of the responsibilities of the designer.

Information accessibility in design

The early scribes of books worked tirelessly to create beautiful hand lettering that could be read with clarity and reproduced with beauty and efficiency. At that time, very few people could read, much less even get access to a book. Books generally consisted only of religious texts read by the clergy and were extremely expensive and labor intensive to produce. But when Gutenberg invented the printing press, the cost of producing books started to drop. As a result, literacy began to spread.

One pioneer of the spread of literacy was Aldus Manutius, who saw the advent of printing as an opportunity to spread and preserve the wisdom of classic Greek literature. So, Manutius set up his printing house in Venice, Italy, and employed Greek scholars to edit manuscripts and proof prints. He also employed the type designer, Francesco Griffo, whom he commissioned to produce the very first italic typeface (which saved space) and fonts that have inspired some of today's more popular fonts.

Manutius worked tirelessly to spread Greek literature, and to do so, he needed to innovate a format that would sell well.

What Manutius came up with would later evolve into what we today consider the paperback book. Most books to date had been large, heavy, and bulky, but Manutius created an octavo format that – at only 3¾ by 6 inches – could easily be carried around. It was an appealing book format that was at least inexpensive enough to be owned by the elite classes of government and military officials who lived in Venice at the time.

Starting in 1501, Manutius printed octavo books from Virgil, Plato, Aristotle, and others, and was eventually granted a monopoly on Greek publishing by the Venetian government.

It's probable that Greek literature would not have had the influence on Western culture that it has, were it not for Aldus Manutius's innovations. By producing a book format that worked for the people whom he wanted to reach, he was able to spread the information that he wanted to spread.

Designing with such utility in mind was at the crux of the modern movement in typography. Jan Tschichold set out to standardize business communications in the modern age for maximum efficiency with his 1928 book, *The New Typography*. Besides proposing that business communications be printed on standardized paper sizes for easy filing, Tschichold also proposed that business cards be printed with certain portions of information in certain spots, so that they could be filed and sorted according to name, geographic location, or other pieces of information.

This underlying idea of the spread of ideas through printing is still at the backbone of design. When you're designing something, you're trying to convey a message. Part of your mission as a designer is to get that message to anyone to whom it applies, especially if someone is actively trying to find your message.

continued

continued

This important principle is often lost with modern designers. Designers and clients often find themselves focusing on the aesthetic and experiential qualities of websites, while ignoring the underlying structure of the information. Ill-advised use of Flash, which locks away information where it can't be accessed by search engines or accessed through a browser's Find command, reduces the communicative reach of a website.

I've seen some beautiful websites with very interesting information on them. But because they were built in Flash, you can actually copy and paste a string of text from these sites into Google and come up with no results at all. All that great information is locked away inside Flash. Even if Flash were used on these sites in a search-engine-friendly manner, once you got to them, you wouldn't be able to use the browser's Find command to scan the information for keywords of interest.

For reasons of search engine friendliness and users being able to use the tool of the browser as intended, it benefits a designer to surrender to whatever limitations may be present in the combination of HTML and CSS. Granted, with the advent of HTML5, these limitations are becoming fewer and fewer, but in any case it's best to work with HTML.

The reason for this is that, besides the really visible parts of a design – the words and pictures and other content – underneath all that lies the semantic language of HTML, which turns information into a structured hierarchy that powers the web and its amazing information-finding capabilities. A designer should be aware of this information structure, so she can design with SEO best practices in mind and reach the intended audience.

The basics of SEO are stupidly simple. It seems like everyone who works with the web talks about SEO as if they know all of it, but it's surprising to me sometimes how rarely SEO best practices are actually utilized. Here's a very basic refresher of why SEO is important, how it works, and what you can do to make sure that you're doing the best you can.

NOTE I'll be talking Google-centrically because Google will likely account for the vast majority of your inbound search traffic. Additionally, if you rank highly on Google, you'll probably do pretty well on other search engines anyway.

I've been writing with SEO in mind – and using best practices as best as I can – on my blog, kadavy.net, for seven years now, and as you can see in Figure 4-13 my search traffic has steadily increased.

FIGURE 4-13
Writing and designing with SEO in mind has yielded steady growth in search engine traffic for Kadavy.net (data before December 2005 unavailable).

Understanding why SEO is important

SEO is the "location, location, location" of doing business on the web. If you have a bicycle shop on a busy street, you're going to sell some bikes. It doesn't matter how high your prices are, or how rude your employees are, you're going to sell some bikes. Likewise, if you rank highly on Google for "bicycles," you're going to sell a lot of bikes, because a lot of people search for "bicycles." That's your foot traffic.

I don't want to make the mistake of assuming that everyone knows just what it means to rank highly on a keyphrase. If you're selling a product or service, ranking highly on keyphrases related to that product or service is essentially free money. If you rank first on Google for "bicycles" (which is darn near impossible, by the way), you'll get a huge number of visitors on your site looking for bicycles, and it will cost you nothing. This is called *organic traffic,* and it's what SEO builds for you.

But, as shown in Figure 4-14, some businesses pay big bucks for such traffic by buying Google's AdWords. In doing so, their sites show up next to Google's organic search results, and they pay whenever someone clicks through to their site. For the keyword *bicycles,* those businesses pay an average of 71¢ per click. For the keyphrase *Cambria bicycle,* they pay an average of $12.55.

Paying for traffic like this can be profitable if the campaigns – and conversion within your site – are managed carefully. But, obviously, free traffic is ideal and translates to big sales. This is why SEO is important.

Paid results (Pay $$)

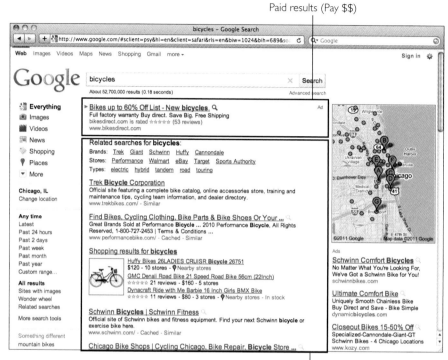

Organic results (Make $$)

Choosing the right keywords

Before you make sure that you're using SEO best practices, it's helpful to have some idea what keywords or keyphrases, you want to rank highly on. But just because you pick a descriptive keyphrase, doesn't mean people will find you. It has to be a keyphrase that people are actually searching for. My blog gets lots of traffic for the keyphrase *lump in mouth* because that's what people search for when they have a *mucocele* (basically, a clogged salivary gland). Most people don't search for "mucocele" because they don't even know what one is – until they get a lump in their mouth and search for it.

Ideally, each page on your site should compete well on a couple keyphrases that are descriptive of the content on your site, that have reasonable search volume, and on which you stand some chance of competing.

You can find out the volume of keyphrases by using the Google Keyword Tool (`http://adwords.google.com/select/KeywordToolExternal`). If you're just starting a site where you sell bicycles, it would be nice to compete well on the keyword *bicycles,* which has a monthly search volume of over 7 million searches per month – but you don't stand a chance as a new site. If your site is for a bicycle shop in Chicago, then you'd probably have better luck competing on *chicago bicycle shop,* which Figure 4-15 shows has a measly 390 searches. Once you dominate that keyphrase, then you can start trying to compete on *bike shop in chicago,* which has 6,600 searches.

If you're just starting out, you have a better chance of completing on this keyphrase than you do this one

FIGURE 4-15
If you're just starting your site, it's likely easier to rank highly on a low-volume keyphrase than a high-volume keyphrase.

A good place to start to find keyword opportunities from your site is your existing data. If you don't already have a stats package set up on your site, you should. Google Analytics (`http://analytics.google.com`) is great, and it's free. If you happen to already have Google Analytics installed, you can find the keywords that visitors are using to get to your site under Traffic Sources → Keywords, which is shown in Figure 4-16. Here you can see what keywords are bringing in the most traffic, and if you've set up e-commerce or marketing (such as lead-generation) goals, you can see what keywords are actually converting into business. You're likely to find a few keywords you didn't expect that you happen to rank pretty highly on. It's a good idea to aim to build upon this success by targeting these keywords further, or targeting related keyphrases. Look for synonyms that you may not already be using (bump/lump, mouth/lip), and update your content accordingly.

Ranking highly for your target keywords

There are endless complex theories on just how a site ranks highly on search engines. Some of those theories have no basis at all. The truth is, nobody except little robots at Google knows just how a site ranks higher than another. What we do know is that the content of a page, how the page is coded, and the authority of other pages that link to a page – especially for the topic in question – are the most powerful dictators of how well a page ranks on search engines.

You can set up goals (like purchases or newsletter sign-ups) to figure out which keywords are most effective.

FIGURE 4-16
You may find some surprising keywords in your Google Analytics data, which you can use to develop your SEO tactics.

Analytics will show you which keywords people are using to get to your site. You may find some surprises!

Considering content and coding

The content of a page – meaning the words within that page – has a huge impact on how well a page ranks for given keywords. If your target keywords don't appear on your page, you'll have a hard time ranking highly for that keyword. It's not impossible, but I'll get to that later. Relevant content has to be within your page – as code (meaning not as an image) – for search engines' *crawlers* (the robots that read your pages) to read that content and rank you for the appropriate keywords. This is a strong reason why Flash websites do poorly on search engines, and former print designers that just slice up a design on a WYSIWYG program make poorly performing websites: The real content gets locked away, where crawlers can't access it.

It's also essential to use good coding practices in building your pages. There are standards for writing HTML content, and they help rank chunks of content within a page in order of importance. This helps search engines know the

difference between the important – and less important – information on a page and, thus, rank that page for various keywords.

Following is a rundown of important content-based factors that dictate how your pages rank on search engines.

URL

Before a search engine's robot can read the HTML on your page, it will read the URL at which that page resides – and the content of this URL has pretty heavy influence on how that page ranks on search engines. So, if my bike shop is at `http://bikeshopinchicago.com`, it will rank very highly on *bike shop in Chicago*. If I have a page for Cambria bicycles, I may want to put it at `http://bikeshopinchicago.com/cambria-bicycles`. Note that you shouldn't automatically pick your top keyphrase to be the domain that you purchase, because branding – and planning for the future expansion of your business – are both important. But you should have search engine (and human) friendly URLs that are in plain English instead of `http://example.com/?p=34`.

Title tag

The `title` tag of a web page is the strongest piece of information indicating what a page is about. Many businesses make the mistake of naming this page "Home Page," or ignoring it altogether. (This is why, if you search for "Welcome to Adobe GoLive," you'll get tons of results.) For any given page on your site, your `title` tag should contain the exact keyphrases that you want to rank highly on, as shown in Figure 4-17. If it's the home page, or if your business name contains your target keyphrases, you could then follow that with your site's name. So, if your business is David's Bike Shop, your title should be "Bike Shop in Chicago – David's Bike Shop."

FIGURE 4-17
`Title` tags have a strong influence on what keywords a page ranks highly for.
Reproduced by permission of Arlo, Inc.

Meta tags

The `meta` tags also contain some information that search engines give strong authority to when evaluating a page. There are several different `meta` tags, but the one that you should concern yourself with is the `description meta` tag. This is a very short (like around 200 characters) description of what the page contains, and search engines use its content not only to evaluate what a page is about, but also to display to users – as in Figure 4-18 – when your page is listed in search results.

FIGURE 4-18
The `descrip-tion meta` tag is believed to hold some weight in search engine rankings and sometimes shows up in search results.

Headers

Then there are the headers within your HTML document. These are ranked in order of importance: H1, H2, H3, H4, H5, and H6. There should be only one H1, and it should probably be used for the actual title of your page (which may or may not be the same as your `title` tag). Some people like to use the H1 for their logos and link to their home pages – it depends on how narrow of a focus your site has. So, if you have a long document, full of text, it's a good idea to break it up a bit by inserting some useful headers that also happen to contain some of your target keywords.

Content: em, strong, img

Finally, you have the actual content of your page, which is hopefully helpful, interesting, and – incidentally – contains your target keyphrases. In addition to your target keywords, your content will probably bring in visitors on a number of "long tail" keyphrases that just happen to show up naturally within your great content.

Within your content, you'll hopefully have some images, because they're useful for users. Much as the URL of your page is important to search engines, the filenames of your images are also important and should be descriptive. So, if you have a JPEG of a mountain bike, your image should be called `mountain-bike.jpg`, or – even better – include the color and brand: `mountain-bike-schwinn-blue.jpg`. The `alt` attribute of your `img` tag also should be descriptive, so `blue schwinn mountain bike` would do. Don't forget, you can end up with a large amount of traffic from Google Image Search, if you use descriptive `alt` attributes.

The italic and bold HTML tags (`em` and `strong`, respectively) also hold higher authority in an HTML document than your plain content (which sits inside of `p` tags). When you italicize or bold words within your content, it lets search engine crawlers know that those words are important and relevant to the point of the page in question, so it's a good idea to do a little of this – provided it supports the experience for your human users.

Authority of linking pages

Ranking highly on Google is ultimately all about the authority of your page or site on the keywords in question. This concept of authority also applies generally to your site just being an authoritative site. Google uses a ranking called PageRank to measure how much authority a given page has, on a scale from 1 to 10. There is a complex algorithm behind PageRank that you shouldn't concern yourself with, but Google does provide a Firefox plug-in called Google Toolbar (shown in Figure 4-19), which shows what the PageRank of a page supposedly is. Seven is considered a very high PageRank. NYT.com has a PageRank of 9. Kadavy.net's home page is a 4, which is considered decent for a personal blog.

A number of factors go into determining a given page's PageRank. Although the actual algorithm is an ever-changing secret, here are a few factors that are widely accepted to be a part of the algorithm:

> Age of domain (how long the domain has been registered)

> Authority (or PageRank) of pages that link to the page from other domains

> Date of expiration of the domain (Is the domain expiring soon, or has the owner registered it a couple years into the future? This is in one of Google's patent filings.)

Content of linking pages and of anchor text of links

To put it very simply, when other pages on a given topic link to your page of a related topic, search engines generally will rank you higher on that topic. If the PageRank of the page linking to your page is particularly high, Google will rank you higher for that.

Also important is the actual *anchor text* (the content between a tags) of the link that links to your page. So, a link that says "Bike Shop in Chicago" will do more to rank "David's Bike Shop" higher for searches for "bike shop in Chicago" than if the anchor text says "David's Bike Shop."

The a tag also has a couple of attributes, such as the `title` attribute, which can have descriptive text applied to it. I haven't seen anything to make me think that using this title attribute helps with SEO, but it certainly wouldn't hurt. The `rel` attribute can have a value of `nofollow`, which tells Google's crawlers not to follow the link and, therefore, not to give the page any extra authority based upon the link. Most blogs give all links in comments a `rel="nofollow"` attribute to discourage SEO-minded spammers from exploiting the comment functionality.

Everything in moderation

So, if you took all this knowledge literally, you might stuff all your pages full of keywords to the point that they didn't make any sense. You might also contact site owners all over the web, purchasing links, and stuff all your pages full of links – full of your keywords – to other pages. You might even obscure these links by making them the same color as your background or hiding them with CSS.

Using some of these tactics in extreme moderation may even help you a little bit, but anything more than that will be heavily frowned upon by Google. It

supposedly takes very sophisticated measures to detect use of these tactics and will downgrade a site for doing so – which is something you do not want to experience (think immediate loss of tons of business). There are tons of shady tactics for getting links. As a general rule of thumb, if it feels like it's deceiving someone, Google probably has some way to detect it and you can bet they won't like it.

Getting the content, getting the links

Having a site full of relevant keywords, and being linked to by sites with relevant keywords, is a means to an end, not an end itself. You achieve this by using good coding practices and generating useful and compelling content that others want to link to.

Here are a few legit ways – that Google doesn't frown upon – to get content and links to your site:

> **Have a blog.** To rank highly on keywords, it's pretty much a must to have useful content, rich with your target keywords, that is updated on a regular basis. A blog is the best way to have these attributes. Unfortunately, Google still ranks some pretty awful content really high, so I'd say that having some not-so-well-written content is better than having none at all – but hopefully this will change when they improve or someone gets around to building a better search engine.

> **Get into directories.** DMOZ is the highest-authority directory, and it's free – but it's nearly impossible to get into. There are plenty of paid directories out there, but the only ones I know of that are definitely high-authority are Yahoo! Directory and Business.com. Be wary of other directories or consult a professional. Then, still be wary.

> **Write guest posts on other sites.** Find a high-authority site that your target audience reads, and pitch a guest post to the author. They'll get great content, and you'll get links and exposure to their audience.

> **Write link bait.** The best way to get lots of links is to write content that other people will link to, share, and talk about. A really thorough, information-rich how-to is a good example, but writing posts that are very controversial works well, too (unfortunately). Such posts then get shared on social news sites such as Reddit, and on Facebook and Twitter.

Do lots of research and make some pretty graphs, and your chances of getting lots of links increases again.

> **Find your audience.** When you've written really great, useful, and interesting content, get as many people in your target audience to see it as you can. Submit to a social news site in a category where those people hang out, or buy traffic in your target category on StumbleUpon (pay a very small fee per visit, with a chance of unlimited free traffic). Another good tactic is to find an already popular post on your target topic, find other sites that have linked to it, and pitch to the authors of those sites.

NOTE There are probably some very reputable SEO firms out there who are great at applying this knowledge, and more, but be wary – because there is so much mystery behind SEO, the field is rife with consultants who overcharge and use tactics that will either work only in the short term or get your site downgraded.

Knowledge Applied

To do work that is appropriate stylistically, you need to understand how technological and cultural factors influence design. Additionally, part of design is conveying information, so be aware of how your intended audience will find your information.

> When the budget or objectives of your project permit (see Chapter 2), pay extra attention to how current technology and culture influence your project.

> Avoid simply copying a graphic style, and try to understand its technological and cultural influences.

> SEO is a part of design. Design with SEO best practices in mind, and build your design around whatever limitations may result.

Part III: Composition

Fool's Golden Ratio:
Understanding Proportions

PROPORTION IS KEY in making things look beautiful. Our eyes seem to be naturally attracted to a sense of order in the things that we see. You may have heard someone talk about proportions before: "His nose is out of proportion with the rest of his face." But what does it really mean for something to be "out of proportion"? Better yet, what makes something "in proportion"?

Although tastes do, and always will, differ, a great deal of study and thought has been given to proportions throughout history. What is it that makes the face of a model beautiful? Similarly, what is it that makes a sculpture beautiful? What makes a logo beautiful? Beautiful proportions are a hidden but important factor in all these cases.

In this chapter, I explain what proportion is and how proportions have been used throughout history to make things beautiful. This is a topic that has fascinated many philosophers, mathematicians, and, of course, artists and designers for millennia. Proportional patterns have been found in nature, as well as in artifacts from ancient societies. These patterns have been studied and then used deliberately in an attempt to crack the formula for beauty.

As I'll explain, although understanding proportional relationships can help you understand what makes things beautiful, there is no one particular formula that you must follow. Instead, like many things in design, there are more simple guidelines that can get you creating beautiful design more consistently.

So, the subject of proportions in design is in no way something that you must obsess over to create successful design. If it happens to light up your brain, however, there is no harm in pursuing it. Experimenting with different approaches to geometric proportions may fascinate you for hours at a time – or a lifetime.

You'll gain a general understanding of proportions through this chapter, and it'll come in handy in understanding the next two chapters. Chapter 6 covers how to create interesting compositions using a few key design principles, and Chapter 7 shows you how to use all this knowledge to better organize information.

What Is Proportion?

Proportion, loosely defined, is how the size or magnitude of one thing relates to that of another related thing. Objects have proportional relationships within themselves and with other objects outside themselves.

A printed photograph (remember those?) has proportions. If it's a Polaroid, it will have nearly square proportions – one side is almost the same length as another side (a Polaroid photograph is about 3½ × 4¼ inches). If it's a photograph printed from a 35mm film camera, it will have oblong proportions – maybe 4 × 6 inches.

But at the same time, the subjects within the photograph may have proportional relationships with one another. Look at the photograph of flowers in Figure 5-1. The flowers themselves have proportional relationships with one another. In the physical world, they're likely approximately the same size, but in this photograph their sizes vary greatly. The flower that is most prominent in the photo (the one in the lower right) appears larger than the other flowers in the photograph.

This flower has proportional relationships within itself. Each of the petals – each about the same size – has a proportional relationship with the rest of the flower. The center of the flower also has a proportional relationship with the petals, and with the flower as a whole.

This flower – like all the flowers in the photo – also has a proportional relationship with the photograph itself. The photograph has certain dimensions in this book, and the flower takes up only a certain amount of the total area of the photo. The position of the flower within the photograph also has a proportional relationship with dimensions of the photograph. The flower is positioned in the lower-right corner of the photo, which gives the flower a different proportional relationship with the photograph as a whole than if the flower were in the center of the photo.

In Figure 5-2, the photograph of the flower has been cropped. Now, instead of being oblong in proportion, the photograph is perfectly square. The flower was once in the bottom-right of the photo, but now it is completely in the center.

FIGURE 5-1
The flowers in this photo have proportional relationships with the photo and with each other. The parts of the flowers have proportional relationships with the flowers themselves.
Parvin (http://www. flickr.com/ people/55948751@ N00/)

FIGURE 5-2
The same flower photo from before has been cropped. Now the proportional relationships of the flower to the photo are different. The proportional relationships of the dimensions of the photo have changed as well.
Parvin (http://www. flickr.com/people/ 55948751@N00/)

Look at how much the cropping has changed the appearance of the photo! Whether you look at the flowers in the photo as objects, or imagine them as shapes of color, the composition of the photo has changed completely. Before cropping, the *composition* (the overall arrangement of subjects, shapes, and colors within the piece) was completely different from what it is now. Before, the photograph gave a feeling of depth – you could easily see more flowers in the background. Now that the photograph is cropped, the flower has been abstracted a bit. It's as if it's just a bunch of shapes are bursting out from the center of the photograph.

Proportion and Design

Proportional relationships can completely change the way that a piece of design feels. Different proportional relationships can make one thing look important and another thing look unimportant. Proportional relationships help organize the various elements involved in a design, not only drawing the attention of the viewer, but guiding her eye throughout that piece of design. Whether you're taking photograph of a flower, chiseling a sculpture out of marble, or crafting the interface of a web application, understanding proportion is critical not only in attracting the attention of the viewer, but in holding her attention while guiding her eye.

Look at the two simple compositions in Figure 5-3. The one on the left is generally not very visually interesting. But the one on the right is. I'm speaking relatively of course – I don't expect it to end up in the Louvre.

But these compositions have the same shapes, the same number of shapes, and the same colors, so how can one of them be so much more attractive than the other? The difference in visual interest between these two compositions is mostly due to changes in proportion.

FIGURE 5-3
The composition on the right is more visually interesting than the composition on the left, despite sharing similar characteristics, because it possesses different proportional relationships.

The composition on the right has more variety in the sizes of the circles within it. The sizes of these circles have a particular proportional relationship with one another. The way that the circles are arranged has a carefully chosen proportional relationship as well. They may look haphazardly strewn about the

composition, but I've carefully considered how the placement of each circle relates to the proportions of the canvas.

The canvases themselves – the dimensions – of each of these compositions differ as well. I've intentionally chosen visually interesting proportions for the canvas on the right.

All these invisible considerations – far more subtle than those of colors or shapes – go a long way toward making designs visually interesting and communicating clearly. But to understand how to use proportions, you need to understanding which proportions are interesting and how those proportions are used.

The Broken Promise of the Golden Ratio

The opening sections of this chapter are admittedly very basic. I've introduced proportions in the simplest way possible, and there's a good chance that all along you were waiting for me to mention the golden ratio.

Ask just about anyone what proportion is considered to be the most beautiful in the world, and if he has any opinion on the matter at all, he'll likely tell you that it's the golden ratio. Or, at least, that's what he's heard.

The golden ratio has fascinated scholars, mathematicians, and artists for millennia. Whether the ancient Greeks truly understood its potential aesthetic properties is still up for debate, but this fascinating irrational number is believed to have been discovered by Pythagoras in ancient Greece in the sixth century BC (although the Greek mathematician Euclid wrote about it extensively in the third century BC).

The golden ratio, often denoted by the Greek lowercase phi (ϕ) is expressed algebraically as follows:

$$\frac{a+b}{a} = \frac{a}{b} \equiv \phi$$

Segments of a line divided according to the golden ratio will interrelate to each other as such: The length of $a + b$ is to segment a as the length of a is to segment b, as shown in Figure 5-4.

FIGURE 5-4
A line divided
according to the
golden ratio will
consist of two
segments. The
long segment (*A*)
has the same
proportional
relationship with
the entire line as
the short segment
(*B*) has with the
long segment (*A*).

The golden ratio rectangle – which is famously believed to be found in nature, art, and architecture – is constructed by drawing an arch with a line the length of the midpoint of a square to the opposite corner. The farthest point this arch reaches then defines the length of the long side of the rectangle, as shown in Figure 5-5.

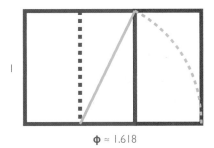

φ ≈ 1.618

FIGURE 5-5
A golden ratio
rectangle, which
has proportions
of approximately
1:1.618, is
created by
drawing an arch
that has a radius
that extends from
the midpoint of a
square to an
opposite corner.

The rectangle that lies outside the original square has the same proportions (approximately 1:1.618, or 61.8 percent) as the overall rectangle. As shown in Figure 5-6, drawing a line that subdivides the internal rectangle into a square produces yet another rectangle of these same proportions. This subdivision can continue on forever, which is why this ratio is so fascinating.

FIGURE 5-6
Golden ratio
rectangles can be
progressively
subdivided with
a square ad
infinitum.

The golden ratio and the Fibonacci sequence:
Similar, but different

The golden ratio is very closely related to the Fibonacci sequence, which is a series of integers in which each subsequent number is the sum of the two previous numbers, like so: 0, 1, 1, 2, 3, 5, 8, 13, 21, 34, 55, ... Dividing a number from early in the sequence by its following number produces a percentage that is somewhat close to that of the golden ratio (2 ÷ 3 = 66 percent); later on in the sequence, the ratio is almost exactly the same (34 ÷ 55 = 61.8 percent).

The Fibonacci sequence and the golden ratio can produce logarithmic spirals that are nearly indiscernible from one another. This spiral is created by drawing arcs from the opposite corners of each square within the rectangle, as is shown with the spiral in Figure 5-7, created from the Fibonacci sequence. Each 90-degree turn in the spiral is about 61.8 percent of the size of the previous 90-degree turn.

Logarithmic spirals similar to this can be found in nature in the shells of snails, the arms of galaxies, and radar images of tropical cyclones. However, as I'll talk about in more detail later in this chapter, these spirals are not all built from the golden ratio.

FIGURE 5-7
A spiral created from the Fibonacci sequence – which is nearly indiscernible from a spiral created from the golden ratio – is a series of quarter turns each of which is progressively about 61.8 percent the size of the previous quarter-turn.

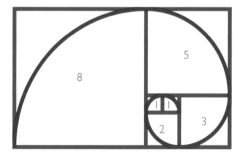

Although the golden ratio and the Fibonacci sequence are technically different, they eventually produce about the same ratio and proportions. So, if you're simply talking about using geometry to guide aesthetic decisions (not an exact science, as I'll demonstrate), it's safe to use them interchangeably. I'll simply refer to it as the golden ratio.

The golden ratio in the human form

One of the more famous examples of the golden ratio at work is present in the Vitruvian Man (see Figure 5-8). Leonardo da Vinci created this famous drawing based upon the work of Vitruvius, who wrote extensively about his belief that architectural proportions should be based upon the proportions of the human form.

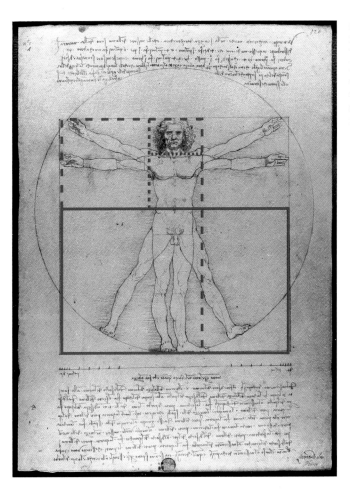

FIGURE 5-8
Leonardo da Vinci's Vitruvian Man is subdivided according to golden ratio rectangles.

The relationships between the proportions of the Vitruvian Man and the golden ratio – and the interrelationship of the parts of the Vitruvian Man – are, indeed, very impressive. As you can see in Figure 5-8, a golden ratio rectangle

that spans the length from fingertip to fingertip of the model (a distance that is the same length as the height of the model), aligns perfectly with the navel. A second golden ratio rectangle – this time upright – aligns perfectly with the shoulder on the right side of the model. Subdividing the rectangle that results from this intersection with a square lines up with the shoulder on the left side of the model. Subdividing this remaining rectangle with another square lines up with the top of the shoulders and frames the head.

The writings of Vitruvius, and Leonardo's resulting drawing, fascinate architects and designers to this day and have inspired a great deal of geometrically rationalized design, art, and architecture. Although this has produced some impressive work, probably the better work occurs when the geometric relationships are merely incidental.

Architect Le Corbusier used Leonardo's Vitruvian Man to develop an entire architectural scale called Modulor, which he used in a number of buildings, such as the residential Unité d'Habitation in Briey, France (see Figure 5-9). The parallax from the camera has likely caused some distortion in this image, but you can see that the elevation of the building is approximately two descending golden ratio rectangles resting side-by-side. The bounds of the individual units, and the openings to the balconies are also perfectly influenced by the golden ratio rectangle.

FIGURE 5-9
Le Corbusier's
architecture was
heavily inspired
by the golden
ratio.

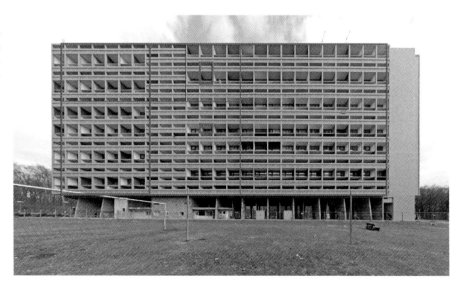

If you're turned off by the aesthetics of this building, I couldn't blame you. It follows an architectural philosophy of exposing the functions of a building, known as Brutalist architecture. The sometimes-unappealing appearance of a modern building such as this is as much a product of this philosophy as it is a product of such a literal attempt to produce geometric perfection.

Literal use of the golden ratio appeared more recently when Twitter's designer tweeted a link to the image shown in Figure 5-10, revealing that the celebrated redesign was influenced by the golden ratio.

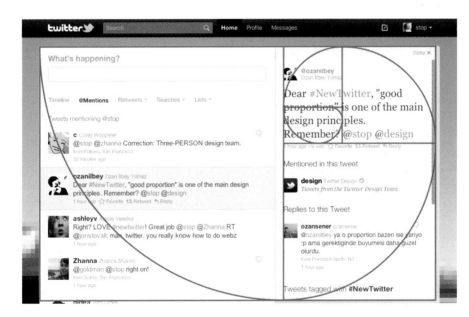

FIGURE 5-10
According to Twitter's creative director, the website's celebrated redesign is based upon the golden ratio.
Reproduced by permission of Twitter, Inc.

Misconceptions about the golden ratio

With all this use of the golden ratio in famous architecture and design, it's no surprise that people are still fascinated by it. But there are some misconceptions about the golden ratio. Mainly, it is presented as a magical proportion of unparalleled beauty, present in nearly all aspects of our lives. But many of the claims about the golden ratio are unfounded or downright untrue.

The golden ratio in ancient Greece

Because the golden ratio was written about by ancient Greek mathematicians, many historians have worked to try to find the golden ratio in ancient Greek

architecture and art. One such artifact that they try to find this in is the Parthenon. It is said that the Parthenon is based upon the golden ratio – the facade, the columns, and even the sculptures within the structure all were supposedly designed according to the golden ratio.

But actual measurements of the Parthenon don't support this theory. Although the golden ratio was written about by the Greek mathematician Euclid, he did so just as a fascination with it as a rational number and its presence within certain geometric shapes. There is no evidence to support the idea that the Greeks made any conscious effort to incorporate the golden ratio within their designs.

As you can see in Figure 5-11, the floor plan of the Parthenon has no clearly deliberate relationship with the golden ratio.

FIGURE 5-11
An attempt to find golden ratio influence within the floor plan of the Parthenon produces less-than-impressive results.

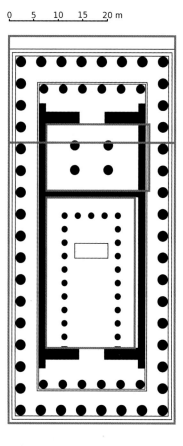

The golden ratio in fine art

Some scholars have even tried to find golden ratio influence in paintings such as the *Mona Lisa*. With all of Leonardo da Vinci's fascination with the golden ratio, and its influence on the human body, it would make sense for there to be some striking golden ratio influences in the painting. In Figure 5-12, you can see that, although a quick attempt to find such patterns does reveal that the subject's head is positioned within a subdivided golden ratio rectangle, and that her brow line falls along the subdivision of another rectangle, it seems strange that if there were such intentions in producing this painting the artist wouldn't even bother to make the canvas itself of golden ratio proportions. Instead the proportions of the canvas are about 2:3.

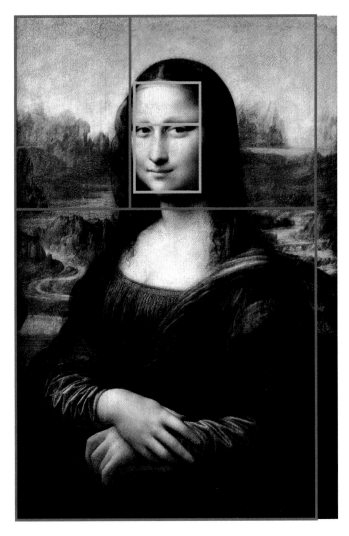

FIGURE 5-12
Some very modest – though probably arbitrary – golden ratio influence can be found within the composition of the *Mona Lisa,* though the canvas of the painting is of a different proportion.

The golden ratio in nature

Probably the most misleading, and most often referenced, example of the golden ratio being found in nature is that of the shell of the nautilus supposedly being composed of a golden ratio spiral. This has been referenced so many times, you have to wonder if anyone ever bothered to verify this claim or if they've been knowingly perpetuating it just to carry on the legacy of the golden ratio.

Although the logarithmic spiral present in the shell of the nautilus is certainly strikingly beautiful, it is not, in fact, created from a golden ratio spiral at all, which you can see clearly in Figure 5-13. I have superimposed such a spiral over half of a nautilus shell. There are likely variations seen from shell to shell, but to find one that actually followed the golden ratio would be a very unusual departure from the norm.

FIGURE 5-13
The spiral of the shell of a nautilus comes nowhere near the golden ratio spiral.
Chris 73 / Wikimedia Commons (http:// commons.wikimedia. org/wiki/User:Chris_73)

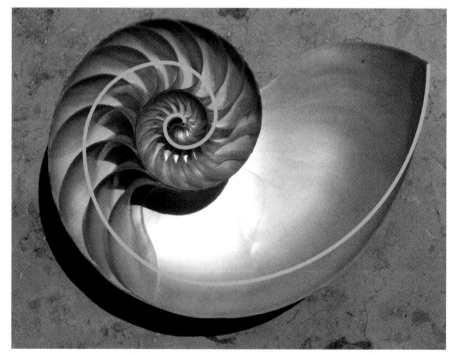

The golden ratio in psychology

Much of the claims that the golden ratio is beautiful by some aesthetic imperative are based upon research done by Gustav Fechner in the 1860s. He presented

subjects with only ten different rectangles of varying proportions and concluded that since 90 percent of the subjects chose one of the rectangles that was either 0.57, 0.62 (the golden ratio), or 0.67, the golden ratio was the most pleasing ratio. Clearly something surrounding that proportion was the most attractive, but there were plenty of subjects who didn't choose the golden ratio rectangle.

Since Fechner's studies, more studies have been done to try to determine what rectangle has the most pleasing proportions, and results have been varied and ultimately inconclusive. There is no one ratio that is universally superior to all others.

Other Pleasing Proportions

Proportion, by its very nature, is contextual. Proportion is a function of how something relates to other things. You don't have to look far in Western culture to realize that there are many other very common proportions at work. Understanding these proportions can help you design in a way that is relevant to your audience.

Proportions such as the golden ratio and the proportions I introduce here can be used to guide design choices in dividing information on a grid (which I talk about in Chapter 7), creating visually pleasing and clean-looking compositions, as well as determining white space and type sizes. I'll talk more about using proportions in Chapters 6 and 7.

The root 2 rectangle

The root 2 rectangle, which has proportions of 1:1.41, has the impressive property of being able to be subdivided in half continuously and still have the same aspect ratio. If you begin with a root 2 rectangle, and divide it in half, you'll have two root 2 rectangles. Repeat the process with one of those rectangles, and you'll again have two smaller rectangles, and so on.

This is why the root 2 rectangle is at the basis of the International Organization for Standardization (ISO) paper sizes. This system results in minimal waste because it consists of several standard sizes that can all be cut from subdividing a single sheet of paper.

As you can see in Figure 5-14, a root 2 rectangle can be created by drawing an arch with the radius that is the square root of a particular square. The resulting rectangle can be divided in half endlessly.

FIGURE 5-14
A root 2 rectangle is constructed by drawing an arc with a radius created from drawing a line from one corner of a square to another.

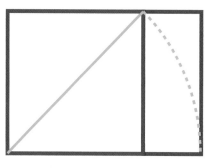

$\sqrt{2} \approx 1.41...$

The 2:3 rectangle

Proper construction of golden ratio and root 2 rectangles can get complicated. Even if you don't do all the fancy geometry tricks to create them, their resulting proportions (1:1.618 and 1:1.41, respectively) can be tough to remember and difficult to calculate. This is one good reason why proportions that are simpler, such as 2:3, can be equally attractive but easier to work with.

The success of this ratio can be found in its relationship with the number 3. Any time you have three of something, no matter how you divide them, the relationship is 2:3. In writing, there is a principle known as the *rule of three*, which suggests that things that are in groups of three are inherently more interesting and, often, funnier.

The rule of three can be found in classic examples such as *The Three Stooges* or *Goldilocks and the Three Bears.* If I suggest that a square, a golden ratio rectangle, and a root 2 rectangle walk into a bar, this is supposedly a more interesting and funny setup for a joke than if I were to suggest that a golden ratio rectangle and a root 2 rectangle walk into a bar.

In art and design, the rule of thirds suggests that compositions are more pleasing when they're visually divided by thirds. Notice, for example, that the

biggest flower in the picture I introduced at the beginning of this chapter (refer to Figure 5-1) is in the bottom-right third of the photograph.

The 2:3 ratio is sometimes used interchangeably with the golden ratio as support for the supposed inherent and flawless beauty of the golden ratio. True, these proportions are similar (0.618 versus 0.66), but 2:3 can be much easier to work with because it's easier to perform calculations in your head with 2:3. Calculating two-thirds of 9 is much easier than calculating 0.618×9, for example.

The 3:4 rectangle

The 3:4 rectangle is another ratio that is simpler to work with but also very attractive. As I'll talk about more in a bit, 3:4 can be found in art, music, dance, and even nature. It has the added benefit of being easily divisible in multiple combinations, which makes it easier and more flexible to work with when constructing grids (see Chapter 6).

Research in the world of visual arts suggests that 3:4 is a beautiful ratio. A survey of 565 paintings from famous artists in history, conducted by Agatha Olariu in 1999, found the average value for the ratio of the sides of the canvases to be 1:1.34 (or 0.75 or 3:4). Given that the artists whose paintings were surveyed have gone down in history as notable, it's safe to assume that their canvases, too, were of attractive proportions.

Much as the 2:3 rectangle's beauty is sometimes attributed to the golden ratio, so is that of the 3:4 rectangle. But the 3:4 ratio is even farther away from the golden ratio than the 2:3 rectangle (0.75) is. Because it is found in so many places, the 3:4 proportion is probably the most underappreciated of all.

Proportions in Our World

Besides the examples given for rectangles, common proportional relationships can be found throughout Western culture, and even in nature. Our music, writing, dance, paper, and displays for mobile devices and computers all indicate that some proportions are more pleasing than others.

These proportional relationships aren't always created intentionally, but understanding and appreciating them can give you better intuition as you design.

Music and dance

Although some experimentation has been done with irrational numbers, such as the golden ratio, the most popular music tends to contain very simple patterns. Most rock songs are in 4/4 time, meaning that there are four beats per measure. Also occasionally found in popular music is 3/4 time, meaning there are three beats per measure; 3/4 time is the time signature of waltz music.

One of the most fascinating examples of proportion in music can be found in proportion's influence on tone, as shown in Figure 5-15. If you strum an open guitar string tuned to C, you'll hear a C note. If you shorten the length of that string to half its original length, you'll hear another C note, but this time an octave higher (the eighth note in the major scale). If you take that same string and strum it instead at three-fourths its original length, you'll hear an F note (the fourth or subdominant note in the major scale). If you strum the string at two-thirds its original length, you'll hear a G note (the fifth or dominant note in the major scale).

<div style="text-align: right;">FIGURE 5-15
Shortening a
guitar string to
three-fourths or
two-thirds its
original length
produces the
subdominant
and dominant
notes,
respectively, in
the major scale.</div>

By forming chords from these root notes – C, F, and G – you have a common blues chord progression, and the most common chord progression in rock and pop music, properly referred to as "I–IV–V" (for the roman numerals for 1, 4, and 5). Pull this chord progression from the D major scale (D, G, A), and you have the chord progression of "Twist and Shout" as sung by the Beatles.

Dance, naturally, is the bodily expression of music. Salsa dancing consists mostly of 3/4 proportions. As shown in Figure 5-16 (top), the lead steps forward and then back within the span of three beats, and then pauses for the fourth beat. The lead then repeats the process, this time stepping backward. The pause on the fourth beat gives an exciting sense of inertia for turns and spins.

Bachata is another form of Latin dance. It originated in the Dominican Republic and breaks up steps along the proportions of 3/4. The lead steps sideways for three beats, taps his trailing foot on the fourth beat, and then repeats the process in the other direction (see Figure 5-16, bottom).

FIGURE 5-16
The Latin dances
of salsa (top) and
bachata (bottom)
both consist of
steps that involve
three beats of
motion and one
beat of pause,
before changing
direction.

Nature

One of the more compelling cases for a proportion such as 3:4 can be found in the very nautilus shell that is normally alleged to relate to the golden ratio. As shown in Figure 5-17, by creating a logarithmic spiral based upon the proportion of 3:4 (meaning that each quarter-turn of the spiral is a section of a circle that is three-fourths the radius of the previous section), we get a spiral that fits this particular nautilus shell perfectly.

Not that the golden ratio is totally absent in nature. As you saw earlier in the chapter, the golden ratio has some impressive relationships with the proportions of the human body. The golden ratio also can be found in the proportions of various fish. In Figure 5-18, I've divided a clownfish according to the golden ratio. The body of the fish fits perfectly within two golden-ratio rectangles laid side-by-side. The line where these two rectangles meet perfectly aligns with the beginning of the fish's second dorsal fin. This line also marks the end of the fish's central white stripe. Subdividing both of those golden-ratio rectangles with squares creates lines that align convincingly with the pectoral fin and the end of the second fin. A further subdivision of the subdivision that lines up with the pectoral fin aligns perfectly with the fish's eye.

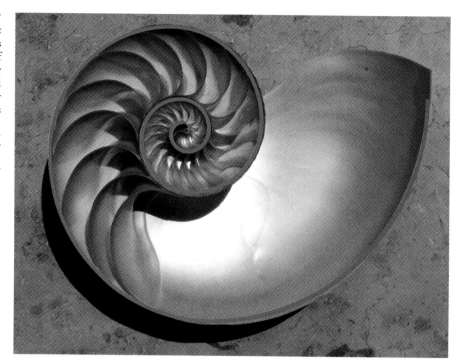

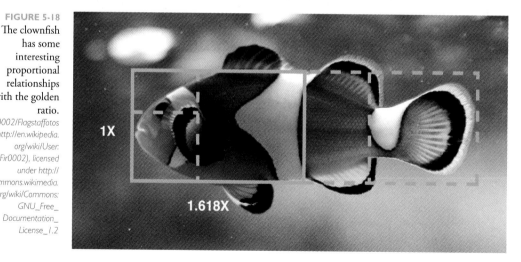

The powder blue tang also shows some proportional relationships with the golden ratio, although its proportions are different from those of the clownfish.

As you can see in Figure 5-19, the body of the fish fits within a golden-ratio rectangle that has had another golden-ratio rectangle appended to it. Subdividing the main golden-ratio rectangle a couple times reveals more convincing alignments with the pectoral fin and eye of the fish.

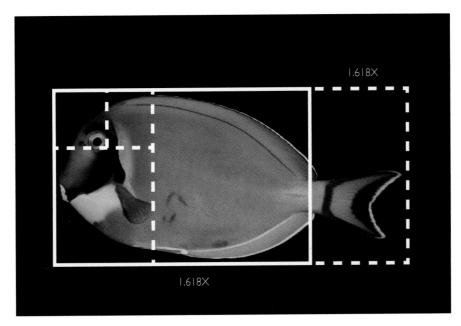

1.618X

1.618X

FIGURE 5-19
The powder blue tang also has proportions that seem to relate to the golden ratio.
Ltz Raptor (http://commons.wikimedia.org/wiki/User:Ltz_Raptor)

Computers and mobile devices

Proportions somewhere near the golden ratio are found not only in nature and in the most popular music of the Western world, but in the very electronics that the modern designer often finds herself designing for. Being aware of these proportions is useful when you're trying to create compelling and clean design, as I'll cover in Chapters 6 and 7.

The once popular computer screen resolution of 1,024 × 768 is a 3:4 aspect ratio (0.75). Apple's iPhone 4, with a resolution of 960 × 640 has a 2:3 aspect ratio (0.66). Google's Nexus S phone, and the MacBook Pro are closest to the golden ratio (the golden ratio is 0.618), with proportions that can be found in the progression of the Fibonacci sequence. The Nexus S has a resolution of 800 × 480, or a 3:5 aspect ratio (0.6), while the MacBook Pro's resolution of 1,280 × 800 has a 5:8 aspect ratio (0.625). Modern flat-screen televisions – based upon

the proportions of movies – produce the most extreme rectangles at 16:9 (0.56). (See Figure 5-20.)

FIGURE 5-20
A variety of proportions, most closely related to the golden ratio, can be found in electronic devices that modern designers design for.

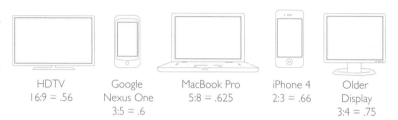

HDTV	Google	MacBook Pro	iPhone 4	Older
16:9 = .56	Nexus One	5:8 = .625	2:3 = .66	Display
	3:5 = .6			3:4 = .75

Although none of these findings supports the notion that there is any one superior ratio, the evidence suggests that attractive proportions lie somewhere in the range between the golden ratio (0.618) and a 3:4 aspect ratio (0.75), with the 2:3 ratio (0.66) sitting comfortably between these.

Proportions at Work

Now that you have a good overall idea of different kinds of proportions and some of the places they can be found, I'll touch a bit on just how proportion can be applied in design. This will be a pretty basic overview – I'll dive into this subject more deeply in the coming chapters.

The proportions common within today's mobile phones and computers are especially relevant to designers – the relationship of a design to the proportions of its canvas dates back to some of the earliest forms of the written word. The great 20th-century typographer, Jan Tschichold analyzed hundreds of early manuscripts and printed books, and one of his recommendations for determining the proper text area size and margins for the pages of a book, as shown in Figure 5-21, goes as follows:

1. Starting with a two-page spread, draw diagonal lines from one corner of the spread to the other (A1, A2).

2. Draw diagonal lines from the top-center of the spread to each of the outside bottom corners (B1, B2).

3. Draw a box with the same aspect ratio as your full page (C1), and place it so that B1 intersects the top-right and bottom-left corners of the box, and A1 intersects the top-left corner of the box.

If you're using a drawing program, a good way to achieve this is to draw a box that is the size of one of your pages and then scale it proportionally.

4. Once you have achieved margins that are to your liking, mirror those margins on the opposite page.

C1 and C2 are now your live text area.

FIGURE 5-21
The ideal book margins can be created by strategically placing live text areas with the same proportions as the page itself.

Creating book margins in this way achieves one of the fundamental objectives of any great design. By establishing geometric relationships between the canvas and the content, you're helping to keep your viewer's eye within the composition of your design.

Modern applications of design tend to be much more dynamic than this, but similar methods can be experimented with. As demonstrated in Figure 5-22, margins for establishing a content area for an iPhone app could be determined this way. These margins are a bit more interesting than if you chose for them to be the same on all sides. You could also experiment with harmonics by trying a 3:4 live content area within the iPhone's 2:3 screen and aligning the top corners with lines that connect opposing corners. The resulting guidelines are congruent with the popular rock music chord progression I talked about earlier: I–IV–V.

Remember the more attractive composition from earlier in the chapter? If not, here's a refresher in Figure 5-23.

FIGURE 5-22
Tschichold's recommended book margin method can be adapted for device screens.

FIGURE 5-23
This simple composition was created with some very specific geometric choices.

As I said earlier, I made some very specific choices in creating this composition:

> The canvas of the composition has an aspect ratio of 3:4. The composition is three-fourths as tall as it is wide.

> The sizes of the circles in the composition haven't been left up to chance. The largest circle in the composition has a diameter that is equal to the height of the canvas. The second-largest circle is about one-fourth the diameter of this largest circle. The third-largest circle is three-fourths the diameter of the second-largest circle. The smallest circle on the canvas is three-fourths the size of the third-largest circle. So, the canvas relates to the 3:4 ratio, and the sizes of the circles themselves are determined by the 3:4 ratio as well.

> The actual placement of the various circles is determined by this very same ratio. I've divided the canvas into a grid (see Chapter 7) – three units vertically and four units horizontally. As you can see in Figure 5-24, I've lined up the edges of the largest circle with the central horizontal grid line and with the edge of the top third of the canvas. The second- and third-largest circles are centered where grid lines intersect.

FIGURE 5-24
The circles in this composition are placed according to imaginary grid lines.

You may notice that the smallest circle on the canvas doesn't line up perfectly with any grid lines, though it does touch the leftmost grid line. I did this for a very specific reason, but I'll talk about that more in Chapter 6, where I explain composition and design principles.

Why the MailChimp logo is beautiful: A geometric perspective

If you're not a fan of my composition, I couldn't blame you. It's pretty basic. But, similar proportional decisions appear to have been made in one of the more recognizable logos of the Internet startup world. The e-mail marketing and list-management provider MailChimp (www.mailchimp.com) has one of the most attractive and memorable logos of any startup out there. The concept is simple: It's just a drawing of a chimp with a bag of mail. But if you really analyze it, you find some very subtle but powerful geometric relationships at work.

The MailChimp logo was designed by the incredibly talented firm Hicksdesign (www.hicksdesign.co.uk), led by Jon and Leigh Hicks, who also designed the logos for the Firefox browser and the usability testing software developer Silverback. They have a nice illustrative style, but they also have some very tight design fundamentals, including nice use of geometric proportions.

The circles that define the head and belly of the chimp relate in size to the circle that defines the body of the chimp by a factor of 0.75. The circles that define the eye, hand, and ear of the chimp also relate to the circle that defines the cheek by a factor of 0.75

Reproduced by permission of The Rocket Science Group

The body of the chimp is mostly based off of a series of circles that descend in size proportionally. The circle that builds the body of the chimp is the largest circle of all. As shown in the following figure, the head of the chimp and the circle that defines the soft, hairless underbelly of the chimp are both three-fourths the diameter of this largest circle.

The proportional relationships between these larger circles and some of the finer details of the chimp are subtler than this. Without very close observation, you might think that the sizes of the circles that define the chimp's features make a jump from the size of the head to the size of the circle that defines the cheek of the chimp. From there, it's pretty clear that the circles descend in size by three-fourths to define the area around the eyes of the chimp, the chimp's ear, and even the chimp's hand.

But how was the size of the chimp's cheek defined? Was another circle size simply chosen at random? The size of this circle is not one-half, one-third, or three-fourths the size of the circle that defines the chimp's head. The same can be said for the inside and outside parts of the chimp's ear.

That's because the circles that define the features of the chimp are all created on, as Robert Bringhurst calls it in *The Elements of Typographic Style*, a *varied scale*. The circle sizes are defined by starting with the largest circle size and multiplying it by 0.75 repeatedly, thus creating a descending scale of sizes with which to work. So, if that first circle is 400px, then the next smallest circle is 300px (400 × 0.75 = 300). Then, the next smallest circle is 225px, then 169, then 127, 95, 71, 53, 40, 30, 23, and so on.

1X
body

1X × .75
belly
head

...

1X × .75^4
cheek

1X × .75^4
eye
hand
outer ear

...

1X × .75^6
inner ear

The features of the chimp are defined by a series of circles constructed from a varied scale that descends by a factor of 0.75.

So, the size of the chimp's cheek is determined from this scale. It's just that a few steps in the scale were skipped between the size of the head of the chimp and the size of the cheek.

continued

continued

A number of other effective uses of compositional techniques and design principles are present in the design of the MailChimp logo – I'll be discussing these in Chapter 6. The use of proportions in the MailChimp logo, however, are undeniable and effective.

Knowledge Applied

Whether deliberate or incidental, man-made or natural, the role of mathematical proportion in making things beautiful is very powerful. Using proportions in ways that I've demonstrated isn't a requirement to create great design, but, whether intentional or not, it's often a product of great design. By understanding how proportions are present in design and nature, you have a good framework on which to build an understanding of composition and design principles, which I'll discuss in Chapter 6.

> The next time you see something that you think is beautiful, take a careful look at its proportions. Can you find any patterns in how the various elements are arranged and sized?

> Drawing either with pen and paper or with your favorite drawing program, try creating a simple composition like the one I introduced in Figure 5-3. Examine what effects different proportional relationships have upon how attractive the composition is. Try making your decisions based upon the golden ratio, the root 2 rectangle, the 2:3 ratio, or the 3:4 ratio.

> When choosing font sizes or making decisions about how large to make things such as pictures and icons, try creating a varied scale like the one I demonstrated for the MailChimp logo. (I'll talk more about how to do this in Chapter 7.)

chapter **6**

Holding the Eye: Composition and Design Principles

IN OUR CLUTTERED world, full of disparate pieces of information all commanding our attention, the attention of your audience is at a premium. As I talked about in Chapter 1, making your work visually interesting ensures that your message is taken more seriously and gets this ever more precious attention. If you have a visually interesting interface on your application, customers will choose your product over one with equal features and pricing that is less visually interesting. In some cases, they'll pay more for the perceived extra value created by a more visually engaging interface.

Using design principles and good methods of building compositions isn't useful only in creating a sense of value for your customers. Understanding how to lead the viewer's eye throughout a composition or an interface can actually make it more organized and, ultimately, more useful to your customers.

Compositional Relationships

The term *composition* refers to the way that elements are arranged within a piece of design, the interrelationships between those elements, and – if applicable – the relationships between those elements and a canvas or display. A good composition is what attracts the viewer's eye and engages it, guiding his eye throughout.

Figure 6-1 shows the simple composition I introduced at the beginning of Chapter 5. This composition is generally visually interesting, especially when compared to the boring composition I introduced along with it. In Chapter 5, I talked about how well-considered geometric relationships help make this simple composition interesting. In this chapter, I'll explain some effective design principles to be aware of, and – at the end of the chapter – explain how design principles make this composition interesting.

FIGURE 6-1
Aside from carefully considered geometric relationships, good use of design principles help make this composition interesting.

Reading direction

You can better understand just how effective use of design principles make this composition more interesting if you understand the way that a viewer typically consumes any piece of design. In the Western world, because we read from left to right and from top to bottom, we typically begin looking at any composition or piece of design – whether a piece of sculpture, a book, a magazine, or a web page – from the top-left.

As you can see in Figure 6-2, eye-tracking heat maps of web pages are a testament to this fact and are highly relevant to the modern designer. Website visitors scan a page in an *F* pattern, starting at the top left, scanning across a bit, then tracking down the left-hand side of the page. Understanding this behavior,

while also understanding how compositional factors can guide and hold a viewer's eye, can help you better understand what your users will look at.

Guiding the eye with composition

Although the viewer's eye will tend to enter a piece of design in a certain fashion, once it is engaged, a successful design guides the eye appropriately. Some of the most successful and beautiful compositions guide the viewer's eye throughout the composition in a manner that keeps the viewer's eye within that composition. It's as if the viewer's eye is "recycled" within the composition over and over again.

Renaissance sculpture

In the Renaissance sculpture of *The Rape of the Sabine Women* (shown in Figure 6-3), Giambologna does a magnificent job of recycling the viewer's eye. A sculpture is likely consumed a little differently from the way a web page is consumed, but whether you enter the composition from the top left, or from any other place within the sculpture, your eye will be drawn throughout the grouping of figures and then drawn back in by some compositional element wherever your eye may attempt to exit the composition. It's as if you literally can't take your eyes off this sculpture.

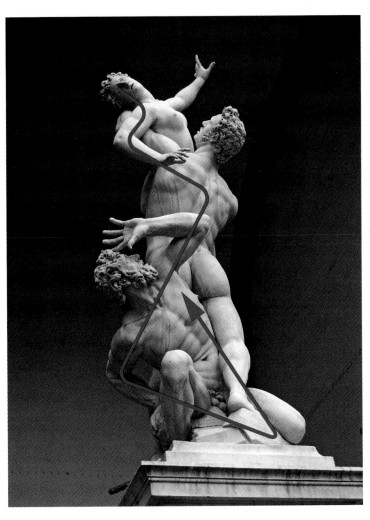

FIGURE 6-3
The Rape of the Sabine Women features a dynamic composition that holds your eye.
Arnold Paul

Figure 6-4 shows a number of different ways that your eye may enter and explore the composition of this sculpture. If your eye enters from the top left – at the woman's head – it will likely zigzag down her right shoulder to her arm, down the back of the standing male figure, through the left arm of the crouching male figure, across his chest and down to his leg, where it will be pulled in once again by the right leg of the standing male figure. Within the overall composition, there are a number of tight sub-relationships between other elements that keep you looking at this masterpiece over and over. Granted, this is a three-dimensional composition, and I can show you only two of those dimensions, but the dynamic twisting of the figures within the grouping make this composition work no matter what your vantage point.

FIGURE 6-4
No matter where your eye goes in the composition of this sculpture, it is immediately drawn to another portion of the composition.
Arnold Paul

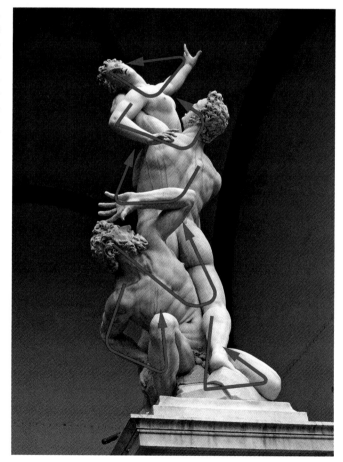

Impressionist paintings

A similar "recycling" effect can be found in nearly every beautiful painting.
A Sunday Afternoon on the Island of La Grand Jatte by Georges Seurat (shown
in Figure 6-5) is one such great example. Despite being very complex in the
number of figures and elements that are within the painting, there are some
very simple but strong things about its composition that keep you looking at it.

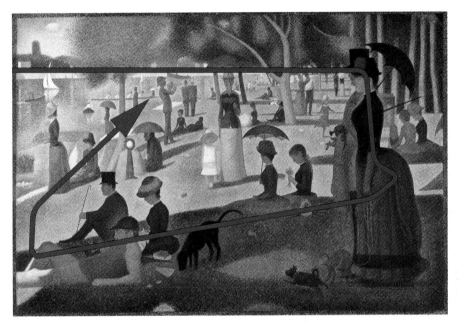

FIGURE 6-5
Georges Seurat's
*A Sunday
Afternoon on the
Island of La
Grand Jatte*
directs the
viewer's eye
with a strong
composition.

As shown in Figure 6-6, if your eye were to enter the painting from the top left,
it would likely follow the strong horizon line present on the opposite side of the
lake. This would lead you to the standing figures on the right side of the
painting. These figures – the man in the top hat and the woman with an
umbrella – are the most dominant elements in the painting. They are dark, large,
and stand right in the foreground of the painting. Your eye would then likely
follow the line of the dark shadow that takes up the rest of the foreground of the
painting, only to be led back up to the horizon line either by one of the upright
figures or trees along the shoreline, or by the strong angle of the shoreline itself.
As your eye "recycles" through the painting, it gets caught in the various smaller
groupings of the painting that invite you to explore the scene in a manner as
leisurely as you might act on a Sunday afternoon in the park.

FIGURE 6-6
The overall composition of this painting leads your eye throughout, but smaller sub-compositions hold your eye in places.

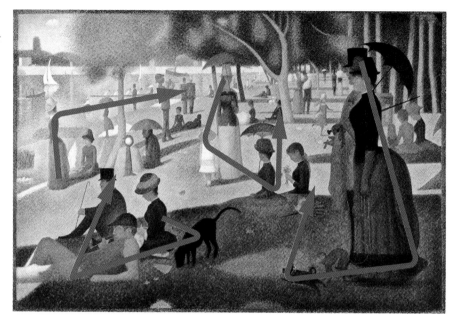

Web design

The design blog, Think Vitamin (www.thinkvitamin.com), sets up its content with consideration for the expected *F* pattern of web users and guides the viewer's eye appropriately. As you can see in Figure 6-7, the most recent blog post is toward the top left of the home page and is made very prominent through its size and its dark background. As you scroll down the page, you can quickly scan the headlines and images of other articles to see if anything interests you. Supplementary information such as the topics of the site, subscription information, and information about the authors, are all stowed away on the right side, where they don't distract your attention from the meat of the site.

FIGURE 6-7
The Think
Vitamin home
page follows
the expected *F*
pattern, placing
the most
important
information
toward the
top left.
*Reproduced by
permission of
Carsonified*

Foreground/background relationships

In many pieces of design – especially in representational paintings – there is an implied third dimension. Some elements may appear to pop off the canvas, while other elements appear to be far off in the distance. Renaissance painters mastered creating depth in a painting by using perspective, but many other factors can be used to create a sense of depth. Size, color, texture, and use of shadows are just some of the factors that can make some things pop, while others recede.

When something appears to be closer to you in a painting or composition, it is considered to be in the *foreground*. Things in the foreground are likely to be noticed first in any composition.

When something appears to be farther from you than things that are in the foreground, they are generally considered to be in the *background.* Naturally, the `background-image` of a web page usually looks as if it is in the background.

Elements can be moved to the foreground or background based upon their relative size, the amount of detail, their colors relative to the rest of the composition (see Chapter 9), or shadows. For example, in Seurat's painting, the people in the foreground have more detail in their facial features and clothing, while people who are farther away have less detail.

In my simple composition (refer to Figure 6-1), the largest circle appears to be in the foreground, despite the fact that everything in the composition is made up of a solid color. Because the circle is large, and especially because it bleeds off the page, it gives the appearance of being closer to you than the other circles appear.

In Seurat's painting

As your eye explores the Seurat painting, the foreground/background relationships help dictate where your eye goes. As I said earlier, the couple on the right side of the painting are among the first things you notice after your eye enters the composition. This is in part because they're very large in the composition, but it's also because they're in the foreground.

Though I'm talking mostly about the foreground and background for simplicity's sake, you may notice that there is certainly a midground to the composition as well. Pretty much everything you see between the dark shadow in the foreground and the horizon line would be considered the midground.

Almost without exception, every painting that represents actual objects and scenes – and even some abstract paintings – has a foreground, a midground, and a background. The appearance of depth that these elements give to a painting makes it hard to keep your eyes off it. The scene of a painting being divided up this way contributes to the composition having a focal area, or the part of the composition that is most dominant (I'll talk more about this in a bit) – the thing that your eye is naturally drawn to.

In interface and web design

You see foreground/background relationships being used in web and interface
design, too. Operating system interfaces have visual cues that produce
foreground/midground/background relationships. As you can see in Figure 6-8,
the selected window in the Mac OS interface has more clearly defined interface
elements. The frame of a window has a stronger gradient on it, giving it a more
tactile sense – letting you know that you could grab it if you wanted to. The
buttons for closing, maximizing, or minimizing are in color, while the windows
that aren't selected have more vague details. This lets you know that you can use
those buttons if you want to, while the buttons on inactive windows remain gray.

FIGURE 6-8
The Mac OS
creates
foreground/
background
relationships
to let the user
know which
elements she can
interact with.

Many web designs try to emulate this sense of depth through drop shadows,
such as on the bordering areas of the main text area of a design, or around
images within the design. Mouseover states that cause interface elements to pop
out cue the user that they can interact further with that element. When a
button visually pops out into the foreground – whether it's through color or a
drop shadow – it's letting users know that they can press it.

Though Think Vitamin's design is mostly solid colors, there is still some subtle use of foreground/background relationships. The most recent – and most prominent – blog post is thrust into the foreground because it is on such a dark background. Also, the fact that it bleeds in all the way from the left edge of the page makes it almost as if it has been placed on top of the light cream background of the main page.

As you mouse over certain elements of the Think Vitamin design, they pop into the foreground, prompting you to interact with them. As shown in Figure 6-9, mousing over the icon that shows the number of comments on the post makes the icon go from pink to red, popping it into the foreground and letting you know that you can click it.

Design Principles

The term *design principles* refers to a series of beliefs or tenets about what kind of features make a composition attractive. Like many things in the world, the concepts that design principles try to encompass are much more complex than the terms that are used to define them. Additionally, there is no set group of design principles that are absolute. A different book on design principles might talk about a completely different set of design principles than I'll be talking about in this book.

You may also notice, as I describe these principles, that many of them seem to overlap. That is, the presence of one principle of design often results in the presence of another principle of design. This sort of interconnectedness can be expected, though, because beautiful design is all about dependent relationships. The objectives of a design work with the message of a design, and through use of design principles, they convey to the audience compellingly and effectively.

Dominance

The principle of dominance creates visual interest in a composition by drawing the viewer's eye to an important element in the composition. When an element is dominant in a composition, it is one of the first things your eye is drawn to. It acts almost like a magnet when you first lay eyes on the composition. It also acts as an anchor – you keep returning to it as you explore other parts of the composition. It pulls you in.

Dominance can come in handy when you're trying to establish a visual hierarchy of information (something I'll talk about more in Chapter 7). But having a dominant element keeps a composition interesting by making it clear what you should be focusing on first.

Elements can be made dominant by being the darkest, the lightest, the largest, or even by having lots of white space around them. The placement of an element on the canvas can help it be dominant as well.

As I mentioned earlier, the man and woman on the right side of the Seurat painting are the most dominant elements in the painting. They contribute to the success of the composition through the principle of dominance. After your eye is drawn to the couple in the Seurat painting, you're prompted to explore other parts of the composition. Your eye continually gets drawn back to the couple – because of their dominance – and then back throughout the composition again.

The largest circle on my simple composition is dominant, in part, because it's the largest element. (I'll talk about some other ways it remains dominant as I introduce more principles further on in the chapter.)

Think Vitamin also uses dominance in its design, again with its treatment of its latest blog post. As I mentioned earlier, the information for the latest blog post

is in a prominent location, at the top left of the page, and is pushed into the foreground. But it also includes a much larger type in its title than anything else in the design. The addition of the author's photo also makes this element dominant on the page.

As you scroll down on a web page such as Think Vitamin's, the latest blog post is no longer visible, of course. As you can see in Figure 6-10, what could be considered "sub-compositions" within the page, such as the other blog posts, use the dominance of icons and large titles to anchor the eye. Dominance is also used through larger titles and dark icons.

FIGURE 6-10
Dominance is used in the smaller "sub-compositions" of the Think Vitamin blog to call out important information.
Reproduced by permission of Carsonified

Similarity

Similarity means that various elements of a composition – their shape, color, line characteristics (smooth or jagged), or texture – are similar to one another. Similarity makes a composition compelling because, as your eye travels throughout that composition, it is constantly reminded of things that it has seen before within that same composition. Use of similarity also is a nice setup for the use of the principle of contrast (another principle I talk about more later).

The Seurat painting uses similarity effectively in many ways. The shapes that the artist uses to draw the people in the composition are smooth and oversimplified. You notice the same shapes over and over again, in the dresses of the women in the painting and in the umbrellas strewn about the composition (see Figure 6-11). You see similarity being used in the repetition of colors such as reds and greens, as well.

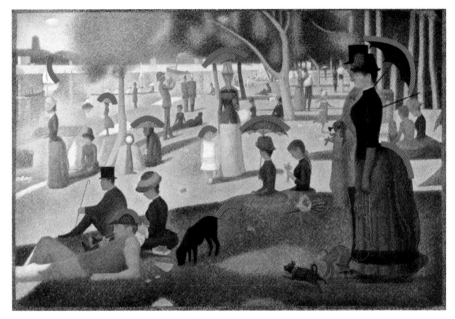

My simple composition (refer to Figure 6-1) uses similarity as well. All the elements in the composition are circles, after all. They're also all the same color and are completely flat, having no shading, texture, or definition.

The overall visual style of the Think Vitamin design is also that of bold basic shapes and solid colors, with very little use of lines and no gradients. Most of the user interface elements are an exercise in the principle of similarity in that they are very rounded (see Figure 6-12). The logo and overall concept of the site are that of a vitamin or a rounded pill. The links for the topics on the right side of the home page, the buttons, and even the search box are all effectively little pills themselves. Similarity such as this makes a design look cohesive, because the various elements within it echo one another.

Rhythm

With similarity often comes rhythm. Rhythm is a bit more abstract than similarity is. Probably the first thing that you think about when you think about rhythm is music. Just as the repetition of a snare or kick drum at a consistent point in a measure of music, over and over again, creates a sense of rhythm in music, the repetition of a particular design element or characteristic throughout a composition create a sense of rhythm in design. Rhythm in a design keeps it interesting because – much like similarity – you're consistently reminded of things that you saw earlier as you view the composition. But rhythm also can be a useful method of managing the principle of direction and of setting up an opportunity to use the principle of contrast (both principles that I'll talk about more later).

FIGURE 6-12
Similarity is used throughout the Think Vitamin site in the rounded shapes of the buttons, icons, and other interface elements.
Reproduced by permission of Carsonified

The Seurat painting makes good use of rhythm. In Figure 6-13, notice how the erect postures of all the people in the composition echo the vertical trunks of the trees. Notice also the cast shadows on the foreground and midground and the sense of rhythm they create along with the shoreline of the lake and the

horizon line. This use of rhythm keeps you looking at the composition, as your
eye travels throughout.

Rhythm is used very sparingly in my simple composition, and its presence is
generally incidental. There is a sense of rhythm in the progression of the largest,
second-largest, and smallest circle. The principle of direction has a stronger
presence in this grouping, but I'll talk about that more later.

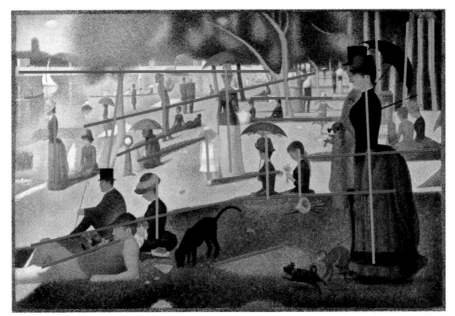

FIGURE 6-13
The repetition of
lines on similar
planes creates a
sense of rhythm
throughout the
composition of
the Seurat
painting.

Think Vitamin's use of similarity also naturally lends itself to rhythm, or a
visual sense of repetition. As you can see in Figure 6-14, the topic links along
the right side create a rhythmic strip that leads your eyes down to the four very
similar and evenly spaced icons in this same sidebar. As you scroll down the
page, you begin to notice that icons similar to these – in that they are all bold
circles – accent the title of each blog post. This creates not only a visual
stopping point that cues you to stop and read the title, but also a sense of
rhythm as you scroll down the page. This makes it clear how the information is
organized on the page – it's all broken down into small pieces that you can
decide to explore further, if you wish, as you scan the page.

FIGURE 6-14
The use of
rhythm in Think
Vitamin's design
guides the viewer
to important
elements within
the design.
*Reproduced by
permission of
Carsonified*

Texture

Texture is the visual indication that something has characteristics that would be palpable if you were able to touch them. For example, if something looks like sandstone – or actually is made of sandstone – then that is texture. Texture is related to similarity and rhythm in that if a shape is repeated enough times, and at a fine enough scale, it generally creates a texture. Texture keeps a composition interesting because it provides an opportunity for the principle of contrast (which I'll talk about soon) and can create a sense of depth in foreground/background relationships.

Because the Seurat painting is composed of thousands of tiny dots of paint (a technique called *pointillism*), it has a strong sense of overall texture. Depending on how far away you view it from, this can look very rough or a little smoother – like sandstone.

But there are some subtle changes in texture throughout the painting as well.
Notice that the edges of the umbrellas and the edges of the people's clothing
are all very crisp. But the leaves on the trees have a very fuzzy appearance.
Meanwhile, the reflection upon the lake makes it look smoother and glassier.

My simple composition really has no texture to speak of. This is one of the
weaker points of the composition, but it also demonstrates that not every
design principle has to be present for a composition to be (relatively) successful.

Think Vitamin also uses very little texture – most of the shapes and design
elements within the site are solid areas of flat color. The main source of texture
in the design is that provided by the text (I talk more about texture of type in
Chapter 3 and in the appendixes). Because there is very little texture in the site
design, the texture of the text stands out more.

The site uses only one font family for the majority of its content, so the
variations in texture come from variations in the weight of the font used, and
from differences in size and variations in the amount of white space around
various pieces of information. The texture variation – aside from the sheer size
and dominance – of the large text of the blog titles, varies from that of the body
text, helping establish differences between these pieces of information.

Direction

The principle of direction helps guide the viewer's eye throughout the
composition and helps keep the viewer looking at the design piece. Direction
can be established pretty explicitly through lines (and sometimes even arrows!),
but sometimes more implicitly through shapes, shading, or even invisible
alignment within the composition.

The direction present in the Seurat painting can be found in some of the
compositional relationships I explained earlier (see Figure 6-15). The groupings
of people throughout the composition form invisible directional forces that
guide your eye throughout. The most explicit uses of direction in the
composition are the horizon line that leads to the couple standing in the

foreground, the main dark shadow in the foreground, and the shoreline of the lake. The angular shapes created by the lake, the sun-drenched part of the grass, and the shadow are all strong directional forces as well.

FIGURE 6-15
Direction is
present in a
number of places
in the Seurat
painting.

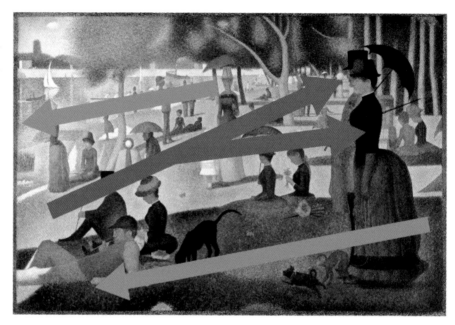

The principle of direction is being used in my simple composition – as I mentioned before – where the largest, second-largest, and smallest circles in the composition line up. As you can see in Figure 6-16, the combination of their progressively smaller sizes and their visual alignment give them a sense of direction that draws your eye diagonally across the canvas.

In Chapter 5, I mentioned imaginary grid lines that were used to place the circles on the composition. As you can see in Figure 6-17, the second-largest circle lines up with the intersection of grid lines that line up with the edges of the largest circle, which visually anchors the second-largest circle to the largest circle. If you look at the largest circle (which is pretty hard to miss), your eye is naturally drawn along the imaginary grid lines to this second-largest circle.

FIGURE 6-16
The alignment of circles in my simple composition creates a strong directional force.

FIGURE 6-17
In my simple composition, the relationships of circles to invisible grid lines form directional forces.

But notice that the smallest circle is not directly centered on any grid lines. Instead, it continues an invisible directional line that is created between the largest and the second-largest circles. Also, since the third-largest circle is perfectly lined up with the first grid line on the left, the smallest circle is placed just off this grid line, instead of being directly centered on it. If the smaller circle were directly on this grid line, it would visually anchor itself to the third-largest circle in a stagnant, vertical fashion. This isn't always a bad thing, but it would take away from the implied diagonal direction that this smallest circle is already a part of.

Direction within the Think Vitamin design is much more subtle and implied. Think Vitamin is designed upon a grid (I talked about this a little in Chapter 5, but I'll talk more about this in Chapter 7), or in other words, the information and design elements are organized along imaginary subdivisions. Think Vitamin's use of direction comes from its alignment of design elements along these imaginary lines.

One such imaginary line is present in the navigation at the top of the page. In Figure 6-18, you can see that there is a middle line created by the logo where the words *Think Vitamin* begin and end. This imaginary guideline (I'll call it an *axis* now) is supported and extended by the tagline "curated by Carsonified" and is extended even further by the words in the navigational items (*home, membership, about,* and so on). There is very little visual ornamentation in this area (other than some subtle background color changes on the navigation items, and the explicit arrow connecting the main logo to the tagline), so this alignment ties the logo, tagline, and navigation into one cohesive unit.

Also shown in Figure 6-18, the left-hand side of this header area – the logo – lines up vertically with the title of the latest blog post. This alignment draws the eye to read this first blog post. But a second vertical axis is created where the body text of the blog post is inset a bit, resulting in a margin in which the author photo can be seen. This usage of two vertical axes in this way allows the first blog post to achieve dominance over the following blog posts even further. Blog posts after the latest one are set along this second axis, so the first blog post looks even more important this way. The resulting margin is a good place for strong icons that call out the titles of the blog posts, but it also allows photos to be more dominant within the composition, as they extend out all the way to the first vertical axis.

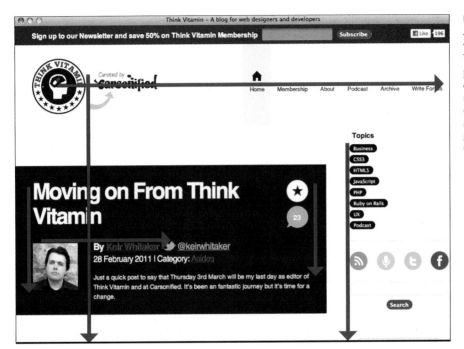

FIGURE 6-18

Alignment
within the Think
Vitamin home
page creates
directional forces
that guide the
viewer's eye.
*Reproduced by
permission of
Carsonified*

As shown in Figure 6-19, direction and alignment also are used in the pages for
the individual posts, especially on the title and metadata of the posts. The title,
author photo, and other elements such as the icon and comment count, are all
grouped into a cohesive unit almost entirely by their alignment with one
another. The left margin of the title lines up with the author photo, which lines
up with the author name, date of post, and category of post. On the right side
of this area, the icon, comment count, and social media widgets all align with
each other.

This imaginary box is completed and highlighted by a strong, dark horizontal
bar that lines up with the social media widgets and extends all the way to the
edge of the browser window. This bar leads your eye into the composition, and
all the alignment I just talked about anchors your eye in this title area. After
you've taken in the basic information about the post, the subtle alignment of the
author name and date with the body text of the post pulls you down to read the
text. Think Vitamin's design can manage to be so clean because it makes good
use of direction through well thought-out alignment relationships such as this.

FIGURE 6-19
Directional
forces within the
post page of
Think Vitamin
group pieces of
information
together.
*Reproduced by
permission of
Carsonified*

Contrast

The principle of contrast causes certain parts of a composition to stand out more than others because of differences – or *contrast* – between elements. Things in a composition can contrast with one another in terms of size, color, value (lightness or darkness), texture, shape, line quality... just about any way imaginable. By using contrast you can create dominance, or create foreground/background relationships. Contrast can be used as a guiding principle throughout an entire design (like if something is entirely black and white), or it can be used sparingly in a design that is mostly homogeneous, for more impact.

Contrast is used in the Seurat painting in the presence of the couple in the foreground of the painting, who appear much larger than any other elements in the composition. There is also heavy contrast between the shaded parts of the grass and the parts of the grass that are in the sun. This makes the people who are in shadows have very crisp outlines. These crisp outlines are a big contrast from the fuzzy shapes that define the leaves of the trees.

My simple composition uses contrast between the color of the circles and the color of the background of the composition. The circles also vary greatly in size – another use of the principle of contrast.

Contrast is a cornerstone of the Think Vitamin design. The simple color scheme used in the design is extremely high-contrast. An extremely light – almost white – cream color is used in contrast with an extremely dark – almost black – gray. Red, which is an extremely intense color, is also thrown into the mix. As mentioned before, the design has very little use of lines and no gradients, so nearly every shape or form – whether it's an icon, a block of ornamentation, or just type – contrasts heavily with its background.

The heavy use of contrast in the design of Think Vitamin contributes to its bold but clean design. As I mentioned earlier, the use of the principle of direction is very light – through subtle alignment of elements – but Think Vitamin's use of contrast is very strong. There is very little that is subtle about color changes on this site.

Think Vitamin also uses a lot of similarity in its design. There is similarity between the shapes of the elements, such as the circular icons, and pill-shaped category links. There are also very few font changes in the design. Subtle alignment is used instead of ornamentation throughout. These uses of similarity further intensify the contrast that is used in the basic but bold color scheme of the design.

Why the MailChimp Logo Is Beautiful: Use of Composition and Design Principles

As you saw in the last chapter, the MailChimp logo (shown in Figure 6-20) – designed by Hicksdesign (www.hicksdesign.co.uk) – makes stunning use of geometric proportions in creating visual interest. But it also makes great use of design principles.

FIGURE 6-20
The MailChimp
logo.
*Reproduced by
permission of The
Rocket Science Group*

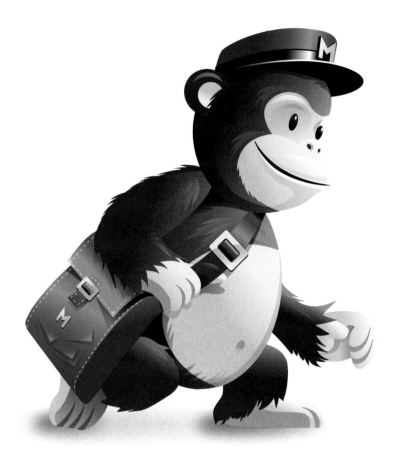

Compositionally, the MailChimp logo generally takes the form of a triangle. As you can see in Figure 6-21, the invisible lines that connect the head to the left hand, and the left hand to the feet, and back up to the head, lead your eye around the logo. It's self-contained.

There are many other directional relationships within the logo as well. If your eye enters the logo from the mailbag, it's led up the mailbag to the head of the chimp. If your eye enters through the extended left hand of the chimp, your eye is led up the arm and once again to the head. The strong triangular nature of the composition keeps you looking throughout the composition of the logo.

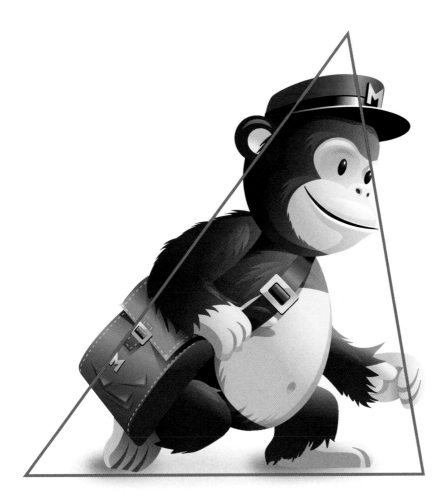

FIGURE 6-21
The MailChimp logo stands alone cohesively because of its strong triangular form. Within the composition of the logo, there are also strong directional relationships.
Reproduced by permission of The Rocket Science Group

Foreground/background relationships

Because the MailChimp logo is a strongly self-contained element, the foreground/background relationships within it are very subtle. The use of shading throughout the features of the chimp, as well as the mailbag, give the chimp a sense of dimension. It really pops out at you.

This comes in handy when the logo is used within a more complex composition. In Figure 6-22, notice, for example, how the dimensional chimp pops off of the

flat background on the MailChimp home page. It's as if the chimp is also on a different layer from the headline and other type on the page.

FIGURE 6-22
The strong sense of dimension in the MailChimp logo makes it pop into the foreground when used within a composition.
Reproduced by permission of The Rocket Science Group

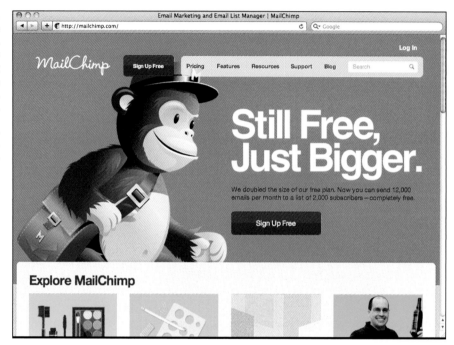

Dominance

The MailChimp logo is a self-contained element, so the principle of dominance isn't used within it a great deal. However, because the logo stands so strongly on its own, it makes a good design element for creating dominance in any composition in which it is used. Notice how the strong directional presence of the logo acts as a visual anchor to hold your eye and direct your eye toward the headline on the page.

Similarity

As I demonstrated in Chapter 5, the MailChimp logo is made up of a series of circles. This gives the chimp very rounded features, which naturally leads to similarity in forms. But the curved forms that are created from these circles are echoed throughout the rest of the chimp's features. Notice, in Figure 6-23, that

there are hardly any straight lines on the chimp. The chimp's hands and fingers are a series of smooth curves that gently transition to one another. Even the mailbag is made up of curved lines.

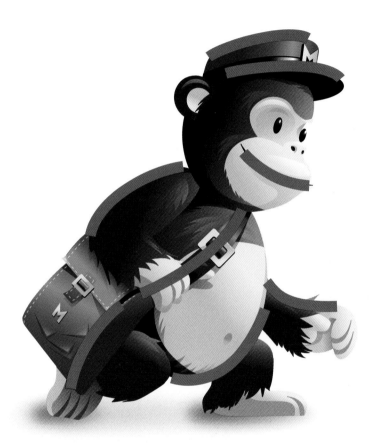

FIGURE 6-23
The MailChimp logo makes good use of the principle of similarity because it is composed entirely of curved lines.
Reproduced by permission of The Rocket Science Group

Many of the more defined parts of the chimp are similar in form as well. Look at the pointy hairs next to the chimp's left hand, for example – they're made up of curved lines. Notice that a very similar shape is used to define the separation between the fingers of the chimp. The chimp's smile is also very similar to the hairs.

Rhythm

The repeated use of curved forms throughout the chimp helps contribute to the sense of rhythm in this logo. Notice, in Figure 6-24, the rhythmic progression between the chimp's left arm, the chimp's left leg, and the chimp's trailing leg. The repetition of limbs creates a sense of rhythm that makes the chimp look like it's in motion. This rhythm is intensified by the hairs on the edge of the chimp's fur. Look at how much coarser the fur is on the left arm of the chimp. As your eye moves to the left foot of the chimp, you notice the hair is less coarse. On the right knee, finally, there is hardly any texture to the hair. This rhythmic progression is punctuated by the hairlike lines that define the toes on the right foot of the chimp.

FIGURE 6-24
The limbs of the chimp give a strong sense of rhythm.
Reproduced by permission of The Rocket Science Group

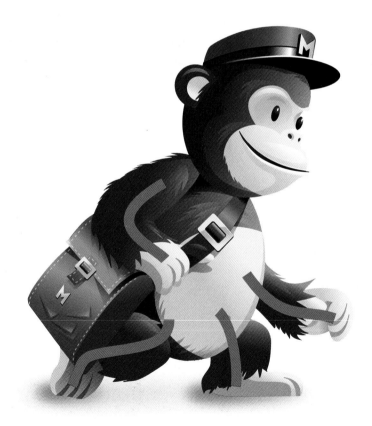

Texture

The MailChimp logo also makes good use of the principle of texture. Overall,
the logo has a satiny sheen to it, which gives all its various parts a cohesive look.
In Figure 6-25, you can see that texture variation is also suggested throughout
the logo. Notice, for example, how the sharp hairs that define the fur differ
from the smooth belly and skin on the hands, feet, and face of the chimp. The
strongest variation in texture in this logo can be found in the shiny buckles of
the mailbag, and the black band that goes around the chimp's hat.

 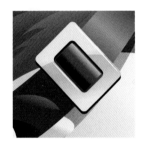

FIGURE 6-25
Despite an
overall satiny
finish, the
MailChimp logo
still conveys a
number of
different textures.
*Reproduced by
permission of The
Rocket Science Group*

Direction

There is a strong sense of direction in the MailChimp logo. Since the chimp is
leaning forward, and is clearly walking or running at a brisk pace, it gives the
overall logo a sense of forward direction. The limbs of the chimp are arranged
in ways that create a strong sense of direction as well. The left hand, left foot,
and trailing right foot all radiate from the center of the chimp and lead your
eye from one limb to another. As shown in Figure 6-26, if your eye rests on the
trailing right foot, your eye is very quickly directed by the strap of the mailbag
back up to the head of the chimp.

Contrast

While contrast isn't a cornerstone of the design of the MailChimp logo, as it is
in the Think Vitamin website, its use still contributes to the beauty of the logo.
The contrast of texture that I've already talked about helps create visual interest;
contrast is also used carefully in a couple key areas to draw the eye to important
parts of the composition.

FIGURE 6-26
Directional
forces in the
design of the
chimp recycle
your eye
throughout.
*Reproduced by
permission of The
Rocket Science Group*

In Figure 6-27, notice that there is a ring of darker fur toward the back of the chimp's head. This darkness, along with the dark brim of the hat, helps frame the chimp's face and makes it pop.

There is also color contrast used in the MailChimp logo. The mailbag and hat of the chimp are blue, but the base color of the fur and belly of the chimp are somewhat orange. I'll talk about this more in Chapter 9, but blue and orange are considered opposites of each other – much like black and white are opposites. This contrast makes the mailbag and the chimp stand out against one another.

FIGURE 6-27
Contrast is used
to frame the face
of the chimp and
make it a focal
area.
*Reproduced by
permission of The
Rocket Science Group*

Knowledge Applied

Many people think of design as colors, shapes, and white space, but as you've
learned in this chapter and the previous chapter, numerous invisible concepts
contribute to beautiful design. Unlike geometric proportions, which are simply
good to know, understanding composition and mastering the use of design
principles is absolutely critical to creating beautiful design. When someone says
that a person "has an eye for design," these design principles are what they're
talking about. Great designers know how to use design principles.

> Look for design principles at work in everything you see. Next time
> you're on a website that looks visually stunning, pay attention to its use of
> dominance in telling you where to look. See how direction is being used
> to guide your eye throughout. What other design principles do you see
> being used (or not being used)?

> If you made a simple composition of your own in the last chapter, try
> experimenting with it to practice, at a very basic level, your use of design
> principles. Concentrate, one at a time, on using each of the principles I've
> outlined in this chapter.

Enlivening Information: Establishing a Visual Hierarchy

THE "COMPOSITIONS" THAT most of today's designers work with are far more complex in information and clearer in objectives than a Renaissance sculpture or an Impressionist painting. If they're designing an interface for a blog, for example, there are specific tasks and objectives for the user. The user needs to be able to navigate to any page that he wants, but at the same time, the articles on the blog need to be easy to read. Categories need to be easy to navigate to, and information about the blog and its authors need to be clearly accessible.

Making these compositions visually compelling is important for getting new users to stay and for conveying a mood to visitors. But a compelling composition is of little use if the user can't find what she's looking for. Many visual standards and user interface patterns have been established for designing on the web, and certain user expectations come along with them.

For a user to be able to navigate through all the information in a website or application, that information needs to be clearly presented and have a clear hierarchy.

What I Mean by "Hierarchy"

The term *hierarchy* implies that information has a linear progression of important to not important, but this isn't precisely true. The importance of a piece of information in an interface can change according to the use case. If you see a new blog post on a site that you read frequently, you probably aren't that concerned with the date of that blog post. If you're reading a technical how-to about software that is frequently updated, though, the date of the blog post may be very important to you.

Although sometimes you can make some safe assumptions about the relative importance of pieces of information, visually organizing information is a much more nuanced process than simply ranking information by importance.

Take for example a standard blog layout, like the one shown in Figure 7-1. You've probably seen many blogs with a layout like this. The logo and title of the blog are at the top. Along with that is the navigation, and maybe even a logo for the name of the blog. In the HTML for the layout, this information is often encased in what is usually called the "header" of the blog.

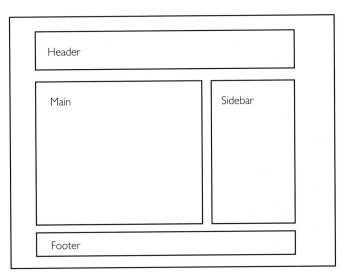

FIGURE 7-1
Most blogs have
a layout generally
like this. The
various sections
are arranged to
establish a
hierarchy.

Below the header usually lies the main content area. Within this main content area, you'll find the content of the blog post in question. This will include the title; the actual content of the blog post; and metadata such as the date of the post, the author, or what categories the post belongs to.

Below the blog post content are comments from readers of the blog. Each of these comments is accompanied, possibly, by a photo of its author and a date and time stamp for the comment.

To the side of the main content area is often a sidebar area, which typically lists categories, a function for searching content on the blog, information about subscribing to the blog, and maybe a few ads.

At the bottom of the page is often the footer. The footer usually repeats links that are in the navigation in the header but also often includes other links such as one to the particular content management system (CMS) the blog is written in or what copyrights the author of the blog reserves.

The various sections of a standard blog layout don't so much rank things linearly by importance; instead, they express how the various sections differ.

Hierarchy is expressive

There is no way that you could accurately rank these pieces of information
from most important to least important and have it apply to every situation.
Establishing a visual hierarchy is much more expressive and less scientific than
this. Pieces of information have personalities and relationships with one
another.

HTML breaks up information into a sort of hierarchy. There are linear
distinctions such as the header tags of H1, H2, H3, and so on, but there are
other tags such as `blockquote` and `code` that simply call out that the nature
of the information differs, rather than the rank of that information.

Establishing a visual hierarchy is somewhat congruent to HTML in this way.
Sometimes user needs or marketing objectives make certain information
indisputably rank higher than other information, but there are many other
subtle differences between pieces of information that have to be expressed with
more finesse.

Many visual factors can affect hierarchy

Many people who dive into trying to learn how to design make the mistake of
trying to work with far too many visual factors when trying to establish a visual
hierarchy. As I'll demonstrate in this chapter, there are many different ways to
differentiate different pieces of information and design elements from one
another. You can alter the white space or make changes in size, typeface, or
visual weight. You can change colors, or use ornamentation such as rules, icons,
or solid blocks of color.

Unsure of how to proceed, many beginning designers try to change too many
of these factors at once. Usually they change the factors that are the most
visually obvious. If they're creating a header in a blog post, they may change
the font, make it larger, change the color, and add a rule or a background
image to it. Usually the result isn't satisfactory. The big secret is, some of the
least obvious factors – such as use of proportion in white space – are the ones
that have the most impact.

If you've never danced salsa in your life, and you were to try dancing to salsa
music, what you'd come up with would probably not be pretty. Unless you

have incredible natural talent (or lots of experience dancing in other styles), you'd probably look awful. Even if you first watched some skilled dancers, learning by seeing would be very tough. You might see them do a back break, a hammerlock turn, an in-and-out, followed by a double spin, but you wouldn't know what to call it, and it would go by so quickly that you couldn't parse it well enough to imitate.

But if you first learned to distinguish the beats of the music, and then learned the basic steps according to this beat, you'd have a good foundation on which to build your salsa-dancing skills. Everything you learned – and everything you saw – would fit within this framework. After learning a three-turn pattern and a cross-body lead, you'd probably look good enough to impress a complete novice. Many dances and lessons later, you'd be a good salsa dancer.

Learning to design – to express and differentiate pieces of information – is much like learning to dance. You have to learn the basic moves before you can tie them together with the more complex ones. But the basic moves of design aren't as apparent and well known as the basic moves of dancing.

The visual factors that affect the hierarchy of information are like dance steps that fall on the beats of music. If you learn to observe and practice each of them in isolation, you can more easily tie them together.

Hierarchical Factors in Isolation

Even the basic blog layout that I've presented is too complex of a song with which to really begin learning to dance. The overall layout has a visual hierarchy: fields of information that differ from one another. These fields of information have hierarchical relationships with each other, but each is also full of hierarchical relationships.

To teach you the basics of creating a visual hierarchy, we need a more basic informational hierarchy with which to work. I'll use text from a basic lead-in to a blog post, as it might look on the home page of a blog. It holds the title of the blog post, a sampling of the body of the blog post, and a lead-in to read more of the blog post. It also holds metadata about the blog post, such as the publication date, the category, the author, and the number of comments on the post.

It's clear that some pieces of information here are more important than others. The title is the most important, because it tells you what the blog post is about. From there, depending on the situation, the body copy sampling of the blog post is probably the next most important. The relative importance of pieces of metadata such as the author name, post time, category, and comment count, however, are unclear.

Maybe these pieces of metadata share the same level of importance, but they definitely differ conceptually from one another, and have different conceptual relationships with the other pieces of information. You might say that the post is "by" the author's name. You may say that the title of the post is "filed under" the category name. You may say that there are three comments "on" this post. You also may say that the post itself was posted "on" a particular date and time. The way that we talk about pieces of information speaks a bit to how those pieces of information differ conceptually.

White space

To really be skilled at expressing how these pieces of information differ, we need to isolate the variables with which we can make those expressions. One of the most important, and maybe the most fabled, is that of white space usage. The term *white space* is usually used to describe any area that doesn't have information, or some other design element within it. You've probably heard someone say that you should "use more white space" or that something "has too much white space." But what does all this really mean?

A piece of information with lots of white space around it will often look more important than other information. Two pieces of information that have very little white space between them will often appear to be related to one another.

To isolate and observe how use of white space affects hierarchy, you need to hold all other variables constant. So, I'll present a composition with all the same font (Helvetica), all the same type size (12pt), and all in regular weight (no bold or italic).

Using a grid to manage white space

To make good use of the white space, I'll employ some of the methods of working with geometry that I outlined in the last couple chapters. I'll start with

a canvas that has a 3:4 ratio and create a live area for content, centered within this canvas, that is a 3:4 ratio rectangle whose dimensions are a derivative of the dimensions of the main canvas (see Figure 7-2). So, since the canvas is 300pts tall, the live area will be 300pts wide and 300 × 0.75 = 225pts tall.

FIGURE 7-2
For my examples, I've created a canvas and live area according to the 3:4 ratio.

I'll create a wide column on the right side of the live area by scaling down another 3:4 rectangle inside the live area. This will create a grid line that will divide the canvas. You could use a similar method to this when establishing a web page layout. By dividing up the live area in this way, you create a wide area for main content and a slimmer area for sidebar content.

Establishing a hierarchy with white space

Figure 7-3 is my first attempt at establishing a hierarchy by using only white space. You can see that the methods available for differentiating pieces of information with these restrictions are pretty limited. Here are some of the things I did to make the best of it:

> I set the title of the blog post in all caps and spaced out the letters a bit to differentiate it and make it more prominent. I also placed the title at the top-left of the composition, because that's where the eye is likely to enter. Notice that I'm avoiding the use of small caps (see Appendix B).

FIGURE 7-3
When restricted
to one font, at
one size, I have
to rely on well-
considered use of
white space to
establish a visual
hierarchy.

MY FIRST BLOG Miscellaneous
David Kadavy May 31, 2004 – 8:16pm

 3 Comments

 Okay, I'm finally trying out
 this blog thing. I don't really
 have any particular intentions
 for this blog, except to ramble
 (and perhaps inform) about
 design, web design and
 the like...

 More >>

> The author name is close to the title of the post to imply a relationship between these two pieces of information.

> Other metadata, such as the publication date and category, are also placed at the top of the composition, but it's all set all the way to the right. This horizontal relationship between the metadata and the title implies that these pieces of information are related, but because this information is all the way to the right, it's less prominent.

> The body of the blog post is aligned along the dividing line that I created. Because it is relatively close to the center of the composition, is highlighted by a large expanse of white space to the left, and takes up a good amount of visual weight because of its sheer size, it takes a fairly prominent role in the composition.

> The "more >>" link is placed along the bottom-right of the live area. This position is a cognitive expression of the concept that it leads to "more." It stands out fairly well because of the amount of white space there is around it.

Knowing how much white space to use

Just as geometric relationships affect the composition of a design, geometric relationships also affect how individual design elements interact with one another. For example, the amount of white space that I included between the title of the blog and the author name was not random. As you can see in Figure 7-4, the white space between these two elements is equal to the cap height of the text itself.

MY FIRST BLOG
David Kadavy

[MY FIRST BLOG

FIGURE 7-4
Geometric relationships are used to establish the amount of white space between elements, such as between the title of the blog post and the name of the post's author.

This same method is used to separate the comment count from the other metadata on the top-right of the composition. The category name and the time stamp, however, are visually linked by having a smaller amount of white space separating them. They're half the cap height away from each other.

Considering white space this way creates a sense of rhythm and order in the design, making it appear "clean." Simply *considering* the amount of white space used between elements, and being consistent, can go a long way toward making a design look more clean.

Considering white space and italic font style

Figure 7-5 tries once again to create a hierarchy using only white space, only this time I've added a little bit of italic font styling into the mix. This is a small factor to change, but it's another way to differentiate pieces of information. In this composition, I've still put the title in all caps, but this time I've made it, along with the author name, flush-right on the dividing line, while the body of the post is flush-left on the opposite side of the dividing line. This creates a directional force that draws your eye to the body copy after reading the title.

The date and time stamp on this composition has been put in its own special area, so it isn't grouped together with the other metadata such as the category and the comment count. Notice how this changes the way you perceive the date. It looks like a more important element in this iteration, which may or may not be appropriate, depending on how this content is really used.

FIGURE 7-5
Italics add
another potential
dimension with
which to
differentiate
information.

MY FIRST BLOG
David Kadavy

Okay, I'm finally trying out this blog thing. I don't really have any particular intentions for this blog, except to ramble (and perhaps inform) about design, web design and the like...

May 31
2004
8:16pm

Miscellaneous
3 Comments

More >>

FIGURE 7-5
Italics add another potential dimension with which to differentiate information.

Using a four-column grid

In my next composition, I'll create a grid that is a little more standard than the grid I was using before. Very often, grids are created by dividing the live area of a design into a set number of columns. In this case, I'll divide it into four columns (as shown in Figure 7-6).

FIGURE 7-6
For my next composition, I'll divide the live area into four columns of equal width.

Note that the lines that flank either side of the main dividing lines indicate the "gutters" of each column, which I'll use in a later composition. The gutter provides some padding between the columns so text elements don't butt up against each other when they're in opposite columns.

Grids that are evenly divided can add a little versatility to a design relatively simply. As shown in Figure 7-7, a four-column grid like this one can be used in a standard blog layout. Three of the columns can be filled with a main area of text, while one of the columns holds sidebar information. Or two columns can create an area for main content, while the other two columns — either right next to each other or flanking the main content area — can be dedicated to sidebar content.

FIGURE 7-7
A four-column grid can be used to organize content in a number of different ways.

Type weight and size

Aside from the careful management of white space, making adjustments in the weight and size of type can go a long way toward differentiating information in your designs. Many inexperienced designers are quick to attempt to use another typeface to try to create variety, but defaulting first to the factors of weight and size can improve your versatility and contribute to elegant designs.

Type weight

In Figure 7-8, I'll be using the bold version of the font to further establish a hierarchy, but I'll still be using only one size. I'll avoid using italics at this point to really give you a feel for how weight changes affect the hierarchy.

FIGURE 7-8
Using a bold
version of the
font in my
design allows me
to make some
elements stand
out more
strongly.

MY FIRST BLOG
David Kadavy

Miscellaneous

May 31, 2004
8:16pm

Okay, I'm finally trying out this blog

thing. I don't really have any particular

intentions for this blog, except to

ramble (and perhaps inform) about

design, web design and the like...

3 COMMENTS

More >>

This composition looks pretty similar to the first one that I created, but there are a few differences. Here's what I've done:

> **I've bolded the title, in addition to using all caps.** This should help the title pop out more. I've also bolded the body copy, which visually connects it to the title. To avoid the body text area dominating the composition too much, I've increased the leading (or `line-height` in CSS), to lighten up the texture a bit (see Appendix A for more on texture).

> **I've separated the comment count from the rest of the metadata.** Because it's close to the body copy, this changes the way you perceive the information. It suggests a stronger relationship between the comments, and the actual content of the blog post. In the first composition, the comment count was grouped with the category and the time stamp, which made an almost dismissive statement about the comments submitted by the readers.

> **I've lined up both the author name and the body copy with the first column grid line.** This connects the two pieces of information. The author name is still close enough to the title to be connected to it, but the title extends all the way to the leftmost margin of the composition, elevating its importance.

Type size

On this same grid, I'll create another composition (see Figure 7-9), but this time the only factor I can change is the size of the type. I won't even be changing the weight. I've made the title so large that – even with the metadata above the title – the title still dominates the composition. I've placed the author name above the title, flush-left, and the category and date are in all caps, in a smaller type size, starting from the right-hand side of the composition.

David Kadavy MISCELLANEOUS MAY 31, 2004 – 8:16PM

My First Blog

Okay, I'm finally trying out this blog thing. I don't really have any particular intentions for this blog, except to ramble (and perhaps inform) about design, web design and the like...

3 COMMENTS MORE >>

FIGURE 7-9
The use of a drastic size change in the title of the blog post allows me to place the metadata above the title without superseding it in importance.

Though these three pieces of metadata are connected visually by being aligned with each other, the author name is different. It isn't in small caps and is in a larger type, which is intended to express – in this context – that this is a person, not a chunk of data.

The comment count, and "more >>" link are differentiated from the body copy in that they are in slightly smaller type, but in all caps.

It's clear that making size changes can have dramatic effects on hierarchy, but I haven't chosen these type sizes haphazardly. Just as early printers were very restricted on how many different fonts they could use (because making new fonts was such an involved process), they were also very restricted in how many different type sizes they could use. In fact, a set scale of type sizes was usually produced when a new font was made.

This restriction was a blessing, because changes in size are best done with some proportional consideration. Since there are so many other ways to differentiate information, it's best to make size changes that make a discernible difference. Using 13px type to differentiate from 14px type isn't very effective or attractive.

This is why, just as the circles that make up the MailChimp logo (see Chapters 5 and 6) have a proportional relationship, it's good practice to pick some proportional scale of type sizes to work with. For example, Figure 7-10 shows the type sizes that I typically work with.

FIGURE 7-10
These type sizes have a 3:4 proportional relationship.

5 7 9 12 16 21 28 37 50 67

Type sizes such as 5 and 7 are pretty much reserved for print applications or for when I'm using all caps, but I built this scale by starting with the smallest size I might conceivably use, 5pts, and dividing it by 0.75 (and rounding) repeatedly. The result is a scale of type sizes that have a proportional relationship with each other.

Sometimes jumping directly from one of these sizes to the next highest or lowest doesn't have as much impact as you might hope. For example, the size difference between 9pts and 12pts is pretty subtle. You can achieve a similar change in hierarchy by sticking with 9pts and simply making headers bold, instead of larger, as demonstrated in Figure 7-11.

FIGURE 7-11
Using factors such as font weight, or more dramatic size changes, to differentiate information is better than using subtle size changes.

When you say it
Say it clearly

12pt & 9pt

When you say it
Say it clearly

9pt, bold & regular

When you say it
Say it clearly

16pt & 9pt

Or sometimes it's useful to just skip a step in the scale. The size difference between 9pts and 16pts, for example, can actually have a meaningful impact.

With the limitless choices in type sizes today, working with a scale such as this
can simplify your choices, and remind you that there are other methods you
can use to differentiate information.

Combining weight and size

While weight changes or size changes alone can produce dramatic effects, the
two factors together can differentiate information even further. In Figure 7-12,
I've bolded the title, the author name, the number of comments, and the date
and time stamp. The combination of large size, all caps, and the bold weight of
the font make the title dominate the composition. The fact that the title takes
up most of the left half of the composition (the first part to be read) makes the
title look about as important as it could.

FIGURE 7-12
Using size and
weight changes
in combination
can produce an
even wider range
of visual
importance.

Directly on the opposite side of the *gutter* (the padded space between the
columns) are the category, the body copy, and the "more >>" link. It's generally
not polite to "scream" on the web, but the introductory piece of the body copy
is short enough (and letterspaced enough) that using all caps is okay in this case.

Color

Adding color to the mix can make some hierarchical acrobatics possible, too.
Notice in Figure 7-13 that even though the body copy and title are the same size
in this composition, the title still stands out as much more important. Because
the title is red and bold, it stands out much more than the gray body text does.

A red as intense as this naturally stands out more than a light gray and even contrasts strongly with a pure black. But the interactions between colors are often much more complex and nuanced. (I talk more about how colors interact with each other in Chapter 9.)

FIGURE 7-13
Making the title
red makes it
stand out,
despite the fact
that the light
gray body text is
the same size as
the title.

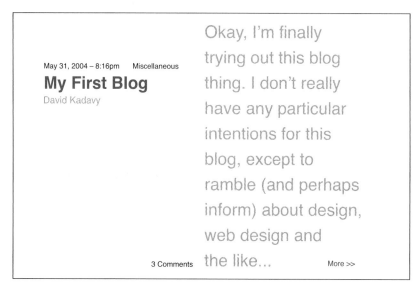

Visual ornamentation

Even with all the various combinations of size, weight, and color that you can use to establish a visual hierarchy, chances are, most projects you work on will have much more to them than this. Iconography can be indispensable in helping to guide your user, and images are usually a requirement for communication at some point. Additionally, with the complexity of most layouts, vertical and horizontal rules, blocks of color, and even gradients can help to divide and enliven the page.

I've started with the simplest implementation of visual ornamentation possible in Figure 7-14. This composition is simply a revision of the first composition, which you saw back in Figure 7-3, but this time I've added a very thin horizontal rule underneath the title.

The rule "bleeds" all the way from the left edge of the composition, so your eye naturally enters on this rule. Because the title is so close to this rule, it's one of the first things you notice. I've even changed the title from all caps to mixed lowercase and capital, and it still manages to be very prominent in the composition by virtue of its presence in the top-left (where reading begins) and its proximity to this horizontal rule.

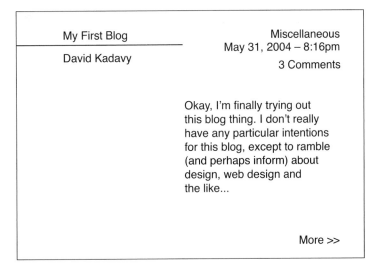

FIGURE 7-14
A simple but strategically placed horizontal rule is enough to make the title prominent.

In Figure 7-15, I've mixed the use of visual ornamentation with other factors such as weight, size, and color. The only visual ornamentation that I've used here is a thick, black horizontal rule. Aside from its dominant presence – just by virtue of being large and dark – because it "bleeds" all the way from the left edge of the composition, your eye is naturally drawn to this bar.

FIGURE 7-15
The dark black
bar helps the
title stand out,
despite actually
being smaller
than the body
copy of the post.

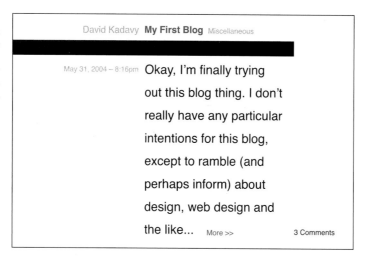

To demonstrate the impact that visual ornamentation can have, I've made the title smaller than the actual body copy of the post. Because the title is red and bold, it contrasts sharply with this large black bar, and because your eye is naturally drawn to this bar, the title is easily noticed because of its proximity. The author name and category flank the title, each with its own styling.

As valuable as visual ornamentation is, it often gets overused. When a simple layout doesn't quite look "clean," many beginning designers instantly lean on the crutch of visual ornamentation. But, just like any other factor of visual differentiation, ornamentation can be used sparingly if other factors are used skillfully.

There is no more common example of overuse of ornamentation than in tabular data. Most people think that tables, constructed of columns and rows of data, need plenty of vertical and horizontal rules. The logic behind this for most people probably lies in how a table is read – the rules presumably help guide your eye to find the data in any specific column/row.

Figure 7-16 shows a typical application of tabular data. Each piece of information has been cordoned off into its own little box by having dark rule lines border all sides. This is ostensibly to help guide the eye, but it really just adds to the clutter of the design.

Top 5 Cities for Walking	
Boston, MA	12.55%
Washington, D.C.	9.97%
San Francisco, CA	9.59%
New York, NY	9.44%
Philadelphia, PA	8.05%

FIGURE 7-16
Data is often presented in tables such as this one, which is cluttered with unnecessary rule lines.

As Edward R. Tufte explained in his book *Envisioning Information,* attempting to further differentiate information in this way is an example of the concept of 1 + 1 = 3. What this means is that pieces of data arranged in a table such as this are already visually divided by virtue of the white space between them. When you interrupt this white space with a rule, you now have two areas of white space and a rule (three things) all with the purpose of separating these pieces of data. So, 1 + 1 = 3. To make matters worse, you also have entire elements (the rule lines) that don't carry any information, thus cluttering the design.

Upon hearing this, you might argue that the rules are there to guide the eye. But, as I demonstrated in Chapter 6 when explaining the design principle of direction, the mere alignment of elements can be very powerful in guiding the eye.

Figure 7-17 shows the same tabular data, this time with no visual ornamentation at all. Instead, the title of the table has been bolded, and the numbered data is in italics. There is also more white space between the title and the first row of data than there is between the rows of data themselves.

FIGURE 7-17
Utilizing the
principle of
direction, by
virtue of
alignment of
elements, can
make tabular
data much
cleaner.

Top 5 Cities for Walking

Boston, MA	*12.55%*
Washington, D.C.	*9.97%*
San Francisco, CA	*9.59%*
New York, NY	*9.44%*
Philadelphia, PA	*8.05%*

Admittedly, this is a very simple table. Sometimes tables with much more data points can be more difficult to navigate. Although you may surprise yourself with how little visual ornamentation you can get away with – whether you're working with tabular data or a complex layout – sometimes a little more visual differentiation can be helpful. For example, Figure 7-18 shows the same table, this time with alternating highlighted rows. Highlights such as these can help the eye keep track of the row when tables of data are very wide. They also can make the table look more interesting (which, in itself, isn't a great reason to use them).

FIGURE 7-18
Highlighted rows
can sometimes
assist in
navigating a
table, but other
ornamentation
can still be used
sparingly.

Top 5 Cities for Walking

Boston, MA	*12.55%*
Washington, D.C.	*9.97%*
San Francisco, CA	*9.59%*
New York, NY	*9.44%*
Philadelphia, PA	*8.05%*

Notice that there is still very little use of rule lines in this table. The highlights themselves are a good indicator to separate the various rows of data, and border lines are not necessary to signal the ends of those highlights. The outside edges of the table are clearly defined by the ends of the highlighted rows. The ends of the highlighted rows also line up with the ends of the horizontal rules that signal the top and bottom of the data rows. This conscientious use of visual ornamentation results in a table that is both easy to read and clean looking.

I'm using tabular data as an example to expose the logical justification for using visual ornamentation because tabular data has a clearer purpose than most information that you may encounter in your projects. This same thought process can be applied when designing a blog layout, an interface for a social application, or an interface for a mobile application. What's most important is that every design element, every graphic or piece of ornamentation, and every expanse of white space – big and small – is at least considered.

Hierarchy at Work

Now that you've seen how all the different factors that can shape the hierarchy of information can work independently – and with one another – you're better equipped to understand the thought process behind more complex designs.

The online magazine The Bygone Bureau (`http://bygonebureau.com`), designed by the design firm Sleepover (`http://sleepoversf.com`), makes very good use of subtle manipulation of hierarchical factors (see Figure 7-19). The result is a design that is very simple and clean and that invites the reader to take his time with the content. This makes sense, because the site's mission statement says that they "believe in publishing good ideas and polished prose." They appreciate language, and the site's design is all about the words.

FIGURE 7-19
The Bygone
Bureau has a
clean-looking
layout and
design because it
uses typography
elegantly.
*Reproduced by
permission of The
Bygone Bureau*

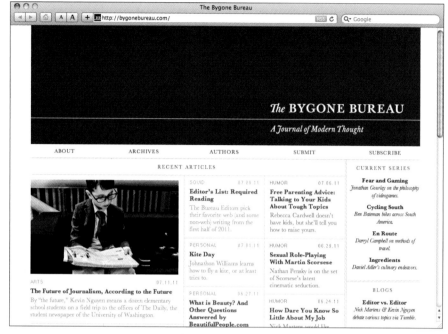

The Bygone Bureau uses typography elegantly in its design. Changes in fonts are very subtle and limited in the site's design. The main font on the site is Baskerville, which is a classic and one of the first transitional fonts (see Chapter 3). Baskerville is used in the site's masthead, in titles of articles, and anywhere else there is a small amount of text to be consumed.

Considerate of readability, they cleverly switch to the Georgia font for body text. Georgia is very similar to Baskerville, but because it's specifically designed to be displayed on-screen, it's much more readable in body text. Baskerville has some more subtle forms, though, and this is why it does very nicely as a titling font. (See Appendix B for more on pairing fonts).

NOTE It's normally poor form to work with two different serif, or two different sans-serif, typefaces. But because fonts that read well at body-copy sizes on the web don't tend to look so good at header sizes, there are exceptions to this rule. (See "The exception to the rule" in Appendix A for more.)

Because Baskerville and Georgia are so similar to each other, carefully considered chunks of white space, and carefully considered size and weight changes are used to differentiate pieces of information from one another. Notice in Figure 7-20 that the distance between the title, subtitle, rule, and paragraphs are all the same.

FIGURE 7-20
The white space between elements is carefully considered.

As you can see in Figure 7-21 Helvetica is thrown in to separate informational chunks (such as category post and date) from the meatier content of the site.

FIGURE 7-21
Helvetica is used on some of the article metadata, which expresses the different nature of this information.

The overall layout of the home page gives the reader a sampling of some of the content. The site is laid out on a five-column grid. The very dark and heavy masthead of the site dominates the composition, but its design is still as simple as the design of the rest of the home page.

The most recent article is called out as the most important because it spans two columns of the layout, is accompanied by an image, and sits on the top-left, where the reader first starts reading. The rest of the excerpts take up one column each and are color-coded according to category. I should acknowledge that the pastel colors are, in fact, a little hard to read, but the elegant use of typography is nonetheless impressive.

The various article excerpts are separated with very thin and light vertical and horizontal rules. It's possible that these rules may not be necessary, but they're definitely less intrusive than the ones in my table description from earlier. Instead of using a thicker or darker rule to separate the final sidebar column from the rest of the layout, double rules have been used, which adds some sophisticated styling.

A really interesting decision has been made about the hierarchy of the layout on the post pages of The Bygone Bureau. Instead of placing the masthead at the top-left of the page, as is generally a website convention, they've placed the title of the article in the prime spot at the top-left of the page. This makes a statement about their belief in the importance of their content and calls into question this convention: Is the name of the website always more important than the content of the page? Prioritizing this information on the page also places the title of the article above the name of the site in the HTML code, which actually makes sense for search engine optimization (SEO).

The Bygone Bureau design makes some elegant use of typography through subtle hierarchical changes, while making a statement about the core beliefs behind the site.

Knowledge Applied

Today's design challenges present very complex hierarchical relationships. At the same time, designers can work with a number of different factors to establish this hierarchy. Understanding how each of these factors works in isolation is critical in developing your design skills.

> The next time you see an interface – or even a poster – that you think is well designed, look carefully at how the designer has established a hierarchy of information. What factors has the designer worked with to differentiate pieces of information from each other?

> The next time you're designing something, try stripping out all the excess visual ornamentation, using only one font, and starting with the same type size. See how well you can establish a hierarchy with these restrictions. When you've explored a bit, try adding in other factors such as bold type or size changes.

> Try working with a varied scale of type sizes like the ones I described in this chapter. You can work with the sizes that I provided, or experiment with building a scale of your own using the proportions in Chapter 5. Once you get accustomed to using a certain scale, choosing the right type size will become second nature to you.

Part IV: Color

Color Science

COLOR IS ONE of the most mysterious and subjective aspects of design. Color tastes and meanings vary across cultures, and from individual to individual. In fact, the very notion of color is rooted in subjectivity. As I'll explain in this chapter, what we perceive as color as a species varies from the experiences of other species. There are colors we can see that, say, a dog cannot see. There are other colors that other animals – such as birds – can see, that we cannot. Additionally, there are variations within the human experience of color. To complicate matters further, our representations and codifications of color (such as the hexadecimal color system that powers the web) often don't do color its full justice, and representations of color vary from medium to medium, and device to device.

No matter how subjective of an experience color is, one thing is for sure: to use color lucidly, it's very helpful – if not a requirement – to understand how color works. Understanding the incidence and impact of colorblindness, for example, helps you know when it's appropriate to rely on methods of communication other than color. Additionally, understanding how different devices (such as computer screens or printers) reproduce colors will ensure that the colors your audience sees are the colors you intended for them to see. Finally, being a master of the science of color can make your work faster and more efficient (while impressing your friends), so you can move on to other aspects of your project.

In this chapter, I'll provide you with an understanding of how color works, so that you can work with color lucidly, no matter what the medium. I'll explain exactly what color is, how our visual system processes color, and how to consider colorblindness in your designs. I'll explain exactly why the color on your printed business card will never match the color on your website and what systems you can use to get those colors as similar as possible. Finally, I'll teach you how to think in hexadecimal color, saving you coding time and impressing the hell out of your friends.

Will the world end if you don't learn these things? No. Do all professional designers even know these things? No way (but they should). This chapter will bring you a true understanding of color, which will prepare you for Chapter 9, where you'll learn what about the physics of color and how the way our bodies process color causes color to affect our emotional responses to design. By understanding what color is and how our visual system processes color, you'll

be better prepared to understand how Target uses red to get you to buy, and why Chase bank uses blue to get you to trust them. You can use this knowledge to create landing pages that convert and interfaces that are usable.

What Is Color?

It sounds almost like a philosophical question as deep as the debate on the meaning of life, but what is color? What color is to you may not even be a color to me. As I'll explain later, what color is to you probably isn't a color to your dog. What color is to all those annoying pigeons downtown, surprisingly, may not be color to you.

It could be argued that color isn't color unless you can see it, but the color that we perceive is simply electromagnetic radiation. As you can see in Figure 8-1, the electromagnetic radiation that we perceive as color is the same electromagnetic radiation that pops a bag of popcorn in your microwave, sends tunes to your FM radio, X-rays your broken clavicle, or changes the channel on your television (with your infrared remote control).

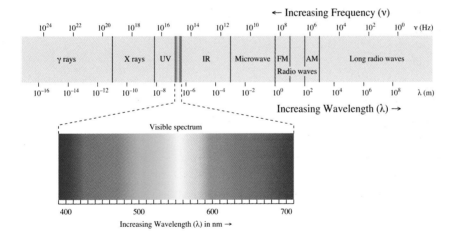

FIGURE 8-1
The colors that are visible to humans lie within a specific range of electromagnetic radiation.
Sakurambo (http://commons.wikimedia.org/wiki/User:Sakurambo)

The electromagnetic radiation that humans can generally see is called the *visible spectrum*. These wavelengths range from about 390 to 750 nanometers in amplitude and cycle at 400 to 790 terahertz.

Around the early 1700s, Isaac Newton discovered that white light refracted through a triangular prism disperses into the visible spectrum of color. By showing that portions of this spectrum traveled through an additional prism unchanged in color, and by recomposing this spectrum back into white light using a lens, he proved that this spectrum truly was the separation of white light, rather than colors somehow created by the prism. Before Newton's experiments, scientists believed that white light was colorless.

Though there are no clear separations between the colors within this spectrum, Newton classified the colors and arranged them in a circle. He chose to divide the circle into seven colors based on the belief of the ancient Greeks that colors are connected to the musical notes (there are seven notes in an octave) and days of the week. You can see Newton's color circle in Figure 8-2, with musical notes – arranged according to the Dorian mode in the key of D – assigned to their respective colors.

FIGURE 8-2
Newton arranged
the colors of the
visible spectrum
in a circle,
according to
musical notes.

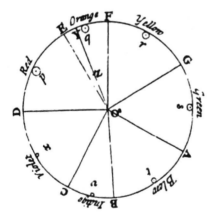

The Tricks Your Eyes Play

The perfect division of white light into the visible spectrum of colors really only occurs in a vacuum. In the real world, there are all sorts of factors that come into play that make the light you see a little less pure. But, your eyes – or, more accurately, your visual system – play a few tricks to bring some consistency to the visual world.

Metamerism

Though this "rainbow" spectrum may be very familiar to you, in your day-to-day world, you'll almost never encounter such a pure representation of color. The colors that you observe in the physical world are spectra that consist of varying frequencies. Your eyes and brain approximate the color of a given spectrum, and this is how you see colors.

Though one spectrum may differ from another, they may appear to be the same color. This phenomenon is called *metamerism,* and it's the basis for how we are able to approximate and reproduce colors across a variety of media. A photograph of a red car may consist of spectra that vary from seeing that same car in real life, under sunlight, but thanks to metamerism, those colors look essentially the same.

So, when you do see any of these pure colors from the "rainbow" spectrum, it's because of this parsing that your visual system does. It senses the dominant color and causes you to experience that color. What you're seeing in this book isn't the pure colors of the spectrum. Instead, they're printed on the page by a combination of dots of ink. Even the lighting in the room you're in is affecting the spectra of wavelengths that are hitting your eye. But your visual system still reads them more or less as pure colors.

Color constancy

Color constancy is another shortcut your visual system takes to make sense of what you're seeing. Color constancy is a phenomenon in which your eye reads two instances of the same color as being the same color despite the fact that one instance is in light, and another is in shade. Notice, for example, that the parts of the hot air balloons in Figure 8-3 are very clearly the same color, despite the fact that part of the balloon is in direct sunlight, and part of it is in the shade.

This phenomenon can cause some interesting optical effects. Notice the checkered board in Figure 8-4. The square marked *B,* which is in the shadow of the green cylinder is actually the exact same color as the square marked *A.* But these two squares appear to be different colors because of color constancy.

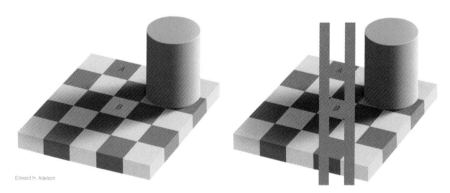

Afterimages

Afterimages are another interesting visual phenomenon. If you stare at the red circle in Figure 8-5 for 10 seconds, and then look at the gray outlined circle, you'll notice a greenish-blue ghost image remains. This happens because the red color receptors in your eyes grow accustomed to the visual stimulation of red. When your eyes go back to a blank space, your receptors are still accustomed to seeing red in that part of your vision, so the visually opposite color is sent to the brain instead.

FIGURE 8-5
Staring at the red circle for 10 seconds, and then looking at the gray outlined circle, will result in a greenish-blue afterimage.

The phenomenon of afterimages is related to the concept of complementary, or opposite, colors (see Chapter 9). Artists who follow the popular color theory model believe certain pairings of colors, such as red and green, are the highest in contrast to one another and create a sense of vibration where they meet.

Impressionists such as Vincent Van Gogh took advantage of this phenomenon by using contrasting colors, creating a sense of vibration and movement in their paintings. Van Gogh wrote about this in a letter to his brother, Theo, in August 1888:

> To exaggerate the fairness of hair, I come even to orange tones, chromes and pale yellow.... I make a plain background of the richest, most intense blue that I can contrive, and by this simple combination of the bright head against the rich blue background, I get a mysterious effect, like a star in the depths of an azure sky.

How the Visual System Works

These are some cool phenomena, but what is it about the operation of the visual system that makes this stuff happen? To really understand the way we perceive color, and to understand some of the underpinnings of color theory that will be presented in the next chapter, it's helpful to understand how the human visual system works.

Cones

Your retinas have millions of photoreceptors (the ones that adapt to create afterimages) called *cones,* which process colors within the visible spectrum.

Other photoreceptors, *rods,* are responsive in dark conditions and do little, if any, color processing.

There are three types of cone cells in human eyes, and each type processes its own part of the visible spectrum (though there's a great deal of overlap). Figure 8-6 shows the color response of the three different cone types. There are short-wavelength (S, or blue) cones, medium-wavelength (M, or green) cones, and long-wavelength (L, or red) cones. (When you look at how each of these cones relates to the colors in the diagram, you can see that the color names are merely approximate.) S cones are most sensitive to violet light, M cones are most sensitive to green light, and L cones are most sensitive to yellow-green light.

FIGURE 8-6
The various cone types of the human retina handle their own respective portions of the visible spectrum, with some overlap.

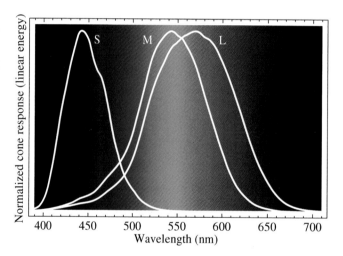

This combination of cone response allows us to distinguish about ten million colors, though some animals, such as birds, have extra receptors for ultraviolet light, which allows them to see a far wider range of colors. Pigeons, for example, have five cone types and can distinguish an estimated 10 billion colors. This acuity of vision allows some birds to distinguish ultraviolet patterns in each other's plumage (which are used in courtship), identify certain foods that reflect UV light, or track prey that leave trails of urine or feces that reflect UV light.

Trichromatic theory and color opponent theory

In humans, this arrangement of cones with three different response curves is compatible with *trichromatic color theory,* which postulates that our perception of color is made up of three different photoreceptor cells.

Scientists used to believe that trichromatic color theory was incompatible with the *color opponent theory,* which proposes that there are three opponent channels that make up our vision: red versus green, blue versus yellow, and black versus white. The color opponent theory states that humans can see only one of the colors from a channel at a time.

It turns out that both trichromatic theory and color opponent theory are consistent with what we know today about our perception of color. The trichromatic theory is, of course, compatible with the way that our cone cells work, with each cone type detecting its own range of colors. The color opponent theory is compatible with what we know about the next step in our visual system's processing of color.

After color is processed in the retina by the cone cells, the information is sent to ganglion cells (after making a quick stop at bipolar cells), which then process the information from the cones in an antagonistic manner. There are two types of ganglion cells that handle color information.

The first type of ganglion cell that processes color does so by processing the information from the L and M cones (or red and green) in an antagonistic manner. In other words, it can process one or the other – either the color processed is more green, or it's more red.

The other type processes information from the S cones in an antagonistic manner with a combined signal from the L and M cones, so the color processed is essentially either more blue or more yellow.

Of course, this is a simplistic explanation, but Figure 8-7, which is inspired by a similar explanation on the blog A Smart Bear (`http://blog.asmartbear.com`) summarizes what this system looks like.

Because of this opponency, humans are unable to see color combinations such as green-red or blue-yellow. Although you learned in grade school that yellow and blue make green, some researchers believe that there exists a color that would appear both yellow and blue at the same time. Also, while red and green paint mixed together will give you a brown color, and red and green light mix to make yellow, some researchers believe that there is yet another possible color sensation that appears both red and green at the same time.

FIGURE 8-7
The human
visual system
sends color
signals from
the three
photoreceptor
types to ganglion
cells that process
color in an
antagonistic
fashion. Red and
green and yellow
and blue are
pairings that
can't be sensed
simultaneously.

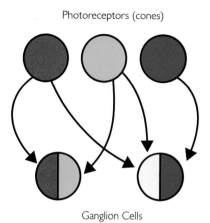

Researchers Hewitt Crane and Thomas Piantanida built a device that reportedly allowed participants to briefly experience the theoretical colors of green-red and yellow-blue, by mixing the stimulus from each eye. If you cross your eyes while looking at Figure 8-8 (so that the white squares match up), you may be able to experience a yellow-blue sensation similar to what their participants experienced.

FIGURE 8-8
If you cross
your eyes so the
white squares
match up, you
may be able to
experience the
theoretical color
of yellow-blue.

Mixing of dominant wavelengths and the color wheel

Notice that in the visible spectrum there is no purple (not to be confused with violet, which is at the beginning of the visible spectrum). There exists no pure "dominant wavelength" that is purple. Instead, our perception of purple comes from a combination of colors, such as red and blue, which – because of the way our ganglion cells process stimulus from our cones – actually can be perceived at the same time.

Whereas the visible spectrum exists linearly, the popular artist's color wheel is arranged in a circular fashion, with purple bridging the gap between the shortest (violet) and longest (red) wavelengths, as shown in Figure 8-9.

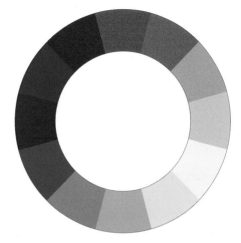

FIGURE 8-9
The popular and familiar artist's color wheel features purple, which exists as a combination of red and blue wavelengths of light.

This color wheel is very important in the color theory behind art and design, which I cover in Chapter 9.

Colorblindness

Some people have different forms of colorblindness that prevent them from distinguishing certain colors from one another. The most common type of colorblindness is red-green colorblindness, which occurs in as many as one in ten males. (Because the genes for cone cells are located in the X chromosome, which women have two of, colorblindness is rare in women.)

There are several different types of red-green colorblindness, but dichromacy is often the cause. Dichromacy simply means that one of the cone types (S, M, or L) is either not present or not functioning, so color is processed from only two sources. (Those with impaired S cones have difficulty distinguishing among yellows, greens, and blues.) Most mammals (other than humans) are naturally dichromatic. So, although your dog can distinguish some colors (mostly yellows, blues, and violets), a red ball lying in green grass may be hard for him to find.

Colorblindness is common enough that it's worth considering in your design, no matter who your audience is. Culturally, red and green are often used to

signal opposite information (stop and go on traffic lights, for example). Considering people who are colorblind doesn't mean that you should altogether avoid using these strongly culturally ingrained color meanings (which I'll talk about more in Chapter 9), but it's a good idea to use more than one type of graphic differentiation to communicate meaning. Many people who are colorblind are able to read traffic lights based upon the consistent positioning of the lights, but such lights are more effective when they're presented in different shapes as well. Notice how the icons in Figure 8-10 use shapes, in addition to colors, to communicate their messages.

FIGURE 8-10
These icons would be easy for a colorblind person to understand because — instead of just varying by color — they also vary by shape.

A number of tools are available to help with making designs compatible with the more common forms of colorblindness. For example, Photoshop has a colorblindness simulating proof setting. With a quick search, you can find tools that allow you to preview websites as they might appear to a colorblind person, or color palettes that simulate the colors visible to colorblind people.

The degree to which you make preparations for colorblindness depend upon the needs and use cases of your project. Checking for colorblindness incompatibility is especially useful when creating information graphics, as shown in Figure 8-11.

FIGURE 8-11
By testing designs for more common forms of colorblindness, you can keep your graphics communicating clearly.

Color Chart As Seen by Colorblind As Seen by Colorblind
 (Deuteranopia) After Adjustment

Defining Color

The pure colors that I've been talking about are called *hues,* but there are, of course, many more colors that are visible to humans. Color scientists have been trying for centuries to capture and define the estimated ten million colors humans can see.

One of the earlier attempts to represent all visible colors was the *Farbenkugel* (color sphere) developed by Philipp Otto Runge (see Figure 8-12).

Eventually, scientists learned that all visible colors don't fit into a perfect sphere. In fact, there is a great deal of subtlety within how well the average human can perceive the differences between various colors. With some hues, there is a wider range of values – from light to dark – that we can perceive. As the world started to standardize; the visible range of colors needed to be represented numerically. This would be useful in science – in the description of soil color, for example – but is absolutely critical when representing color in computing.

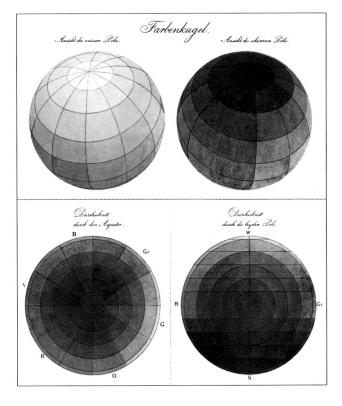

FIGURE 8-12
Philipp Otto Runge attempted to represent all visible colors in three dimensions with his *Farbenkugel.*

Munsell

The first really successful codification of visible colors was that of Albert H. Munsell's, known as the Munsell color system, which – as shown in Figure 8-13 – defined colors based upon their hue (is it red, blue, and so on?), value (how dark or light is it?), and chroma (color intensity – for example, pastels are low chroma). Because the Munsell system is based upon the sensitivity of human perception, it is not uniform in shape, like the *Farbenkugel* (see Figure 8-14). The Munsell system was developed in the early 1900s but is still in active use today.

FIGURE 8-13
The Munsell
color system
codes colors
according to
their hue, value,
and chroma.
*Jacob Rus (http://en.
wikipedia.org/wiki/
User:Jacobolus)*

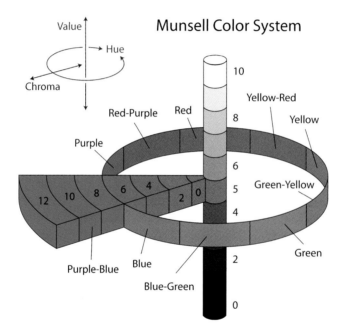

The success of the Munsell system lies in its aim at perceptual uniformity. The codifications of color within the Munsell system are based upon scientific measurement of human subjects' response to color. Because of this, two colors of different hues but identical values within the Munsell system will be equal in perceptual lightness to the human eye.

FIGURE 8-14
Because of the
perceptual
uniformity of the
Munsell system,
some colors have
wider ranges
of value and
chroma. The
color space itself
is not uniform
in shape.
*SharkD (http://
commons.wikimedia.
org/wiki/User.SharkD)*

Hue, saturation, and brightness

The HSB (sometimes called HSV) color model is conceptually similar to the Munsell color system in that it distorts the range of colors into a cylindrical shape upon three axes (hue, saturation, and brightness), but HSB breaks down these values into equal ranges. Where the Munsell system has value ranges that vary (for example, yellow has a higher potential variation for chroma, or intensity, than do light purples), the HSB model has a potential range of saturation (similar to chroma) that is the same no matter what the hue.

Because of this, the HSB model distorts the visible range of colors. So, if you're picking a color on an HSB picker (like the one shown in Figure 8-15), and you start with a bright red and slide the Saturation slider all of the way to 0, you'll have pure white. According to the HSB color model, white and bright red have the same Brightness, even though the actual perceptual lightness of white is higher than that of red.

This is a problem when the HSB color model is used to create graphics where data is represented by colors, but, as I'll explain in a bit, HSB (and similar color models) still remains one of the easiest available color models for picking a color that you imagine in your head.

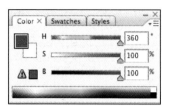
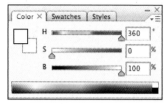

Lab color model

The most popular color space – which is based upon the Munsell color system –
is the CIELAB color model, which is represented in graphics programs, such as
Photoshop, as "Lab" (*L* stands for lightness, and *a* and *b* stand for their own
color-opponent pairs). When you adjust the *a* slider on a Lab color picker, you
essentially choose whether the color is more red or more green. When you adjust
the *b* slider, you choose whether the color is more blue or more yellow. Since
the *L* slider stays in the same place, the overall lightness of the color stays the
same.

While being able to maintain a constant perceptual lightness is sometimes
handy, color pickers available for models such as Lab can make it difficult to
choose the color you're looking for. In Figure 8-16, I'm starting with all three
sliders on their lowest possible settings, which gives me a rich blue color. If I
want to get a violet color, I have to slide the *a* slider all the way to its highest
setting (meaning, essentially, more red). This does change the color to be
slightly closer to violet, but I can now see that if I slide the *L* slider to the right
a bit, I can get the color I was looking for.

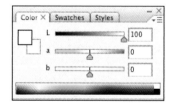
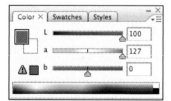

With an HSB color picker (see Figure 8-17), getting the color I'm looking for is
much more intuitive. I can first slide the *H* slider until it's on violet, and then
adjust the *S* and *B* sliders until I find the color I want. By changing modes to a
web color picker, I can get the hexadecimal value. (Choosing a color from a
web color picker is at least as unintuitive as choosing a color from a Lab picker,
by the way.)

FIGURE 8-17
Pinpointing a color on HSB color sliders is very intuitive. You can select the desired hue, and then adjust accordingly.

Color Models and Data-Driven Graphics

The distortion present in a color model can be especially critical when creating data-driven graphics programmatically. Creating colors programmatically from the HSB color space, for example, can cause the appearance of a graphic to miscommunicate the meaning of the data.

Color and qualitative data

When creating pie charts or other graphs that differentiate data qualitatively (meaning, none of the categories is considered better or worse than the others), a common practice is to simply choose different colors for the different categories.

But doing so with most color pickers (such as HSB) usually leads to colors that vary in perceptual lightness and, thus, imply that one category is superior to another. As shown in Figure 8-18, colors picked from the Lab space to have an identical lightness have perceptual weights that are more similar to one another, so no particular category looks more important than the others.

Colors Picked from HSB Chooser Colors Picked from Lab Chooser

FIGURE 8-18
Picking colors from an HSB chart will result in color choices that differ in perceptual lightness and may be inappropriate for displaying qualitative data.

Choosing Lab colors this way can be difficult when using a slider-based color chooser, as described earlier, but some Lab color choosers, such as the one in Adobe Photoshop (see Figure 8-19), allow you to choose a lightness and then select from colors that are all that same lightness.

FIGURE 8-19
The Adobe Photoshop Lab color chooser allows you to choose colors from a fixed lightness.

Color and quantitative data

When choosing a color palette to express quantitative data, you need to understand how different color shifts – within various color models – differ perceptually. The data representations of color that are present in popular color spaces don't always translate to equivalent perceptual differences in the colors produced.

Take, for example, the map of population density by county in Sweden, shown in Figure 8-20. The colors on this map have been chosen by programmatically choosing differing hues from the HSL color palette (similar to HSB), while keeping the Saturation and Lightness values constant.

This is a very common mistake in creating data-driven graphics. The resulting graphic classifies data low to high by shifting in hue from yellow through green to red. The color palette is so bold that it's hard to look at it for very long for careful study. Additionally, the progression from low population density to high population density isn't intuitive in the color palette. Red is the highest-density class, but magenta is the next highest. The blue class – third in ranking – appears to have more visual weight than the magenta. In fact, if you translate the colors from HSL to Lab, you find that the actual lightnesses of these colors

are very inconsistent. Even though the HSL color model supposedly gives colors a lightness value, there is distortion in the space, relative to Lab, which is more representative of actual human perception.

Swedish Population Density

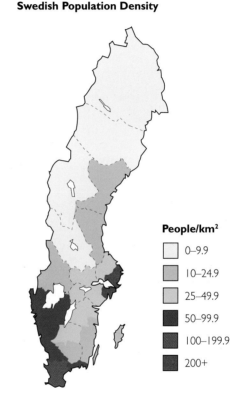

FIGURE 8-20
Program-
matically
choosing colors
by hue in the
HSL model
results in a color
palette that is
perceptually
inconsistent with
the data.

People/km²

☐	0–9.9
☐	10–24.9
☐	25–49.9
☐	50–99.9
☐	100–199.9
☐	200+

Also misleading is the monochromatic color palette in Figure 8-21, which was created by proportionally changing the Lightness value within the HSL color space. This method has at least yielded a color palette that progresses from light to dark as the population density increases, but the last two classes of density are nearly indistinguishable from one another. Though they are represented as having different lightnesses in the HSL color space, they appear almost identical. This is because the Lightness value in HSL – like the Brightness value in HSB – isn't consistent with actual human perception.

FIGURE 8-21
Program-
matically
choosing colors
by shifting
lightness in the
HSL model
results in a
perceptually
inconsistent
color palette. The
two highest
classifications of
density are nearly
indistinguishable
from one
another.

Swedish Population Density

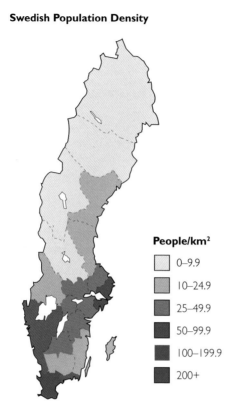

People/km²

0–9.9

10–24.9

25–49.9

50–99.9

100–199.9

200+

The map in Figure 8-22 represents population density with a color palette that is based upon perceptual differences. Each classification of population density is easily distinguishable from the others. Additionally, the more dense areas appear, appropriately, darker, while the less dense areas are lighter.

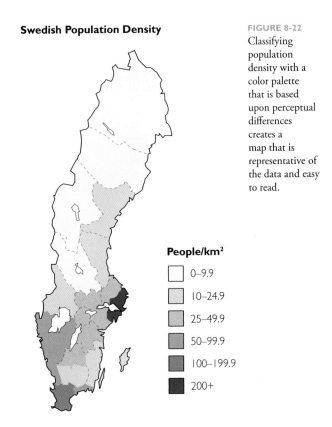

Swedish Population Density

People/km²

▢ 0–9.9

▢ 10–24.9

▢ 25–49.9

▢ 50–99.9

▢ 100–199.9

▢ 200+

FIGURE 8-22
Classifying
population
density with a
color palette
that is based
upon perceptual
differences
creates a
map that is
representative of
the data and easy
to read.

Programmatically creating color palettes that are commensurate with human
perception can be difficult, but Colorbrewer (www.colorbrewer2.org; see
Figure 8-23), created by Cynthia Brewer and Mark Harrower of Pennsylvania
State University, makes it easy to create color palettes that are perceptually
distinct. There are even options to ensure that the color palette you create is
compatible with colorblindness, is print friendly, and/or will still be legible
after photocopying.

FIGURE 8-23
Colorbrewer
makes it easy
to create
perceptually
distinct color
palettes for use
in data-driven
graphics.
*Reproduced by
permission of Cynthia
Brewer, Mark
Harrower, and The
Pennsylvania State
University*

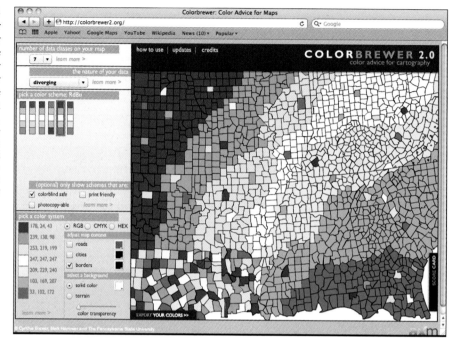

Sequential versus diverging color palettes

The color palette used in Figure 8-22 is created with Colorbrewer and is a sequential color palette, meaning that it represents data that progresses on a continuum from low to high. Defining data in this way is appropriate when communicating something as benign as population density. But sometimes you want to make apparent the very lowest and very highest data points in your graphic, or illustrate a midpoint in your data. In these cases, it's best to use a diverging color palette, which usually will place two concentrated hues, each at its own extreme ends of the data, and fade those hues into a neutral color for data that is around the data point that is neutral (such as the median).

Figure 8-24 illustrates a diverging color scheme – created using Colorbrewer – communicating data on incidence of noncommunicable diseases by country. You can clearly see, thanks to this color palette, that countries such as Japan and France have a very low incidence of noncommunicable diseases, while Iraq and Afghanistan have a very high incidence.

Noncommunicable diseases - 2004

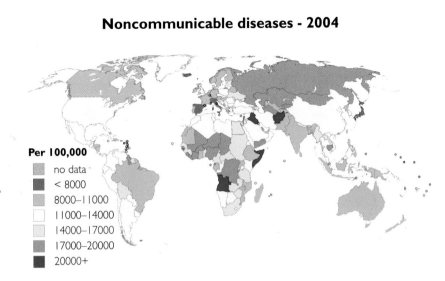

Per 100,000

- no data
- < 8000
- 8000–11000
- 11000–14000
- 14000–17000
- 17000–20000
- 20000+

Thinking in Hexadecimal Color: Understanding the Colors of the Web

Anyone who has ever coded a site with CSS knows how confusing the system of hexadecimal colors is. Only those who are truly experienced in it know that red is #FF0000 and yellow is #FFFF00. Even more rare are those who know that #7C7970 is a warm orangish-gray. Most of us have to resort to using a visual color picker to find the colors that we really want.

There's little point in trying to memorize all the hexadecimal codes. With a little practice, most of us can learn that #888888 is a decent neutral gray for really light text, but what if the color you just typed in is slightly off what you were looking for? If you knew how hexadecimal colors really worked, you could mentally navigate the color space, knowing exactly what changes to make to a color to make it a little more red, or add a tinge of yellow to that neutral gray. This type of lucidity can be achieved if you understand the hexadecimal color space. Knowing hexadecimal colors will save you development time and impress the hell out of your friends.

Understanding RGB

To really understand how the hexadecimal representation of the RGB color model works, you first have to understand how the RGB color model works. Computer screens work off of an RGB color model. RGB stands for red, green, and blue. If you've ever looked closely at an LCD screen, you've probably noticed that each pixel is made up of a red, green, and blue stripe.

In Figure 8-25, you can see up close how these pixels work. To make a solid red, green, or blue color, the respective stripe is turned all the way on within the pixel. To make a white color, all three stripes are turned on. Other colors are some combination of intensity of each stripe.

FIGURE 8-25
Red, green, and blue sub-pixels are turned on and off in different combinations to achieve the desired color for each pixel.
Sei (http://commons. wikimedia.org/wiki/ User:Sei)

Computer and television displays essentially work with what's called an additive color model, taking advantage of the way projected lights mix. Technically, they aren't using additive color (since the color stripes are merely adjacent to one another), but since the stripes within the pixels (called *sub-pixels*) are so close together, we perceive them as blending together.

Figure 8-26 demonstrates how red, green, and blue light mix together. As you can see, red and green light mixed together make yellow; red and blue make magenta; and blue and green make cyan. All three together make white. If you shined three spotlights – red, green, and blue – against a white wall, they would look just as they do in this image.

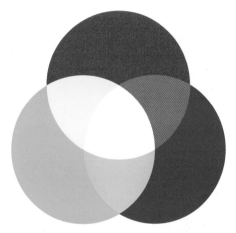

FIGURE 8-26
In an additive color model, red, green, and blue light mix together to make white.

When I was growing up, the rich family in my neighborhood had a home theater system. It was the talk of the neighborhood, and one time they even invited me over to watch a movie on it. I remember being fascinated by the fact that it was essentially just three lights – red, green, and blue – that were cast onto the theater screen. I couldn't help but try blocking one light at a time. If I blocked the red light, the image came out a little blue. If I blocked the green light, the image came out a little pink. For some reason, I was never invited back to watch a movie. Oh, well – their house always smelled like fish stew anyway.

Obviously, my neighbor's home theater system was working with the additive RGB color model that I just described. It cast three images on the screen, and they mixed together to make a full-color image. Blocking any one of the colors would result in an image that was tinted a combination of the other two colors. So, when I blocked red, the other two colors were green and blue, which you can see in Figure 8-26, make cyan. When I blocked the green light, the other two colors were blue and red, which mix together to make magenta.

You can see this in action by taking any RGB image (pretty much any JPG from the web) into Photoshop and turning off individual channels in the Channels palette. Figure 8-27 shows what an image looks like in full RGB (top left), then (going clockwise) with the Red, Blue, and Green channels turned off.

How hexadecimal represents RGB

This interaction of light is the foundation of the hexadecimal color notation that powers the web. Hexadecimal color codes map their place within the RGB color model, which can be thought of as a cube, like in Figure 8-28.

Each axis of this cube represents a color in the RGB color model. The corner you see in the center represents a mixing of 100 percent of all three colors: white. The corner you don't see represents no color at all: black. The bottom-left corner represents 100 percent red, 0 percent blue, and 0 percent green – so, pure red. Blue light and green light make yellow light, which represents the top-left corner of the cube image. So, that corner is 100 percent red, 0 percent blue, and 100 percent green.

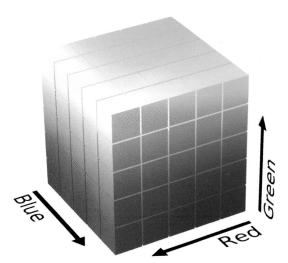

FIGURE 8-28
The hexadecimal color model can be represented by a cube, with each axis representing an RGB channel.
SharkD (http:// commons.wikimedia. org/wiki/User:SharkD)

Hexadecimal color codes are representations of these values (from 0 to 255) in hexadecimal notation. So, red is #FF0000, with "FF" representing a value of 255 for the Red channel.

The first digit of a hexadecimal color code represents a value from 0 through 15. So, 0 through 9 represent themselves, but then A through F represent 10 through 15. Because there are two characters per channel, and each character represents one of 16 values, there are 256 possible values, or, 0 through 255. "00" represents 0, and "FF" represents 255.

Mentally navigating the hexadecimal "cube"

Figure 8-29 shows the 36 colors from the Red "layer" of a 256-color RGB cube. #FF0000 represents red (255 Red, 0 Blue, 0 Green). #FF00FF (on the bottom right) represents magenta (255 Red, 0 Blue, 255 Green). The numbers on the top and left of the grid show how the hexadecimal system represents increases in blue and green light, respectively. By adding 60 percent (153, or "99") to the Green channel, we get #FF9900, or an orangish-yellow.

To know how to mentally navigate through the hexadecimal color cube in a 256-color palette, you need to remember only this progression: 0, 3, 6, 9, C, F. When writing CSS, you can even shorten your codes to three characters. So, #F00 is red, #F0F is magenta, and #F90 is orangish-yellow.

FIGURE 8-29
The Red "layer"
from a 256-color
RGB color
model.

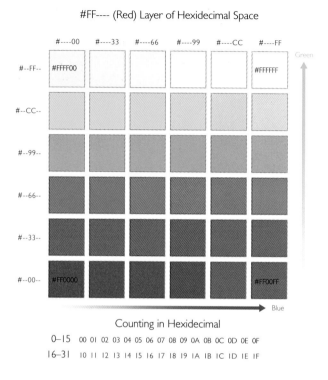

This knowledge can come in handy when coding. Let's say you want to soften up the color palette of some typography, as demonstrated in Figure 8-30. You start off with the type on the left. It's just black type (or #000), but it's a little dark and you want it to be more understated. So, you change the color of the header to a dark neutral gray (#333) and you change the subhead to a lighter neutral gray (#999).

FIGURE 8-30
Making
hexadecimal
changes to change
gray values is
relatively simple.

#000 **You're the man**
#000 now dog!

#333 **You're the man**
#999 now dog!

You know to do this because you know that equal parts of R, G, and B take you from pure white, along the scale of gray, to pure black. Knowing that #000 is black and #FFF is white, you can easily adjust to make the gray darker or lighter. You don't even have to remember 3, 6, 9, and so on. You know that #AAA is going to be slightly lighter than #999.

But let's say you want the headline to be a little reddish. You bump up the Red channel all the way from "33" to "99," changing #333 to #933 (Figure 8-31, top). But that's a little too red for you. Because you understand the way that red, green, and blue light mix, you know that if you bump up the Green channel a bit, it will cancel out some of the red. So, you change the Green channel from "33" to "66," resulting in #963 (Figure 8-31, middle).

#000 **You're the man**

#000 now dog!

#933 **You're the man**

now dog!

#963 **You're the man**

now dog!

#B26666 **You're the man**

now dog!

FIGURE 8-31
By understanding the hexadecimal color cube, you can make more subtle and precise adjustments to colors.

It turns out that #963 is still a bit too orange for you. You turn down the Green channel a little, from "66" to "55," to bring back some of the Red, but #953 turns out to be darker than what you're looking for. So, you bump up the Green and Blue channels (the Green channel from "55" to "66," and the Blue channel from "33" to "66") together, so now you're at #966. It's close, but you still want some more Red. But #A66 turns out to be too neutral, and #B66 turns out to be too red.

This is where real precision comes into play. If "AA" on the Red channel isn't enough Red, and "BB" is too much, you have to find a value somewhere in

between. Figure 8-32 shows a sampling of how hexadecimal values progress. From this, you can tell that "AB" is the next step up in value from "AA," and after you count up to "AF," the next step in the progression will be "B0," then "B1," then "B2," which happens to be almost perfectly between "AA" and "BB."

FIGURE 8-32
By understanding
how hexadecimal
color codes
progress, you can
more easily make
intermediate
adjustments
between colors in
the 256-color
palette.

Counting in Hexidecimal

0–15	00 01 02 03 04 05 06 07 08 09 0A 0B 0C 0D 0E 0F
16–31	10 11 12 13 14 15 16 17 18 19 1A 1B 1C 1D 1E 1F

So, you finally settle in on #B26666 (Figure 8-31, bottom), which you now have to express in six characters. It's a pinkish-gray color not unlike Silly Putty.

The future: HSL

With enough practice – maybe referencing the above to cheat once in a while – you can really be adept at adjusting colors right in your code. But, admittedly, this feat is more like a parlor trick that you can aspire to. Navigating the RGB color model just isn't intuitive, and if you can handle it, you might as well use the rgb() method of defining colors (red equals rgb(255, 0, 0)).

Just as the HSB color model is more intuitive when using a color picker, CSS3 promises to bring a similarly intuitive model to designing for the web: HSL. HSB and HSL are similar models: *H* and *S* in HSL stand for *Hue* and *Saturation* just as they do in HSB, but the *L* stands for *Lightness* rather than *Brightness.* In HSL, any color with 100 percent Lightness will simply be white, and 50 percent is designated for pure hues. In HSB, however, 100 percent Brightness produces a pure hue, while Saturation must be set at 0 percent to produce a white color.

To choose an HSL Hue in CSS, you specify a value between 0 and 360. Hues are implicitly arranged on a circle (see Figure 8-33). Red, green, and blue are equidistant in this circle. So, a value of 120 (which represents 120 degrees) creates a blue Hue, while a value of 240 results in green.

The other two values, Saturation and Lightness, are represented by percentages: 100 percent Saturation and 50 percent Lightness together specify the pure form of the Hue. Figure 8-34 shows a sampling of HSL colors and their corresponding values.

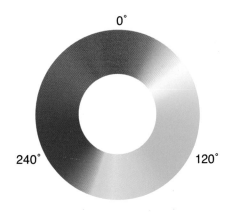

FIGURE 8-33
Hues in the HSL color model are arranged in a circle. The Hue value you choose corresponds to the angle at which the chosen Hue is positioned on the circle.

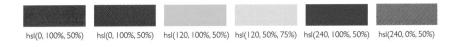

hsl(0, 100%, 50%) hsl(0, 100%, 50%) hsl(120, 100%, 50%) hsl(120, 50%, 75%) hsl(240, 100%, 50%) hsl(240, 0%, 50%)

FIGURE 8-34
A sampling of colors and their HSL properties.

Because hues are arranged in a logical manner, you can learn relatively quickly how to choose the color you're looking for with this model. Additionally, it's easier to programmatically create gradients and data-driven visuals with this color model.

The perceptual lightness of graphics in the latter case will not be entirely accurate, because the Lightness property of HSL is not as accurate as the Lightness property that the Lab color model uses. **REMEMBER**

Unfortunately, HSL color is not supported in versions of Internet Explorer earlier than IE9, so it will be a while before it can feasibly be used for a commercial application.

Color Models in Action: Why Your Business Card Doesn't (and Never Will) Match Your Website

Although Lab, HSB, and HSL color models have their own advantages and disadvantages for representing colors with numbers and choosing desired colors, the colors your final product conveys depend upon the limitations of your

output technology – whether that is a computer screen, or a printer. By understanding how to manage these limitations, you can ensure that your vision for your product is matched as closely as possible.

Every professional cross-media designer has dealt with the frustration of having a client who insists that the color on his business card match the color on his website. Although there are some great technologies (which I'll talk about in a bit) that make colors easier to match between print and screen, really getting a perfect match is simply impossible. Since you'll hopefully be your own client, I'll try to save you the frustration of figuring this out the hard way.

Let's take for example the theoretical website and business card design of Bay Bridge Painters in Figure 8-35. The blue on the business card isn't nearly as vibrant as the blue on the website. This is because of the color limitations of the screen versus the color limitations of printing.

FIGURE 8-35
The blue on the Bay Bridge Painters business card and website don't match because of the differences in color capabilities of printed material versus computer screens.

RGB displays versus CMYK color printing

Computer screens work off an RGB color model. So, the color on the Bay Bridge Painters' website is created by emissions of red, green, and blue light that optically mix together. But the business card doesn't emit light – it reflects it through the ink on the business card, off the paper, and back to your eyes.

The business card is printed in CMYK, meaning that tiny dots of cyan, magenta, yellow, and black ink are arranged to create the desired color. Rather than being

an additive color model, CMYK is a subtractive color model. Instead of adding colors together to make white, like an additive color model, subtractive color models begin with presumably white light (the light source in your room) and subtract from it by reflecting that white light through pigments.

Figure 8-36 shows how CMYK inks mix in a subtractive color model. Did you notice that combinations of any two colors of light in the RGB model created the same colors of ink used in the CMYK model? Well, any two inks (other than black) in the CMYK model essentially mix together to create red, green, or blue. When cyan, magenta, and yellow inks are mixed together, it blocks almost all the light and creates a color very close to black. Black ink is added to the mixture to save ink, add more depth, or render type more crisply.

FIGURE 8-36
How cyan, magenta, and yellow ink – part of the subtractive CMYK color model – mix.

Clearly there is some overlap between the color capabilities of the RGB and CMYK color models, but there are some incompatibilities between the two models as well. Both the RGB and CMYK color models have their own unique limitations in what colors they can reproduce. Additionally, there are bounds to the colors that can be perceived by the human visual system. Understanding the limitations of human vision, within the context of limitations of a particular color model, is key to working with color accurately.

Color gamuts

The boundaries of the color capabilities of a particular color capture or color reproduction system – whether it is that of human vision, a computer monitor,

or a printer – is known as a *gamut.* The colors present in the gamut of one
system aren't always present within another, so these inconsistencies are
compensated for through the process of color management.

To keep color representations consistent as they move from one gamut to
another, gamuts are described by *ICC profiles.* ICC profiles (built on standards
created by the International Color Consortium) hold data that describes how
the limitations of a color space relate to a profile connection space (PCS).
Usually, the PCS that relates to an ICC profile is the Lab color space that I
described earlier.

Figure 8-37 shows the gamut for a few popular color spaces. The RGB color model
(represented by the Adobe RGB and sRGB color spaces) is generally for digital
cameras and monitors, and the CMYK color model is for printers. U.S Web
Coated (SWOP) v2 is simply a color space, representing the CMYK color model,
which is popular in the print industry. As you can see, the color capabilities of the
RGB-based color spaces vary greatly from that of CMYK, and neither of them
really does justice to all the colors that humans can actually distinguish. Of course,
you can't actually see in this image the colors that you're missing out on – because
this image is printed in a book using a CMYK printing process.

Since the ICC profiles that describe these color spaces relate to a profile
connection space (such as Lab), when converting from one color space to
another, there is a clear mapping of what color is intended.

Notice, for example, how far into the blues the Adobe RGB color gamut goes
compared to the CMYK gamut. If you're converting an Adobe RGB image to
CMYK, and the image includes a blue color that lies within this area, that color
has to somehow be translated into the closest perceptual blue that the CMYK
color space can reproduce.

To make this conversion, the color represented in the Adobe RGB tagged
image has to reference an intermediary color space (or PCS), such as Lab, to
determine which color within the CMYK color space will appear most like the
intended blue. This conversion process will take advantage of the phenomenon
of metamerism that I talked about earlier. The resulting color might not
spectrally *be* the same as the source color, but it may *appear* the same.

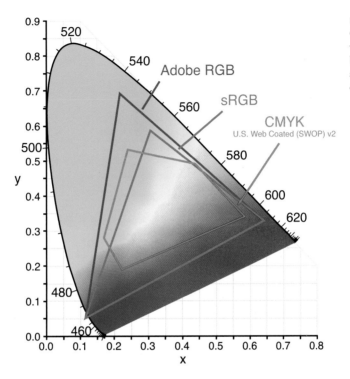

FIGURE 8-37
Color gamuts
vary widely
between color
spaces and
devices.

Working across media and managing color

So, when preparing the graphics for Bay Bridge Painters, the designer – we'll call her Julie – initially designed the logo in Adobe Illustrator, with an sRGB profile attached. When it came time to design the business card, Julie had to translate the color to one that would work well in the CMYK space. As pictured in Figure 8-38, Adobe Illustrator was giving her an "out of gamut" warning on the color picker to warn her that the color she had picked for the logo wouldn't translate well to CMYK.

This was okay since the blue looked so great on-screen. When Julie converted the Illustrator file to the U.S. Web Coated (SWOP) v2 CMYK color space, Illustrator converted the blue to the closest blue that CMYK could reproduce. The blue didn't look the same, but based on her knowledge of color gamuts, Julie knew this was the best she could do.

Adobe RGB versus sRGB

Looking at the wide color gamut of Adobe RGB versus the color gamut of sRGB, you may be led to believe that Julie should have used the Adobe RGB profile instead. But, although Adobe RGB actually *represents* a wider array of colors, it still has the same technical limitations for the colors actually being displayed as sRGB does.

Most important, to accurately portray the colors in an image that is tagged with a particular profile, an image-viewing application or web browser has to be equipped with color management capabilities that allow it to interpret the ICC profile and translate it to display colors accurately.

What will happen if you link an ICC profile to an image you use on the web? If you link the Adobe RGB profile to an image, browsers without color management (Chrome and anything prior to Internet Explorer 9) will interpret the colors within these images as if they were sRGB images, and the colors will appear flat. If you link an image with an ICC profile of any kind, and place that graphic on a background that is coded as the same color in CSS, the colors from the image won't match the colors from the background on color-managed browsers on Mac OS (Firefox and Safari, but not Chrome). Instead of interpreting the untagged CSS color as sRGB (which would make sense), Mac OS treats the image as if it were tagged with the profile that the monitor of the computer is assigned to.

Because support for color management on the web is so unreliable, you can get the most predictable results by working with your images in the sRGB space,

but saving them without an ICC profile attached. Fortunately, the default Color Settings setup in Adobe products such as Photoshop is to handle RGB files in the sRGB color space, while the Save for Web option strips the ICC profile from images by default.

"Proofing" and previewing color shifts

Julie was using the proper color workflow, but the owner of Bay Bridge Painters – Aaron – wanted to have a better idea of what the business card was going to look like printed out. Fortunately, Julie was used to this, so she had already created an ICC profile for her monitor using a device called a spectrophotometer. The operating system on Julie's computer used this ICC profile to adjust the colors of the monitor to look as much like the colors in the objective, standardized, profile connection space (Lab) that was being used to translate from one profile to another.

But Bay Printing's printer has its own characteristics, as does the paper stock that Julie chose for printing Aaron's business cards. So, Bay Printing ran some test prints on the paper and created yet another ICC profile. Julie used the Proof Setup in Adobe Illustrator to simulate, on-screen, what the business card would look like once Bay Printing produced the cards.

So, Julie translated the RGB logo to CMYK and then simulated the printed colors using ICC profiles for both her monitor and Bay Printing's printer.

Mac OS and color management on the web

By saving your web graphics without attaching an ICC profile, you're preventing Mac OS from mismatching colors from your image with colors from CSS. This does mean that all your colors – within the image and within CSS – are slightly misinterpreted, but at least they're consistent, which is critical when you're working with an image that has to match a background color.

There's no harm in saving a stand-alone image with an sRGB ICC profile attached. Color-managed browsers will correctly interpret the ICC profile, while most other browsers will simply assume that the image is sRGB anyway. Note that attaching an ICC profile will add about 4k to the size of each graphics file you save this way. To save an image with an ICC profile attached, check the appropriate box in Adobe Photoshop's Save for Web.

Thanks to all this color management, Aaron wasn't surprised that the blue didn't match perfectly. As you can imagine, even with this careful proofing, the proof of the business card didn't look exactly the same on-screen as it did printed out – but at least it was close.

Printing with spot colors

What I just described is a hypothetical scenario, but if Aaron were really doing a large run of business cards, Bay Printing probably would have used spot colors in printing. These are inks that are custom-mixed to match a particular color. PANTONE (www.pantone.com) is the most popular provider of printed swatch books (see Figure 8-39) and ink recipes that designers and printers use to better predict how colors will turn out. They even create swatch books that show the best hexadecimal match to their printed inks.

When printing with spot colors such as PANTONE, a pure form of the desired colored ink is used, rather than a mixture of CMYK dots. The color is more predictable and comes out smoothly. Spot colors are used to print flat colors or line-screened tones of that specific color, and their use is restricted to large industrial offset printers. If you're ordering from most quick-run online printers, you'll get to print only in CMYK.

FIGURE 8-39
PANTONE swatch books allow designers to choose spot colors for printed materials – and sometimes make recommendations for the closest color match for web use.
Rocco Lucia (http:// www.flickr.com/ people/foxtwo/)

Knowledge Applied

No matter what your tastes when it comes to color, in order to use color successfully, you need to understand what you're working with. By understanding the capabilities and limitations of color, the systems we use to define color, and the final display media of color, you can ensure that the colors you intend to communicate are the colors that your audience ultimately sees.

> Understand how red, green, and blue light interact. Try a few CSS experiments with hexadecimal code, changing the values in individual channels to see how the colors change. Next time you're changing a color in CSS code, try mentally navigating the hexadecimal color space to make your adjustments.

> When working with graphics in which color differences are important to your message, try soft-proofing your colors with Adobe Photoshop or another tool, to ensure that the colors are distinguishable to people with the more common types of colorblindness.

> If you're creating data-driven graphics, use color palettes that contrast in a way that is appropriate to the nature of the data. Use colors with a consistent perceptual lightness for qualitative data sets, and color palettes with appropriately perceptually contrasting lightness for quantitative data sets.

> When working cross-media, remember that the CMYK and RGB color models have different color capabilities, or gamuts. When working with an RGB image, make sure to work within the sRGB color space, so the image's colors can be interpreted across a wide variety of devices. Don't attach an ICC profile to web graphics that you need to match with CSS colors.

Color Theory

WE KNOW A great deal about the science of color, and yet color – and the usage of it – is full of subjectivity. Although we have some psychological reactions to color that stem from prehistoric life, colors carry meanings that differ across cultures and from person to person. Additionally, color is contextual: A color that may connote positive feelings in one context may have the opposite effect in another context. Still, in pursuit of beautiful aesthetics, a great deal of thought and practice has been applied toward understanding and bringing structure to how colors interact to establish a particular mood or feeling. By understanding how colors interact, and what factors are at play in giving color meaning, you can begin to use color well.

To begin to understand color, you need to understand how humans have been conditioned to react over time to certain colors. Additionally, there are some physiological reasons that may contribute to how colors impact us. These factors have worked together throughout the establishment of various cultures to attach particular meanings to colors over time, causing color associations to differ across audiences. On the web, however, some conventional uses of color have begun to emerge that sometimes cross cultural boundaries. Aside from more explicit color communication, some formulaic color relationships have been studied by artists and theorists over time that contribute to implicitly creating a mood or feeling in a design.

In this chapter, I'll explain how you can use color to create beautiful design, while communicating clearly to your audience. I'll introduce you to some theories about how color signals that helped early humans survive have lived on to affect us psychologically and have become ingrained in our cultures. I'll outline some of the cultural factors to consider when designing for an audience from an unfamiliar culture, and explain some color usages that have become conventional in web design. Finally, I'll explain some common color relationships that can help you choose colors that go together well.

Like most things in design, there is no one right way to use color. But armed with this thought framework through which you can examine color in your own design work and the work of others, you can begin to use color with purpose, instead of just guessing or hoping to one day receive a divine gift of impeccable color intuition.

Color Response throughout Human History

Color meanings vary across cultures and from person to person. Most people's associations with particular colors have been formed over time. When we're exposed to particular colors in certain contexts, we tend to associate colors with those things. But early in human history, reacting to a color correctly may have helped our ancestors live on. Those who reacted to colors wisely were able to pass on their genes, and it's likely that some of those color associations are deeply ingrained in our physiological and psychological responses to color.

Color associations may have helped us find food that was edible – many edible berries are red, and green foliage may have helped attract us to lush lands. The blue reflection of the sky off of water has likely become soothing to us because where there is water, there is likely to be food. The sun and fire are still associated with the colors yellow and orange and may have positive connotations in certain contexts because of this.

But, some of these same colors may have been associated with danger in certain contexts. Red is the color of blood, and depending on whose blood it is, it would have different meanings in a hunt or battle with an opponent. Very little edible food is blue, but mold is often blue, so blue may be associated with spoiled food. The colors yellow and orange definitely have an alarming effect when seen on a snake or even an otherwise innocent-looking (but probably poisonous) frog. Dark colors may appear menacing because our ancestors learned to be wary of predators that roam at night or to run for cover when a thunderstorm rolled in.

Color Response and Human Biology

There are some potential biological reasons for the way that we react to colors. It's generally believed that we react in a relaxed manner to colors on the "cool" end of the visible spectrum (violet, blue, and green), while "warm" colors (yellow, orange, and red) have an excitatory effect.

As covered in Chapter 8, human color vision works by the stimulation of cones within our eyes. The short-wavelength cones that detect the cool portions of the visible spectrum are outnumbered by both the middle- and long-wavelength cones, which overlap in detecting the warmer portions of the visible spectrum. Additionally, short-wavelength cones are completely absent from the *fovea*, which is the center of our visual focus, where we can best see detail.

So, it's quite possible that the supposed calming effect of blue and other "cool" colors is due, in part, to the fact that they simply stimulate our visual system less. Although a great deal of scientific research has been done to try to find a physiological response to blue, results have been mixed. As I'll talk about next, convincing evidence shows that red can have some powerful effects on our bodies.

The Power of Red: Why You Don't Stand a Chance in the "Target Challenge"

The American retailer Target is known as one of the most brand-savvy companies in the world. In addition to creating well-designed but affordable products, people have come to know a trip to Target as a test of their wills – every time they go to Target, they go in intending to buy a few items but somehow end up buying much more. Target is so skilled at getting consumers to buy, that it's a running joke, as you can see in Figure 9-1. Supposedly, it's impossible to set foot into a Target store without spending at least $100.

FIGURE 9-1
Target is so skilled at getting you to spend, it's a running joke.
Reproduced by permission of Elaine Ellis

The typical trip to Target often goes a little like this: You go to Target thinking that you need to get only a few basics, like shampoo, toothpaste, and toilet paper. You figure you'll probably spend about $30. While at Target, you see something that looks cool, whether it's a new soap dispenser for your bathroom, a picture frame, some candles, or a big bucket of trail mix. You notice that the price on the item looks reasonable. "Oh, it's only $5.99," you think to yourself, and you toss it into your cart. This process repeats with several more items. You check out at the register, only to be horrified that it rings up to about $140. "How does that add up?" you think to yourself. You've gone this far, so you go ahead and buy everything, even though you're spending more than you planned.

There are plenty of ways that Target manages to get you to behave in this way time and time again. They involve complex research on store layouts, product offerings, and pricing psychology. But a powerful key may be as simple as the color of Target's branding: red. Research has shown that red, in certain contexts, can reduce your ability to reason and make wise decisions – and every Target store is bleeding from floor to ceiling in red.

The effect of red on your brain

The power of red was exposed by researchers Andrew J. Elliot and Markus A. Maier, of the University of Rochester and University of Munich, respectively. They found that exposure to red can overload your brain's executive functioning center, making it difficult for you to rationalize. The most amazing part of this is that red has this effect without your having any clue that it's happening.

Elliot and Maier conducted a series of experiments in which participants were given various cognitive skills tests – such as an anagram puzzle (rearranging letters to form words) or an IQ test – with the only difference among participants being the colors the tests were presented in: red, green, or gray.

In one study, participants were told that they were going to take an IQ test. Some participants were presented with test booklets that had red covers, while others were presented with test booklets that had green or gray covers.

Then, EEG readings were taken of the participants' brain activity. The participants who were presented with tests with red covers showed more activity in the prefrontal cortexes of their brains than did participants who were presented with green or gray covers.

The prefrontal cortex and rational thought

The prefrontal cortex is considered the portion of the brain responsible for executive functioning. So, just by being presented with red test covers, participants suddenly had fewer cognitive resources available to differentiate between good and bad, to work toward defined goals, to delay immediate gratification in return for longer-term rewards, or to exhibit social control and suppress urges.

The prefrontal cortex is believed to be the part of the brain that gives us sentience and makes us human. Over the last 5 million years of human

evolution, the prefrontal cortex has grown at double the rate of the rest of the human brain. Reduced volume of the prefrontal cortex, and reduced nerve linkages within the prefrontal cortex have been linked to attention deficit hyperactivity disorder (ADHD), criminal behavior, and drug addiction. So, by exposing participants to red test covers, Elliot and Maier were effectively giving them ADHD and turning them into animals.

This reduced executive functioning was apparent in the behavior and performance of the participants. The participants exhibited avoidance-motivation-related behavior. When given the choice of what test questions to take, the group exposed to the red test chose the test questions that were rated easier. Participants showed avoidance with their body language: Sensors attached to the participants revealed that those who were presented with a red-covered test on a table actually moved their bodies farther away from the test than the other participants did. Finally, the participants who took IQ tests with red covers actually scored lower on the tests than participants who were presented with tests with green or gray covers.

Apparently, just by mere exposure to the color red, participants were fear-struck. Their prefrontal cortexes were overloaded, and, as a result, they were unable to perform the complex tasks of an IQ test as well as they might have otherwise. Subconsciously, they were aware that their performance was hindered (as evinced by their avoidant body language and their choices to take easier test questions), but when they were asked to consciously rate their own performance, it turned out that they weren't aware of any of it. All the avoidance, the physiological responses of their brains, and their reduced performance – it all happened without their knowledge. They rated their own performances just as well as did participants who were presented with tests that had green or gray covers.

The attack on your prefrontal cortex

If the findings of Elliot and Maier hold true in everyday life, then the reason we have so much trouble monitoring our spending inside a Target store starts to make more sense. Every time you walk into a Target, your prefrontal cortex is being attacked by the ubiquity of red (see Figure 9-2). There is red on the front of the store, as you approach. The shopping carts are red. The checkout aisles

are red. Your eyes are assaulted by red when you enter a Target store, and this may be using up resources within your prefrontal cortex.

One of the most surprising parts of shopping at Target is that, when you get to the register, the total never seems to make sense. That bag of chips was only $3.87, that fancy whitening toothpaste was only $5.64, and that fancy picture frame was only $16.99. It could be that being in a Target store – with all that red around – just makes you bad at math. This would make sense – after all, Elliot and Maier's participants did poorly on the IQ tests when exposed to red.

The prefrontal cortex and decision-making

But having an overloaded prefrontal cortex can do much more than just make you bad at math. It can affect your ability to make wise decisions and cause you to make decisions based on your emotions, rather than for rational reasons.

This was exhibited in a study done by Professor Baba Shiv of Stanford University, in which participants with overloaded prefrontal cortexes regularly made more emotional, less healthy decisions. Participants were told to memorize a series of numbers. The participants were divided into two groups: one group had to remember only two digits, while another group had to remember seven digits. They were then told to walk down the hallway and recall their string of numbers to a researcher in another room.

It's well studied and documented that a seven-digit number is pretty difficult for a person to remember right away. This is why phone numbers are divided up into three- and four-digit chunks, a practice called – appropriately enough – chunking. So, the participants who had to remember seven digits had their work cut out for them. They had to store a string of numbers in their brains that brought their short-term memory store to its limits.

As the participants were trying to remember their numbers, their short-term memory stores – which are believed to be handled by the prefrontal cortex – were in overdrive. They were likely repeating the numbers in their heads, trying to remember them for just long enough to get down the hallway. This was obviously an easier task for those who had only two digits to remember than it was for those who had to remember seven digits.

But, as part of the experiment, they were interrupted in the hallway by another
researcher, who presented them with two snack options as a reward for

participating in the study: a big piece of chocolate cake or a bowl of fruit salad, an unhealthy option and a healthy option.

Knowing what we've learned so far about the prefrontal cortex and how people behave when their prefrontal cortex is overloaded, it shouldn't surprise you to learn that the people who were simply trying to remember a longer string of numbers than the other participants made a less wise, less rational, and more emotional choice for their snack. That's right, they chose the chocolate cake – at a rate 50 percent higher than that of the participants who had to remember only two digits.

Surely, if Target were to stop using red tomorrow, it would still manage to stay in business. The folks at Target are experts on manipulating human behavior and developing the right products at the right prices, but based upon what we know about the effect of red on the brain, its role can't be trivial.

Color and context

One big distinction between Elliot and Maier's IQ test study and shopping at a Target store is that of context. Just like anything else, the meaning of, and our reaction to, color will differ depending on the context. Take for example the role of red from an evolutionary standpoint. Elliot and Maier's study takes place in a performance-focused context. Participants are encountering red in a context in which they may suffer the consequences of failure. Red is relevant to these situations from an evolutionary standpoint, because a high-testosterone, high-status opponent may be flushed in red, which would signal danger. This probably has a lot to do with why stop signs, do not enter signs, and fire trucks tend to be red.

But in other contexts, red may take on a different meaning and have different effects. In a romantic setting, red may be connected to the flushed skin of an attracted or aroused partner. This probably has a lot to do with why most lipstick is a shade of red and every store is stocked with red cards, gifts, and flowers around Valentine's Day.

Red is also used a great deal in branding of fast food restaurants. Pizza Hut, McDonald's, KFC, In-N-Out, and Chick-fil-A all use branding that are almost entirely red. In the context of food, red may be associated with the flames of a

cooking fire or red blood of a fresh kill from a hunt. You'll rarely see blue in branding for food companies, just as you'll rarely see blue in any natural foods (unless the food is spoiled and caked with mold).

Red is used much less often in branding for banks. U.S. Bank and Bank of America use red in their branding, but they have a patriotic, American color palette of red, white, and blue. Most banks or financial institutions use blue or green in their logos, because blue is believed to have a calming effect and green is, of course, associated with money and success. Chase, Wachovia, TD Ameritrade, and Citibank all have green or blue as dominant colors in their branding. Red is still not unheard of in bank branding, but its use is usually restricted to small "accent" areas. Anyone who has looked at the interface for his stock portfolio or bank account and seen numbers in red can attest to the fact that, when money is involved, red is not a good color.

Whatever the context of red – between Elliot and Maier's research, and the anecdotal evidence of use of red in romantic and food-related settings – you can be sure that red has an excitatory effect. It reduces our ability to reason and – at least a little bit – brings out the animal in us. Who amongst us hasn't pursued a lover to later regret it or gone on a junk food binge that we wish we hadn't? Red is the most powerful color of all, so use it wisely.

What this means to you

So, how can you use this newfound knowledge of red to make your design work better? Here are a few ways:

> **Use red in contexts where you want to drive user behavior forward.** If you're showing a sale price, a call-to-action button such as "Buy Now," or a clock counting down until an offer ends, red will create a sense of urgency and cue your users to act.

> **Use red in error messages and other urgent notes.** Red will immediately alert your user that something is up and will make your message look important.

> **Consider using red if you're doing any work related to food.** Red is associated with food and has worked well with many food companies and restaurants. Avoid strong use of blue in these contexts, however – it's believed to have an inhibitory effect on appetite.

> **Avoid red in performance-based contexts.** If you're creating a quiz application, red may interfere with the performance of your users.

Research on Other Colors

Aside from the research that has been conducted on the color red, there is little evidence to support that any one color has a physiological effect on humans. However, effects of certain colors have been found in a variety of situations.

A study at the University of British Columbia found that blue enhanced performance on creative tasks and found that participants preferred more creative ads for products as long as the ad was blue.

Another study done at Cornell University found that NFL and NHL sports teams in black uniforms were rated as more mean and aggressive and got enough penalty yards and penalty-box minutes to prove it. They reasoned that black is associated with death and evil. This may be true in the context of sports, but how many times have you heard a woman swoon over a man that was "tall, dark, and handsome" or joke about how every man looks good in a black tux? Although the color black may be associated with aggression and evil in one context, it may be associated with sophistication, exclusivity, and intrigue in another.

No color will have a definitive effect in every possible situation. Our reactions to colors depend upon their context, our individual experiences, and the culture from which we come.

Color and Culture

The innate responses to color that we've inherited from our ancestors have shaped and been shaped by culture and interactions between cultures. The cultural meanings of colors are often a product of the availability of pigments associated with a color, the colors of flora and fauna local to an area, or seemingly whimsical choices.

Here are some interesting ways that colors have come to be associated with certain things within a culture:

> Because the ultramarine pigment used in blue dyes was so expensive in medieval Europe, royal blue became associated with the wealthy classes, while common people wore mostly green and brown.

> Orange has special significance in many Eastern cultures, probably due to the significance of saffron, an expensive spice with a long history of medicinal use. A saffron-orange color is used in the Indian national flag, is prominent in Hinduism, and is the color of robes worn by Theravada Buddhist monks.

> Yellow is often associated with taxis in the United States, probably thanks to the Yellow Cab Company, which was founded in Chicago in 1915. It's believed that the founder, John D. Hertz, chose to use yellow cars because of a University of Chicago study that indicated that yellow was the easiest color to spot from a distance.

> Red is used very commonly in national flags, often to symbolize courage or the blood of fallen soldiers.

It would be impossible – and inefficient – to try to list every possible color meaning to every culture in the world. But if you're designing for a culture that you're unfamiliar with, or if you're designing for an international audience, it's a good idea to do some research on colors that are important to a particular culture before designing for them.

When designing for an unfamiliar culture, trying to choose colors wisely is a bit like having a conversation with someone you've just met at a party. You don't

want to express strong views on politics or religion, or bring to mind death or sadness. When researching color meanings for a particular culture, think about the strong, potentially polarizing things in that culture. So, ask:

> What colors are on the flag for the particular country or region?

> What is the dominant religion? What colors are associated with that religion?

> What colors are worn in weddings in this culture? How about funerals or other religious ceremonies? (Try an image search.)

> What are some popular holidays in this culture, and what colors are associated with them? This is especially important if your design will be seen during one of these holiday seasons.

> Are sports important to this culture? What are some prominent or rival sports teams, and what colors are associated with them?

For example, although red can have some strong effects in certain contexts, when paired with white and blue, you get a color scheme that looks patriotic to Americans and also may be associated with holidays such as Memorial Day or Independence Day, depending on the time of year. The color orange will take on a different meaning to viewers in the state of Nebraska during the Halloween season than it will when their college football team happens to have a match scheduled with the Texas Longhorns.

By doing a little research on an unfamiliar culture, you can get a sense of some of the culture's dominant color associations and work toward clear communication.

Color Schemes and the Color Wheel

Centuries of experimentation have been dedicated to understanding how colors interact with one another and developing a framework by which to teach the use of color. In the early Renaissance, oil painters worked to try to find the perfect combination of paints to use to be able to create all the colors they wanted. Making paint was a labor-intensive process that involved the use of expensive pigments, so it was economical to be able to make as many colors as

possible from as few colors as possible. From this, the now well-known and popular artist's color wheel was born.

The artist's color wheel identifies three colors – red, yellow, and blue – as *primary colors.* For centuries, artists have been able to create nearly any color they wanted from these three pigments, so it was believed that all colors came from these colors.

You probably learned in preschool that red and yellow make orange, yellow and blue make green, and blue and red make purple. These colors, which result from mixing any two primary colors, are called the *secondary colors.*

As you learned in Chapter 8, humans can distinguish between about ten million colors, so we certainly can't stop with the primary and secondary colors. If you mix one of these primary colors with the adjacent secondary color, you get another set of colors called tertiary colors.

These colors together – the primary, secondary, and tertiary colors – make up the traditional artist's color wheel, which you can see in Figure 9-3.

Technically, the artist's color wheel may not be scientifically correct. As has been discovered with modern printing techniques, cyan, magenta, and yellow inks (rather than red, yellow, and blue) can optically mix together to make just about any color, and – as you learned in Chapter 8 – red, green, and blue light can work together across an even wider gamut.

FIGURE 9-3
The traditional artist's color wheel.

The artist's color wheel may not be constructed upon scientific precision, but there is a great body of knowledge and theory built up around it. Countless successful artists and designers have been taught from this color wheel. Additionally, most tools available for creating color schemes assume knowledge of this color wheel. So, although it's quite possible that someone could scientifically reconstruct the artist's color wheel, and all the color theory that accompanies it, I won't be reinventing this wheel, so to speak.

Color Choices and Web Conventions

When designing for the web, there are already some established standards and patterns for color choices. Here are a few patterns that you see often in color usage on the web.

Backgrounds

The color choice that will have the most impact on your design is that of the background color of your site or application. Choosing your background color is like choosing the stock of paper on which you print your résumé. Brilliant white, hot pink, or cream-colored paper all have impact, each in its own way, and make an immediate impression. So, too, will different background colors on your website.

White

Web designs with predominantly white backgrounds are, without a doubt, the most common on the web. Most people are used to reading material – such as newspapers or magazines – that are printed on white paper. A white background, when used with dark type, provides good contrast for reading and conveys a sense of trustworthiness. White is associated with purity, cleanliness, and innocence in Western cultures. Even though some Eastern cultures, such as India and China, often wear white to funerals, white is still used on popular websites in those countries. Google, Guruji (an Indian search engine), and Baidu (a Chinese search engine) all use white backgrounds.

The more widespread the audience of a website, the more likely it is to have a white background. White can be considered a standard on e-commerce websites, and it's a good idea not to waver from this standard.

Off-white

Natural, unbleached paper, is an off-white, cream color, so an off-white color is also pretty popular on the web, though you won't usually find it on high-traffic sites with a wide audience, such as in e-commerce. Off-white or cream colors often are associated with things that have a natural feel to them. Additionally, off-white or cream gives a stronger sense of intimacy than does pure white. Off-white gives a sense of antiqueness, too, like paper that is old and has started to yellow. An off-white background may be appropriate for a website for a landscaping company, a historical novel, or a fine, aged whiskey.

Dark

You won't see many successful e-commerce sites using dark backgrounds, but that doesn't mean that using them is out of the question. Dark backgrounds can remind visitors of a fun night on the town, which is why you often see black backgrounds on websites for restaurants and nightclubs. You'll also often see dark backgrounds on websites for web designers or even fashion designers. Dark backgrounds can provide a sense of exclusivity and sophistication.

Bright

Brightly colored backgrounds, such as yellow, pink, or cyan, definitely make an impact, but that won't always be a good thing. If you choose to use a brightly colored background, make sure it's relevant. Bright backgrounds are also best reserved for sites with splash pages that are very short on content but that you want to make a strong impact.

The TXP Mobile website (`www.txpmobile.com`), shown in Figure 9-4, is a good example of a site that uses a brightly colored background well. The site is short on information – its only objective is to tell you a bit about the product and get you to download it. If you had to do much more reading on this site, the bright yellow background would be too much, but in this case, it works.

FIGURE 9-4
Brightly colored
backgrounds can
be distracting,
but the small
amount of
content on the
TXP Mobile site
makes its use
of a yellow
background
appropriate and
engaging.
*Reproduced by
permission of
Oliver Ker*

Graphics and text

Just as there are standards in traffic signs, the web has standards as well –
although they may be unofficial. There are some similarities in usage patterns
from site to site, so some common ways of communicating with colors have
emerged. Additionally, interface design often takes advantage of already-familiar
cultural cues and metaphors to communicate with users (think about the
metaphors of a "desktop" or a "trash can," for example). Understanding patterns
in color usage on the web can help you make quick decisions that communicate
clearly to your users. Here are some common usages for colors in web design.

Green

Green often can be seen in websites as a mark of progress. There are a number of icons and interface elements that often show up green. A green checkmark is often used in product comparison charts to indicate that a product has a particular feature. A message that indicates that something has been successfully completed is often shown in green. Green is also a popular color for call-to-action buttons and sometimes tests better than other colors; red often performs well, too. (See Figure 9-5.)

FIGURE 9-5
Green is often used in contexts of progress or success.

Yellow

Since most of us have – at some point – used a yellow-colored highlighter to highlight important passages in a book, yellow is often used in website design to call attention to important messages or notes. YouTube uses yellow when you're viewing one of your own videos to let you know that the video is private. Basecamp project management software uses a light yellow background to call attention to important notes on its signup form. Google products, such as Gmail, use a yellow background to highlight important messages.

Yellow is also often associated with sales, deals, and prices. Amazon.com uses a yellow "treasure chest" icon to highlight "Today's Deals," as well a yellow stars for its rating system and yellow call-to-action buttons on its product pages. eBay uses a yellow-orange badge to indicate that a seller is "top-rated." The highest-paying bidders on Google keywords have the privilege of having their ads show up on a light yellow background. (See Figure 9-6.)

Red

Red is often used on the web in contexts when there is an error or other urgent message that it's critical for the user to see. Most forms display errors in red, for example. Red also can be powerful for urgent marketing messages. eBay uses red to indicate that an auction is ending soon, Amazon.com uses red to display its discounted prices, and the analytics company Performable conducted one test in which it found that a red call-to-action button outperformed a green one by 21 percent. (It should be noted that the predominant color used in Performable's branding is green, so red also contrasted heavily with that.) (See Figure 9-7.)

This video is unlisted. Only those with the link can see it. Learn more

What's a user?
Users can be people in your company or your clients. Users can log in and use Basecamp together with you to collaborate on projects. All Basecamp plans include unlimited users and contacts. There are no per-user fees.

Top-rated seller

Today's Deals

Coming soon: Better ads in Gmail. Learn more Hide

FIGURE 9-6
Yellow is often used to highlight important information, or to signal that something is special.

FIGURE 9-7
Red is usually
used in contexts
where an error
has occurred,
urgent
information is
being displayed,
or user action is
desired.

Time left: **1m 55s** (Apr 08, 2011 17:40:19 PDT)

Price: **$26.99** & this item ships for **FREE with Super Saver Shipping**. Details
You Save: $13.00 (33%)
Pre-order Price Guarantee. Learn more.

Username

This is what you'll use to sign in.

Password

6 characters or longer with at least one number is safest.

Blue

Blue is the standard color for link text on the web – so much so that some web designers refuse to use any link color other than some form of blue. Usability expert Jakob Nielson indicates in an article on his website, useit.com, that blue is preferred, but that other colors work "almost as well." As a general rule of thumb, if you're working on a very high-traffic site with a wide audience, it's probably best to stick with some form of blue for links. But other colors can be used as well, though probably more appropriate for smaller sites with more tech-savvy users, lower-traffic blogs, or sites where a specific design aesthetic is more important than achieving optimal usability.

In any case, avoid blue text, unless it's on a link. The exception to this rule may be a site that has a color palette with so much blue in it (and a different color for links) that the blue text is clearly part of the design.

Accent colors

Note that any of these colors that have been designated for certain purposes will have much less impact if they don't contrast with their surroundings. For example, Performable's red call-to-action button performed better, in part, because it contrasted with its green color scheme. If you have a site with a predominantly blue color scheme, your blue links aren't going to stand out as much. Also, imagine if you tried to put a yellow "alert" note on the TXP Mobile site – it wouldn't be noticed at all!

This is something to keep in mind when using a color that is intended to attract attention in some way, to accompany important information, or to indicate that an important event has occurred. It won't get noticed if it doesn't contrast with its surroundings.

The Interaction of Colors: Why Monet Never Used Black

To better understand how colors interact, it's helpful to study the work of a group of painters who became obsessed with colors and how they interact. As the popular tendency toward realism began to be rejected by the avant-garde, the Impressionists experimented with color, exposing the inherent qualities of their medium, and Claude Monet is one of the better known of the Impressionists.

Monet's paintings evoke a sense of energy and life. They leap off the canvas with color and contrast, but Monet somehow managed to avoid using the color black for nearly his entire painting career. By understanding how Monet used color, you can better understand how colors interact and use that knowledge to create a similar sense of life and depth in your own design work.

Monet, and other Impressionists, experimented obsessively with his medium: paint, some brushes, and canvas. So, just as pixels prohibit the use of Garamond on the web (see Chapter 3), the characteristics of the Impressionists' tools shaped their work. The inherent qualities of oil paint (thick and viscous), paint brushes (just a bunch of hair on a stick), and sometimes the texture of the canvas itself, lent themselves well to paintings being much more blurry than the more realistic paintings that were popular at the time. Realist painters strived to make these qualities invisible, but the Impressionists embraced them, much like pixel or bitmap fonts embrace the qualities of the pixel.

In the course of this experimentation, Impressionists had to experiment with color to create the desired effects. Much like a rich-colored image is dithered when restricted to a 256-color palette, the Impressionists experimented with creating the illusion of a color by placing colors next to each other. Colors next to each other would then optically mix, making them appear as another overall color when viewed from a distance.

The Impressionists: Masters of color

This effect was experimented with further until it became the major focus of some Impressionist painters as a technique called *pointillism,* which involves painting dots of color next to each other to create the effect of a different overall color. Georges Seurat is credited with developing the technique, and one of his paintings close up doesn't look all that different from a dithered GIF image, as you can see in Figure 9-8, which shows a close-up of one of Seurat's paintings next to a blown-up GIF image with a palette of only eight colors and a pattern dither.

By experimenting this way, the Impressionists were doing much more than simply trying to replicate reality – they were analyzing the area between the subject of a piece of art and the eye of the viewer. They were exploring just what makes ripples on water, with light bouncing off of them, glimmer the way they do. They analyzed what collection of colors makes up the shadow of an object to give it dimension, and pure black wasn't one of those colors.

FIGURE 9-8
Because he experimented with juxtaposing colors, the pointillism of Georges Seurat is similar to a dithered GIF image.
Photo of David Kadavy reproduced by permission of Masha Safina

Color theory: What the Impressionists discovered

Why the Impressionists avoided black can be explained by color theory. As I described earlier, the color wheel is made up of primary colors, secondary colors, and tertiary colors. But there is an imaginary division in the color wheel, which separates "cool" (green, blue, and purple) and "warm" colors (red, orange, and yellow).

These colors are referred to as such because warm colors give a sense of warmth – and an excitatory effect – to the viewer, while cool colors give a sense of cool – and a calming effect. Culturally, this makes sense: We tend to associate yellow, orange, and red with the sun or fire, while we associate blue with water or ice.

Warm colors pop, cool colors recede

As a general rule, warm hues pop out at the viewer, giving the appearance of being closer, while cool hues recede, giving the appearance of being farther away.

As you can see on the left side of Figure 9-9, the blue block recedes, looking as if it is a hole in the center of the red block. On the right side of Figure 9-9, you see the opposite effect, with the red block looking almost as if it is a tower extruding toward you from the blue block. The warm hue – red – pops out at you, and the cool hue – blue – recedes from you. (The colors for these samples have been chosen so that their Lab lightness values are the same, where applicable.)

FIGURE 9-9
The red (warm) square pops, and the blue (cool) square recedes.

The hue is the pure base color, as taken from the color wheel. To create a more sophisticated color, a hue is tinted or shaded. A tint of a hue is basically a lighter version of that hue. If you were mixing paint, you would just be adding white. A shade is a darker version of the base hue. If you were mixing paint, you would essentially be adding black to create a darker version of the hue.

Tints pop, shades recede

It's probably no surprise to you that – much as warm hues pop and cool hues recede – tints pop and shades recede, as you can see in Figure 9-10. With the same color of blue as the backdrop, a tinted square of the blue pops, while a shaded square recedes.

FIGURE 9-10
The tinted blue
square pops, and
the shaded blue
square recedes.

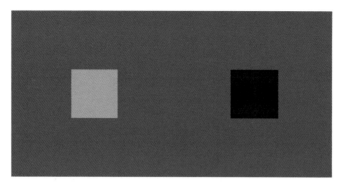

The importance of context

But will that tinted blue square always pop? Of course not. Context is important, too. In Figure 9-11, that exact same square is barely noticeable on the backdrop of slightly less tint, while it really pops on a heavily shaded backdrop.

FIGURE 9-11
The tinted blue
square pops less
off of a tinted
background
than it does
off a shaded
background.

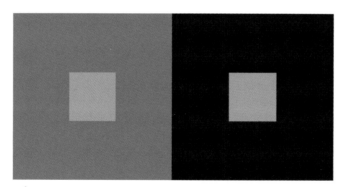

Temperature versus tint

This same phenomenon of context applies to the relative position of two hues on a color wheel as well. Although neither of the middle squares of both sides of this example has tint or shade (and both have the same lightness value in the Lab color space that I talked about in Chapter 8), their appearances relative to the blue backdrop differ drastically. In Figure 9-12, the square that is purple – which is adjacent to blue on the color wheel – almost blends in completely, while the square that is orange, which is blue's complement (opposite blue on the color wheel), leaps violently off the blue field. The contrast between these two hues is so great that there is a sense of vibration where they meet. Also,

note that while purple is a cool hue, it is still slightly warmer than blue, which causes the purple square to pop very slightly.

The effect caused by the relative color wheel position of two hues is so strong that it nearly overpowers the effect caused by tint or shade. Even when laid over a shaded purple backdrop, the tinted blue middle square on the left side of Figure 9-13 recedes. Contrast that with the tinted purple square on the right side of this example, which rockets toward you off of the shaded blue backdrop.

The Impressionists avoided black not only because it nearly doesn't exist in nature, but because the effects caused by changes in hue are so much richer than those caused by changes in shade. When you use pure black to create contrast, you miss out completely on the powerful effects of changes in hue.

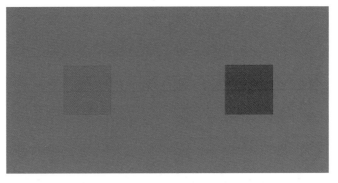

FIGURE 9-12
Even though none of these colors is tinted or shaded, the orange square pops more off the blue field than the purple square does.

FIGURE 9-13
Even when tinted, a blue square (left) recedes into a shaded purple field, while a tinted purple square pops off a shaded blue field. This is because blue is a cooler color than purple.

The left side of Figure 9-14 is the exact same color combination as the right side of the previous example. Notice how the dark blue backdrop recedes away from

the light purple square, lifting it toward the viewer. The dark gray backdrop (a neutral gray of identical perceptual lightness) certainly contrasts with the purple square, but because it has no hue relationship with the purple square, the purple square seems to just float around, while the edges between it and the dark gray backdrop give an unpleasant effect of vibration.

FIGURE 9-14
Even though a tinted purple square pops off a dark gray field, it appears more natural on a heavily shaded blue field.

So, how can you use this knowledge to make your web designs better? By understanding how colors interact with one another, you can more strongly establish a hierarchy of information in your typography. Web conventions have made it widely acceptable to use black on white for text on web pages, but this isn't universally the most readable, nor is it the most aesthetically pleasing option.

How Monet used color

You can see Monet's masterful manipulation of color relationships at work in Figure 9-15, which is a painting from his *Poplar* series. The shaded side of the poplar trees in the midground of the painting cuts through the glowing warmth of the sky and the trees in the distance. The three poplars are very dark on the canvas, and there is a lot of dimension to the scene.

FIGURE 9-15
This piece from Monet's *Poplar* series is a good example of manipulation of color relationships.

But the bold sense of shading on the three poplar trees is not from the use of black. Looking closer (see Figure 9-16), you get a better idea of what's going on. First, notice that the edges of the tree are a dark violet color. Meanwhile, the center part of the tree is a warm, but dark brown, based on an orange hue. Because the main part of the tree is a warmer color, this gives the tree some dimension, making the trunk jut out toward you, while the edges recede.

Additionally, the sky and the leaves of the tree in the background are both based off a yellow hue, which is the complement of violet. This creates the maximum possible color contrast between the sky and the edges of the tree, and creates a sense of the kind of blurry vibration that we might expect when viewing an object against a black background.

Using color like Monet

Monet's painting is a pretty extreme example, with very vibrant colors. You could try to mimic it, but even a touch of color added to highlights and shadows can enliven your designs. For example, you can play with color relationships when working with typography or when creating interface elements.

Enriching your typography

In Figure 9-17, the main text is pure black (#000), while the secondary text is neutral gray (#888), neither warm nor cool. You can see that there is a pretty clear hierarchy here.

FIGURE 9-17
Shifting from
pure black to a
neutral gray
provides some
contrast, but not
much dimension.

The quick fox
© The lazy dog

Figure 9-18 uses the same fonts and text sizes, but this time, a warm, dark gray is used as the base color. The main text is #503e2b, a very dark orange (a warm

hue). The secondary text is a lighter version of this base color, #9E948A. There is still enough contrast as to be readable, but the contrast isn't as harsh as a black versus white. Overall, it's visually pleasing and, well, warm.

The quick fox
© The lazy dog

The main text in Figure 9-19 uses the same dark orange from the previous example, but this time, instead of simply using a tinge of this color, a complementary (cool) gray is used for the secondary text: #808094. This adds extra dimension to the hierarchy we're establishing. Not only is the secondary text smaller and tinted, but now it's a cooler color, causing it to recede even more. Now there is a color relationship between the two pieces of information, which intensifies our intended hierarchy while still creating a sense of harmony and realism.

The quick fox
© The lazy dog

Adding life to your graphics

Skillful manipulation of color relationships is at the crux of creating engaging and lifelike interface graphics, such as buttons. Figure 9-20, created in Adobe Photoshop, features two buttons that are created by vector masks sharing the exact same base color (#C66), but the highlights and shadows are treated differently.

The highlights and shadows for the button on the left are created using a Gradient Overlay layer effect featuring a simple black-to-white-to-black

gradient, a Linear Burn blend mode, and a 26 percent opacity. Using black and white with this blend mode is much like mixing the pigments of the paint. The shadows of the button are just darker versions of the red base color – as if the base color had just been mixed with black. The same goes for the highlights – they're simply lighter versions of the base color. Finally, the drop shadow on this button is composed of black, at 75 percent opacity.

This is a generally attractive button. The lighter and darker colors give us some sense of a highlight and a shadow. But it doesn't have quite the richness of the button on the right, which is created using a green-to-yellow-to-green gradient (green being cool and the complement to red, and yellow being warmer than red) and a dark blue drop shadow.

Mixing colors in this way, we're playing with the relationships between colors on the color wheel. The shadows are closer to a violet color now and are, thus, cooler than the base color, causing them to visually recede. The highlight is skewed toward orange, giving it warmth and causing it to jump out at us a little. For more harmonious contrast, the text on this button is also a very light yellow. The color swatches adjacent to each button illustrate clearly how the resulting color palettes of these buttons differ.

Don't be so quick to use black – if you really master manipulating color relationships to create dimension, you can really add freshness and life to your designs.

Color Schemes

Now that you know how colors interact, you're better equipped to understand how to choose colors for your designs. Designers use some popular and well-established color schemes to choose colors to use in their designs. Sometimes they're using these particular color combinations on purpose; other times these combinations are a product of intuition. The following are some color schemes that design and art students learn – you can find these color schemes in action in some of the best designs on the web.

Monochromatic

A monochromatic color scheme (see Figure 9-21) uses a single base hue – usually with varied tints and shades of that hue – throughout the design. Monochromatic color schemes tend to have a very quiet feeling to them, but depending upon how much the tints and shades contrast within the design, they can still be bold.

The website for Intelligence Squared's Mountain Festival (www.iq2mountain festival.com; see Figure 9-22) uses a monochromatic blue color scheme, with a dark blue background. The shades of blue work together to create a refreshing palette that definitely reminds you of a day on the slopes.

FIGURE 9-22
The Intelligence
Squared
Mountain
Festival's home
page uses a
monochromatic
blue color
scheme, with a
touch of pink
accent color.
*Reproduced by
permission of IQ2
Festival*

Of course, having a *completely* monochromatic color scheme might be a bit boring. They've wisely used a pink accent color for the Buy Tickets button on the top of the site.

Analogous

Analogous color schemes (see Figure 9-23) typically use three hues that are adjacent to each other on the color wheel (for example, green-blue, green, and green-yellow), though sometimes an intermediate color may be skipped between colors (for example, blue, green, yellow). Analogous color schemes tend to be harmonious and quiet.

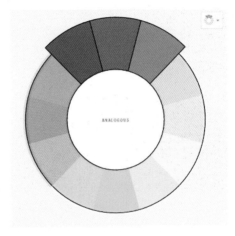

FIGURE 9-23
Analogous color schemes use hues that are adjacent to each other on the color wheel.

Harmonious and quiet is probably what you're going for if you're designing a website for a neighborhood of vacation homes. The website for the vacation home neighborhood Caerwys View (www.caerwysview.net; see Figure 9-24), designed by Andy Clarke, uses an analogous color scheme of green-blue, green-yellow, and yellow-orange and has a very peaceful feel to it. The colors are repeated throughout the photography and illustrations on the site, as well as in the interface elements and typography.

FIGURE 9-24

The website for
Caerwys View
uses an
analogous color
scheme.

*Reproduced by
permission of Stuff
and Nonsense Ltd*

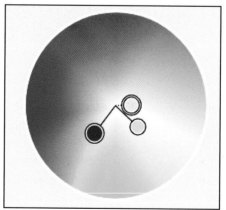

Complementary

Complementary color schemes are made up primarily of two colors that are opposite each other on the color wheel (see Figure 9-25). Complementary colors contrast with each other as much as possible, so these color schemes tend to have an exciting, jarring appearance. For this reason, complementary colors are extremely common in the uniforms of sports teams – the complements of blue and orange are used in the NFL in the uniforms of the Denver Broncos, the Chicago Bears, and the Miami Dolphins, while the colors of the Minnesota Vikings are purple and yellow.

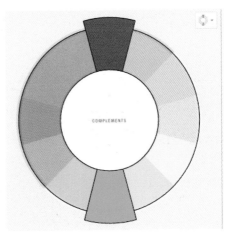

FIGURE 9-25
Complementary color schemes consist of colors that are opposite each other on the color wheel.

But, with a little finesse, complementary color schemes can be much more gentle than a 250-pound linebacker. The site for Carsonified's 2010 Summer Camp Conference (`http://summercamp.carsonified.com`; see Figure 9-26), designed by Mike Kus, uses a complementary red and green color scheme, but the hues are muted slightly, with lower saturation, and a slight tint.

Complementary colors can even be used for a yoga site. The site for Yoga
Haven (www.yogahaven.co.uk; see Figure 9-27), designed by Oliver Ker,
uses complementary red and green hues as base colors, but because a slightly
red-brown color and a neutral gray are used so liberally in the mix, the site
takes on a natural feeling, like a downward dog in a Redwood forest.

FIGURE 9-27
Yoga Haven uses
a complementary
color scheme but
still manages to
present a natural
feeling.
*Reproduced by
permission of Yoga
Haven*

Split-complementary

A split-complementary color scheme is made up of a color and the two colors
that are on either side of the complement of that color (see Figure 9-28). For

example, orange is the complement of blue, so a split-complementary color scheme would be blue, yellow-orange, and red-orange. Split-complementary color schemes tend to feel less jarring and more harmonious than complementary color schemes.

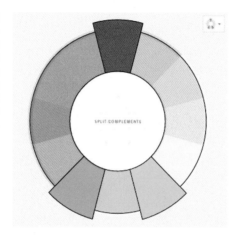

The Amazee Labs website (`www.amazeelabs.com`; see Figure 9-29), designed by Mike Kus, uses a textbook split-complementary color scheme. A desaturated red is accompanied by blue-green and yellow-green. The site has a textured cool (greenish) gray background that helps the colors pop without being overpowering.

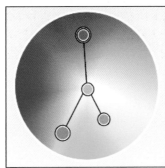

FIGURE 9-29
Amazee Labs
uses a split-
complementary
color scheme
that is colorful
without being
too jarring.
*Reproduced by
permission of
Amazee Labs*

Triadic

A triadic color scheme is composed of three colors that are evenly spaced on the color wheel (see Figure 9-30). The primary colors of red, yellow, and blue make up a triadic scheme, as do the secondary colors of orange, green, and purple.

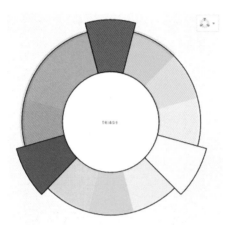

The website for the Chirp conference (http://chirp.twitter.com; see Figure 9-31), designed by Mike Kus, uses a triadic color scheme composed of the primary colors. These basic hues, along with the saturated, bright nature of the colors, gives the site a very cheery and approachable look.

Because primary colors look so cheery, and because they're considered the most basic hues, they're often associated with youth and used in work that is geared toward young children or early education.

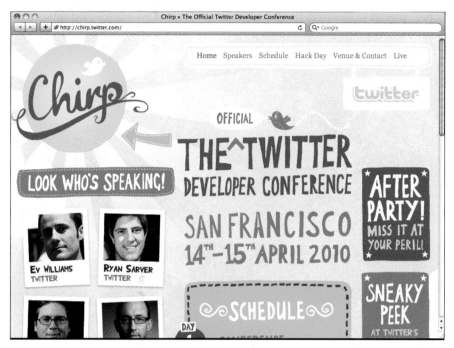

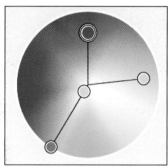

FIGURE 9-31
The Chirp
conference uses a
triadic color
scheme of the
basic primary
colors.
Reproduced by
permission of
Twitter, Inc.

Tetradic

A tetradic color scheme is composed of two pairs of complementary colors, for a total of four colors (see Figure 9-32).

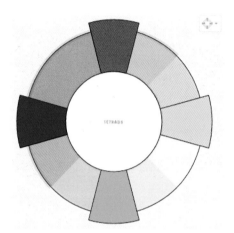

The site for the Twiistup conference (www.twiistup.com; see Figure 9-33), designed by the branding agency, May, is designed with a tetradic color scheme: purple, yellow, blue, and orange. Taken too literally, a tetradic color scheme can come off as too bold and inharmonious, but the blue and yellow of this color palette have both been toned down into grays, while the orange and purple remain bright and saturated.

Variations

These color schemes are great starting points if you don't know where to begin in choosing colors. They can be taken pretty literally with decent success, but you don't need to adhere to them perfectly. When you're comfortable with working with color in some of these patterns, you may want to start using your intuition in choosing colors.

FIGURE 9-33
The site for
the Twiistup
conference uses
a tetradic color
scheme, though
the blue and
yellow colors
come in the form
of cool and warm
grays,
respectively.
*Reproduced by
permission of Twiistup*

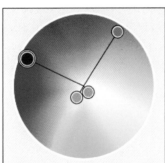

Sometimes you can get away with using just about every color available. That's
what the Carbonmade team did when designing its site (www.carbonmade.
com; see Figure 9-34). Its design mainly consists of red, yellow, green, blue, and
purple, but it also has hints of orange and magenta. Normally, this would be
visual overload, but the delicate desaturation of colors and harmonious
illustrative style make it work beautifully.

Notice how the Sign Up! call-to-action button is more vibrant and saturated than its surroundings. The octopus and accompanying headline work together with this button like a mini analogously color-schemed composition.

Another pattern that shows up sometimes is a complementary scheme, accompanied by a hue somewhere in between the complements. The branding for South by Southwest's 2011 conference (www.sxsw.com; see Figure 9-35) used such a collection of colors. The different segments of the conference – music, film, and interactive – are color-coded green-blue, red-orange, and yellow-green, respectively.

FIGURE 9-35
The SXSW 2011 conference used a color-coded palette that consisted of a complement, with a hue that lies between those complements.
Reproduced by permission of SXSW, Inc.

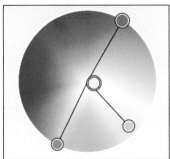

Creating a Mood with Color

You may have noticed in viewing the design samples that accompany these color schemes that the overall feeling of a site can differ drastically in a way that doesn't seem to correspond to a particular arrangement of colors at all. You may see some unofficial patterns in how colors relate to each other in a design. Different arrangements and concentrations of color can have a big effect on how a site feels. Here are some patterns that you might want to look out for.

Mysterious or exclusive

Designs that have a sense of mystery or exclusivity tend to have a very dark overall feeling to them, possibly with some sparse but bright highlights or accent colors. Notice, for example Endor.se (www.endor.se; see Figure 9-36), designed by Sam Brown. It features a very dark background in a neutral gray. This is the dominant color of the design, and it gives a sense that you've just whispered a password into a slot on a door and stepped into a speakeasy. This makes sense since the site is intended for friends and colleagues to recommend one another for work.

Active

Designs that feel active tend to have bright and highly saturated colors that contrast each other. Complementary or triadic color schemes are easiest to make feel active, but with enough contrast in saturation and value, normally quieter color schemes, such as analogous color schemes, can feel active as well.

FIGURE 9-36
Endor.se presents
an image of
exclusivity with
its dark color
palette, with
hints of bright
accents.
*Reproduced by
permission of Sam
Brown, Endorse*

The home page for Gowalla (www.gowalla.com; see Figure 9-37) has a very active feeling. Aside from the main color of the site being bright orange, which

is generally a high-energy color, most of the other colors on the site are very bright and saturated. Additionally, the color palette is from all over the color wheel, with a strong lean toward the complementary blue and orange. This active feeling is appropriate for a service that targets users who like to have fun (Gowalla is a location-based check-in service).

Designs with a muted palette have a very quiet, often calming feeling. Muted color palettes can be from anywhere on the color wheel, but they generally consist of very unsaturated tints of colors – mostly grays, beiges, or even subtle pastels.

FIGURE 9-37
Gowalla presents an active color palette through its use of saturated colors that are mostly complementary to the main color of orange.
Reproduced by permission of Gowalla, Inc.

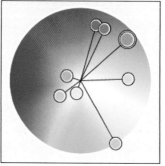

Muted

Muted color palettes are often a good setup for increasing the impact of accent colors, such as in the design of For a Beautiful Web (www.forabeautiful web.com; see Figure 9-38). The design of this site consists mostly of a slightly orange beige color that causes the deep, dark red color used throughout to stand out boldly like a dark Cabernet wine. The design looks sophisticated, strong, and confident – yet calming.

FIGURE 9-38

The dark red color in the design of For a Beautiful Web feels strong and bold, thanks to the muted color palette it accompanies.
Reproduced by permission of Stuff and Nonsense Ltd

Natural

Natural color palettes have an earthy feeling that reminds you of a hike through the woods. Natural palettes often include muted colors that are low in saturation, but this isn't a requirement. Usually, greens, browns, brownish-orange, and brownish-yellow colors are seen in designs that have a "natural" feeling.

The recipe blog Simply Recipes (`www.simplyrecipes.com`; see Figure 9-39) has a natural-feeling color palette. Consistent with the belief that warm colors are associated with food, the color palette is based upon colors from red-orange to yellow. It manages to feel natural without the use of green, though the colors are mostly shaded and slightly unsaturated.

FIGURE 9-39
The Simply Recipes blog has a color palette that makes use of the warm colors that are often associated with food. The design feels "natural," thanks to the shading and desaturation of the hues.
Reproduced by permission of Simply Recipes, Inc.

Tools for Creating Color Palettes and Schemes

There are a number of useful tools for creating color schemes and sampling color schemes from existing designs. Here are a few:

> **ColorSchemer** (www.colorschemer.com): The color palette screenshots you see under the samples in this chapter are captured from the websites using the color chooser from ColorSchemer (see Figure 9-40). ColorSchemer allows you to create, store, and export color palettes, as well as share them with an online community. You can browse color schemes by popularity and vote on them with a star rating system.

FIGURE 9-40
ColorSchemer is a Macintosh application that allows you to create, store, and share color palettes.

> **Color Scheme Designer** (http://colorschemedesigner.com): This free web-based application also allows you to create and export color schemes (see Figure 9-41). It does most of the things ColorSchemer does, but it doesn't have the community aspect.

> **Adobe Kuler** (http://kuler.adobe.com): This free web-based application allows you to create and store color schemes, as well as share them with an online community (see Figure 9-42). You can browse color schemes by popularity and vote on them with a star rating system.

FIGURE 9-41
Color Scheme
Designer is a free
web-based
application that
allows you to
create and
preview color
schemes.
*Reproduced by
permission of Petr
Staníček*

FIGURE 9-42
On Adobe's
Kuler, you can
browse, rate, and
create color
palettes.
*Reproduced by
permission of Adobe
System Incorporated.
All rights reserved.*

Knowledge Applied

This chapter has given you knowledge that will have you seeing color with new eyes. You now understand some of the reasons people have particular reactions to colors. There are biological and evolutionary influences, cultural and personal influences, and all the while, context is important to how color affects us. You now understand how warm and cool colors interact with each other, and how certain patterns of color can be used to evoke particular moods – or be used as guidelines that create palettes that soothe or excite.

Here are a few pointers you can begin using to improve your work:

> When working with predefined color palettes, use accents to your advantage. Just pick one or two colors to dominate your color usage, and use the others sparingly to add accents to particular elements you want to call attention to.

> When designing for an unfamiliar culture, do your research. Make sure you aren't bringing to mind any dominant cultural elements, such as religion or death, unless you intend to.

> Use your knowledge about how colors interact (for example, cool colors recede while warm colors pop) to add extra life and dimension to your designs.

> Use your knowledge of some of the common signals that colors carry with them (for example, yellow for bonus information) to guide your color choices in appropriate contexts.

Part V:
Appendixes

Choosing and Pairing Fonts

A NEARLY LIMITLESS choice of fonts, of varying degrees of quality. Letters that were once carefully chiseled into marble, or cast out of lead can now be reproduced in limitless numbers with just a few clicks. Publishing technology has come a long way, and with it, the number of fonts available to designers has exploded. You can find revivals of old classics, such as Adobe Garamond, as well as thousands of much lower-quality fonts.

This is a stark contrast from the options available to early printers. Early printing type (see Figure A-1) had to be carefully cut, character-by-character, through the process of punchcutting (more on this in Chapter 3). So, printers had access to only a few fonts. If they wanted to use a different size, they had to repeat the process.

FIGURE A-1
Lead type that was used in early printing was very difficult and costly to make, which limited the fonts available to printers.
tonystl (http://www. flickr.com/people/ tunruh/)

Early printers were craftsmen. They dedicated their lives to printing beautiful typography. Their skills were specialized, and it showed in the quality of their work. Yet, they were limited by the type that was available to them.

Contrast that with today's designer (anyone with access to a computer, really). Very few are formally trained to use typography, yet they have many more

fonts at their disposal. So, it's no surprise that choosing fonts is one of the most confounding topics that a new designer encounters. The advice available is confusing and inconsistent. Typeface classifications that have little to do with the spirit of the letterforms are thrown around, along with obtuse rules.

But here's the good news: Like an expert printer, you really need only a few go-to fonts. You could dedicate your entire life to understanding typography and learn to distinguish all the characteristics that make one typeface differ from another. But, chances are, you would rather make some quick progress on your project and have it look as good as possible. By understanding a handful of typefaces, you can quickly make the right decision and move forward with your project.

A basic understanding of why and how typefaces differ can take you far, especially when combined with some fundamental skills in creating a hierarchy of information through subtle typographic changes such as size, weight, and white space. (For more on this subject, see Chapters 5, 6, and 7.)

In this appendix, I tell you what makes one typeface differ from another by explaining some of the underlying philosophies and structures of their letterforms. In case you want to dig deeper into typeface choices, I show you how to choose typeface pairings that sing. Finally, I show you the few quality typefaces you need to be able to create great design in nearly any situation.

Classifying Typefaces

When Apple CEO Steve Jobs spoke to Stanford University's 2005 graduating class, telling of his experiences of dropping into calligraphy classes at his college, he described typography as "beautiful... in a way science can't capture." This lack of definability is part of the reason there are dozens of imprecise classifications for typefaces and their characteristics.

The classification system that is most popular today does a decent job of dividing typefaces, mostly by their decorative characteristics, but these classifications do little to assist designers in understanding the personality of a face, or what makes one font pair well with another. The classifications are worth learning, but the overall structure of letterforms is more critical for understanding the mood or feeling a face conveys (I cover that in the "Looking At Letter Structure: The Form of the Skeleton" section, later).

Typeface versus font

You may hear the terms *typeface* and *font* used interchangeably, but it's worth knowing the difference. A *typeface* (or *type* or *face*) is how the type looks, and a *font* is a file containing the typeface. Many purists are sticklers about the proper usage of these two terms, but for the sake of familiarity, I use the word *font* whenever it isn't grossly inaccurate. It's true that design decisions are technically based upon a typeface, but you choose a font to display that typeface. Chances are, you have more important things to worry about than the difference between these two terms.

Serif typefaces

Serif typefaces have little "feet" – called *serifs* – at the ends of their strokes. These serifs are believed to have originated from pens or brushes, but the limitations of using a chisel may have also contributed to them (see Chapter 3).

Old style

Old style typefaces (see Figure A-2) are generally from the early days of printing during the Renaissance (see Chapter 3), when the forms of letters started to depart from the influence of scribed letters and started to be more influenced by the process of punchcutting (see Chapter 3). Old style types have modulated strokes that still retain some influence of a drawing tool, a slightly slanted axis (as if they had been formed by an angled pen), and serifs that are rounded off much more than if they had been directly formed by a pen.

FIGURE A-2
Old style types are from the early days of printing. They retain some drawing-tool influence from their scribed predecessors (such as a slanted axis and gently modeled serifs) but are also influenced by the process of punchcutting.

Adobe Garamond

Transitional

Transitional fonts (see Figure A-3) started to develop during the mid-18th century, starting with the Romain du Roi (see Chapter 4). Instead of being a

mix of forms from punchcutting and scripture, the forms of transitional types are rationalized more with geometry. They feature heavily modulated strokes, with strong variations between thick and thin, an upright axis, and sharply modeled serifs.

Transitional

Baskerville

FIGURE A-3
Transitional typefaces are a stronger departure from scribed lettering than old style faces are. They're somewhat geometrically rationalized, so they feature strongly modulated strokes, an upright axis, and sharply modeled serifs.

Modern

Modern typefaces (see Figure A-4) are heavily rationalized by geometry and push the limits of lead type with their extreme contrast between thick and thin. Where thick meets thin on the stroke of a modern face, the transition is modeled by the form of a perfect circle. Giambattista Bodoni and Firmin Didot, each with fonts named after them, were the main innovators of modern typefaces. These types have extremely modulated strokes, an upright axis, hairline serifs, and geometrically rationalized *counters* (negative spaces within letters).

Modern

Bodoni

FIGURE A-4
Modern typefaces are heavily rationalized by geometry. They feature extremely modulated strokes, an upright axis, hairline serifs, and geometrically rationalized counters.

Slab-serif

Slab-serif fonts (see Figure A-5), sometimes referred to as Egyptian (though they aren't Egyptian at all) originated in the early 1800s. They have very little stroke modulation and boxy serifs that are about as thick as the strokes of the letters themselves. Because there isn't much stroke variation on slab-serif faces, they don't have much of an axis, but when an axis is apparent, it's upright.

Slab Serif

Museo Slab

Sans-serif typefaces

Sans-serif typefaces (see Figure A-6), as the name implies, don't have serifs. They vary in character greatly, which is why it's important to understand the way that the structures of letterforms differ (see "Looking At Letter Structure: The Form of the Skeleton," later in this chapter).

Sans-serif

Helvetica

Display typefaces

Just about any other typeface would fall into the display (or decorative or novelty) category (see Figure A-7). These fonts are created more for their decorative qualities than for their readability. You can find fonts that are made to look like Swiss cheese, ransom notes, or even jungle animals. Many of these faces also may fit into one of the above categories but happen to have some intentionally produced characteristics such as textures or other imperfections.

Chalkduster

Looking At Letter Structure: The Form of the Skeleton

Although two types may both fit into one of the categories I covered in the previous section, they can differ drastically in their overall mood because of differences in letter structure. For example, Gill Sans, Helvetica, and Futura are all sans-serif fonts, but they convey different moods and images: Gill Sans looks friendly and approachable, Helvetica looks sterile and serious, and Futura looks simple yet sophisticated.

These typefaces' different impressions are rooted in their letter structures, which also happen to be a product of the philosophies with which they were designed. Letter structures have a complex anatomy, but a few structures are a part of all letterforms. Understanding the basic varieties of these structures can help you make sound decisions about fonts.

Humanist typefaces

Humanist typefaces (see Figure A-8) were inspired by the Humanist Movement that drove the Renaissance. The first printed fonts, created during the incunabula (see Chapter 3), were strongly based upon the scribed writings of the 15th century. The forms of scripted lettering are based upon the goal of efficiency of production (the scribes had to be able to reproduce the letters with reasonable speed), so the forms of the letters are influenced by the human body and the nature of the pen tip, rather than by mathematics or logic.

Even though many other styles of fonts were created after the incunabula, the humanist style has lived on to influence modern sans-serif fonts, such as Gill Sans, Lucida Grande, Verdana, Tahoma, and Trebuchet MS. Ironically, the more open counters of such sans-serif humanist letters make them very readable on-screen.

Humanist / Humanist

Gill Sans Palatino

FIGURE A-8
The structure of humanist typefaces is influenced by scribed letterforms.

Geometric typefaces

Rather than being influenced by the humanist leanings of scripted letterforms, geometric letterforms (see Figure A-9) are more directly influenced by the square, circle, and triangle. The *o*'s of geometric typefaces tend to be nearly perfect circles. Futura is the ultimate geometric sans-serif, but Century Gothic is another popular one, which is unfortunate because of its massive *x-height* and awkwardly narrow *s* and *r*. Although the Romain du Roi (see Chapter 3) was heavily influenced by geometry, it retains enough calligraphic influence to instead have a realist structure. Bodoni has enough geometric influence to be the ultimate geometric serif font.

FIGURE A-9
Geometric
typefaces are
directly
influenced by
geometric forms.

Geometric / Geometric
Futura Rockwell

Realist typefaces

The structures of realist typefaces are enough of a balance between calligraphic and geometric influence that they're sometimes also referred to as transitional typefaces. The forms of realist faces are derived neither from calligraphic hand nor from mathematical precision; instead, they lie somewhere in between. Helvetica is the ultimate realist font and is considered so ordinary looking that it's sometimes described as "invisible" or "anonymous."

FIGURE A-10
Realist typefaces
are a hybrid of
calligraphic and
geometric
influence.

Realist / Realist
Arial Georgia

Pairing Fonts

You can get a tremendous amount of versatility from just one font (see Chapter 7), but sometimes using more than one font at a time can improve communication, and make your design appear more dynamic. Finding typefaces that go together well can be challenging. There are some good rules of thumb for pairing faces, but there are exceptions. Truly understanding what makes types pair together can ensure that you make wise choices when you add fonts to your design.

The rule

Although there are plenty of confusing and conflicting "rules" about typography, the common advice to use no more than two fonts – one of them serif, and one sans-serif – is pretty sound. You can easily create a beautiful and clear hierarchy using only one font family (see Chapter 7), but adding another family into the mix can provide dynamism and sophistication that may be hard to achieve with just one font. However, there isn't much point in using two different serif fonts or two different sans-serif fonts. Mixing two serif or two sans-serif types can be confusing to the viewer; plus, it just doesn't provide enough visual variety to justify the added complexity.

In print applications, serif faces are generally regarded as more readable than sans-serif faces. So, if two fonts are being used, a sans-serif face is typically used for titles and headers, while a serif face is used for body copy.

The lower-resolution of the web leads to different habits, however (see Chapter 3 for more on why). Sans-serif typefaces are regarded as more readable on-screen, so when a second font is used, it's often a serif typeface for more sophisticated-looking headers and titles.

Of course, the reverse of this common configuration – a sans-serif font for headers and titles, with a serif font for body copy – is certainly a viable option, provided that the serif face is one designed for the web (such as Georgia) and is displayed large enough to be readable.

The exception to the rule

You don't always have to avoid using two serif or two sans-serif fonts in a design. For example, if you're creating a design with just one sans-serif font, you're likely to have portions of text that appear quite large (as subheads) and other text that appears quite small (as body text or detail text).

In these cases, choosing a more nuanced face – designed for print – for the larger header text sizes is generally acceptable. This is because many typefaces that are designed to be readable at body copy sizes on the web are generally not attractive at large sizes. They're usually designed to have large counters, or are otherwise simplified to maintain the readability of the type at smaller sizes – attributes that looks less than flattering when displayed at larger sizes.

You can see this in action in Figure A-11, which features John Gruber's website, `www.daringfireball.net`. The larger portions of type – the titles of blog posts and the menu items, for example – are displayed in a more nuanced face, Gill Sans. Although the menu item faces aren't very large, Gill Sans still wouldn't read as well in body copy, so Verdana is used instead.

But this pairing is no accident. Verdana has a humanist letter structure that is quite similar to that of Gill Sans. But the giant counters and simplistic details that make Verdana read great at small sizes also make it look awkward and uninteresting at large sizes. Gill Sans is similar enough to Verdana so as to not be disturbing, but it has more character, making it a better candidate for larger titles and headers.

It should be noted that the Daring Fireball logo is neither Gill Sans nor Verdana, but rather a heavily weighted and condensed realist face. This kind of differentiation between the typeface in the logo and the fonts in the rest of the design is standard and helps support the visual importance of the logo itself.

Why certain fonts pair well

To understand what makes two fonts go together well, you need to understand the various attributes that typefaces have. The letter structures that I described earlier have a strong influence on how well two fonts go together, but other important characteristics include texture and character width.

Texture

Texture (sometimes called *color*) is one way in which typefaces differ from one another. It also influences the compatibility of two fonts. *Texture* is the overall look of a body of text in a given typeface. Type designers strive to have a generally even texture throughout a block of text. If you squint while looking at a block of text, no characters should stick out as too heavy or too light. If the texture of a block of type is even, then the letterforms themselves can be read more comfortably.

Harmony versus contrast

If you pay attention to successful relationships and marriages, you may notice that both members of a couple are strikingly similar: They're equally outgoing, they finish each other's sentences, and they may even look alike. But other equally strong relationships are a study in contrasts: One person may be extroverted and creative, while the other is quiet and analytical. It's as if both people in the relationship get to experience the world in a way they wouldn't otherwise because of their partner.

Successful font pairings are a lot like successful relationships in this way. Harmonious font pairings – where the typefaces share a number of attributes – can look beautiful, elegant, and clean. But fonts that heavily contrast with one another also can pair well, creating a sense of boldness. The approach you choose – harmony or contrast – all depends on the feeling you want to convey, but it's the area in between these two approaches that you want to avoid.

In the following figure, you can see that the fonts in the first pairing are in harmony, the fonts in the third pairing contrast heavily, and the fonts in the second pairing are somewhere in between, making them look awkward together.

We're in harmony	We're neither similar	We're so different	When pairing fonts, it's best to achieve harmony or contrast.
With each other	Nor different enough	We go together	
Adobe Garamond & Gill Sans	Baskerville & Gill Sans	Bodoni Bold Condensed & Gill Sans Light	

But just because two high-quality fonts have overall even textures in body copy doesn't mean that they're compatible with one another. Textures can differ most notably in darkness versus lightness and roughness versus smoothness.

Darkness versus lightness

Generally, the lightness or darkness of a block of text is influenced by the overall visual weight of the individual letterforms, but also by the *letterfit,* or how the forms of the letters relate to each other in the pursuit of an even texture. (See the section titled "The Tragedy of Misuse: Why You Hate Comic Sans" in Chapter 3 for more on letterfit).

In Figure A-12, the texture of Arial Black is much darker than the texture of Arial, because Arial Black has much thicker strokes.

FIGURE A-12
Arial Black
produces a much
darker texture
than that of
Arial, but Lucida
Grande –
because of its
looser letterfit –
produces a
lighter texture
than that of
Arial.

If so, perhaps that head start, amplified over the last 13,000 years, provides the answer to Yali's question. Hence this chapter will offer a whirlwind tour of human history on all the continents, for millions of years, from our origins as a species until 13,000 years ago. All that will now be summarized in less than 20 pages. Naturally, I shall gloss over details and mention only what seem to me the trends most relevant to this book.

Arial Black

If so, perhaps that head start, amplified over the last 13,000 years, provides the answer to Yali's question. Hence this chapter will offer a whirlwind tour of human history on all the continents, for millions of years, from our origins as a species until 13,000 years ago. All that will now be summarized in less than 20 pages. Naturally, I shall gloss over details and mention only what seem to me the trends most relevant to this book.

Arial

If so, perhaps that head start, amplified over the last 13,000 years, provides the answer to Yali's question. Hence this chapter will offer a whirlwind tour of human history on all the continents, for millions of years, from our origins as a species until 13,000 years ago. All that will now be summarized in less than 20 pages. Naturally, I shall gloss over details and mention only what seem to me the trends most relevant to this book.

Lucida Grande

But, even though Arial has similar stroke weights to Lucida Grande, Lucida Grande has a lighter overall texture because it has a much looser letterfit. Arial has a much tighter letterfit, due mostly to the fact that it has a realist structure. Without as many subtle curves as the humanist Lucida Grande, Arial can achieve an even texture with a tighter letterfit.

Smoothness versus roughness

As you can see in Figure A-13, while Times New Roman has a much tighter letterfit than Lucida Grande, it also has much more contrast in its stroke width. Characteristic of a transitional typeface, the strokes of the letters go from relatively thick, to extremely thin – to the point that the serifs are very sharp. This difference gives Times New Roman a smooth texture – like a chalkboard – that is similar to that of Lucida Grande.

If so, perhaps that head start, amplified over the last 13,000 years, provides the answer to Yali's question. Hence this chapter will offer a whirlwind tour of human history on all the continents, for millions of years, from our origins as a species until 13,000 years ago. All that will now be summarized in less than 20 pages. Naturally, I shall gloss over details and mention only what seem to me the trends most relevant to this book.

Times New Roman

If so, perhaps that head start, amplified over the last 13,000 years, provides the answer to Yali's question. Hence this chapter will offer a whirlwind tour of human history on all the continents, for millions of years, from our origins as a species until 13,000 years ago. All that will now be summarized in less than 20 pages. Naturally, I shall gloss over details and mention only what seem to me the trends most relevant to this book.

Lucida Grande

If so, perhaps that head start, amplified over the last 13,000 years, provides the answer to Yali's question. Hence this chapter will offer a whirlwind tour of human history on all the continents, for millions of years, from our origins as a species until 13,000 years ago. All that will now be summarized in less than 20 pages. Naturally, I shall gloss over details and mention only what seem to me the trends most relevant to this book.

Arial

If so, perhaps that head start, amplified over the last 13,000 years, provides the answer to Yali's question. Hence this chapter will offer a whirlwind tour of human history on all the continents, for millions of years, from our origins as a species until 13,000 years ago. All that will now be summarized in less than 20 pages. Naturally, I shall gloss over details and mention only what seem to me the trends most relevant to this book.

Georgia

FIGURE A-13

The stroke contrast of Times New Roman gives it a smooth texture – like that of Lucida Grande – despite its tight letterfit. Arial and Georgia, which have less stroke modulation, produce textures that are rougher.

Conversely, Arial's very tight letterfit gives it a rougher texture. The counters of the letters stand out much more than the space between those letters. Arial has a rough texture – like a pumice rock – that is more similar to that of Georgia, which also has a tight letterfit but less contrasted strokes than Times New Roman has.

Font size

You may have noticed in the previous examples, that some of the typefaces actually appear to be larger than the others. Additionally, some of the samples have more visual white space vertically between the lines.

The reality is that the fonts in all these examples are the exact same point size. As you can see in the following figure, some typefaces appear larger because the x-height (the height of a lowercase *x*) varies from one type to the next. The actual point size of a font is largely determined by the distance between the tallest *ascender* (such as the top of a lowercase *b*) and the lowest *descender* (such as the tail of a lowercase *p*).

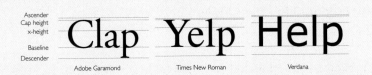

Ascender
Cap height
x-height

Baseline
Descender

Adobe Garamond Times New Roman Verdana

Various properties of a typeface, such as x-height, can change the face's visual size.

Because point size is a leftover concept from when type was set in lead, it actually refers to the overall height of the lead slugs the letters were on. So, there is sometimes some arbitrary extra space accounted for in the point size of a font. This is why the overall height from ascender to descender of Verdana is a bit more than in Times New Roman, even though both samples are the same point size.

continued

continued

The sample text blocks also have the same amount of *leading* (vertical space between lines). Leading gets its name from the time when printers were setting type by hand: They placed strips of lead between the lines of type to regulate the vertical space between them. Leading is also known in CSS as the `line-height` property.

By regulating the leading of type, you can alter the overall darkness or lightness of texture in a block of text. As a good rule of thumb, body copy tends to be most readable when the leading is about 120 percent to 140 percent of the type size (a `line-height` of 1.2em to 1.4em). Smaller portions of text, such as within bulleted lists, tend to look better with a smaller `line-height` (1em or 1.1em).

Character width

Character width is pretty much what it sounds like: the width of the actual letters in the typeface. When two typefaces differ in character width, this creates visual conflict between their overall letter structure (even if the base structure is really quite similar). You can see in Figure A-14 that Verdana and Times New Roman have drastically different character widths – one of the contributing factors to their not being a very strong pairing.

FIGURE A-14
The differing character widths between Verdana and Times New Roman contributes to their being a weak pairing. Adobe Garamond and Gill Sans have more similar character widths.

n Times New Roman

n And Verdana differ in character width, causing them to clash.

n Adobe Garamond

n And Gill Sans have a more similar character width.

The *n* has it

If you're unsure about the letter structure compatibility between two fonts, you can learn a great deal just from the lowercase *n*. As you can see in the following figure, the forms of the *n* are repeated in the letters *b*, *h*, *m*, *p*, *q* (sometimes), *r*, and *u*, so the *n* gives you clues as to what the rest of the typeface looks like.

nbhmpqru

In most typefaces – like Helvetica – the forms present in the lowercase *n* are repeated throughout many characters in the alphabet.

If you look very closely at the following figure, you can see how the *n*'s of Gill Sans, Futura, and Helvetica differ. The letters in the sample have been adjusted in size (because each of the fonts has a different x-height) to be similar.

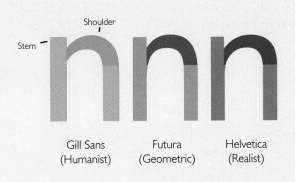

Gill Sans
(Humanist)

Futura
(Geometric)

Helvetica
(Realist)

The differing letter structures of Gill Sans, Futura, and Helvetica are apparent in the *n*'s of the respective typefaces.

Notice how the shoulder of the Gill Sans *n* leaps from the stem like a spout of water, gently curving as gravity causes it to fall. Because it's a humanist face, its forms are more closely tied to the human body and nature.

Contrast that with Futura, whose forms are geometrically rationalized. The shoulder of the *n* on Futura is nearly symmetrical, as if it were an arch on a doorway.

Helvetica's *n* lies somewhere in between these two extremes. The curve of its shoulder bends more deliberately, as if it were a piece of forged iron.

continued

continued

You can see the influence of *n* similarity in action in the following figure. The *n*'s of Gill Sans and Adobe Garamond are both humanist, so the typefaces are in harmony. But Times New Roman has a realist letter structure, so it doesn't go quite as well with Gill Sans.

The humanist letter structure of Adobe Garamond makes it pair better with Gill Sans than Times New Roman does.

n Adobe Garamond
And Gill Sans both have a Humanist letter structure.

n Times New Roman
Has a Realist letter structure, so it doesn't go as well with Gill Sans.

When trying to achieve harmony between two fonts, the *n* can give powerful clues as to how well two fonts pair together.

The ultimate cheat: Staying faithful to a typographer

If you don't want to sift through thousands of fonts to find one that goes well with your favorite font, a good shortcut is to choose fonts that are created by the same type designer. Designing typefaces is a painstaking and all-consuming process, so type designers tend to have their own distinct philosophies about what makes a good typeface.

Most people don't pay any attention at all to who designed the font they're using, but they really should. Designing type is a highly skilled craft, and it pays to respect and understand the backgrounds of those who design your typefaces.

Say, for example, that you really love Gill Sans – the Humanist structure gives your design an approachable and friendly feeling that's perfect for your project. With a quick Google search, you could discover that Gill Sans was designed by Eric Gill, who also designed a serif face called Joanna. It's a safe bet that Joanna goes well with Gill Sans.

As you can see in Figure A-15, these two fonts do, in fact, go very well together. Joanna has a similar humanist letter structure and is full of other subtleties, such as the stroke modulation on the upper part of the *a,* that make it harmonize with Gill Sans.

Joanna

Is a font designed by Eric Gill, just like Gill Sans is.

FIGURE A-15
Joanna and Gill Sans, both designed by Eric Gill, convey the sensibilities of their designer and, thus, go together well.

All the Fonts You'll Ever Need

As I said earlier, if you dedicated a lot of time to learning about all the nuances that make typefaces different from one another, you would be sufficiently skilled to pick the right font for any situation from thousands of fonts. But you don't need to do this.

Table A-1 features all the fonts you'll ever need. By no means are these the only good fonts in existence, but in just about any situation, you can pick one or two fonts (if properly paired) from these and be just fine. You could use nothing but these fonts for the foreseeable future and still manage to create beautiful and useful designs.

Contrast can be good

Subtle differences in attributes such as texture and character width can be displeasing to the eye, but contrast can add visual pleasure when it's deliberate or extreme. Refer to the figure in the "Harmony versus contrast" sidebar, where Bodoni Condensed Bold is used for titling and Gill Sans is used for body text. Bodoni Condensed Bold has a very condensed character width and extreme contrast of thick and thin. It's definitely meant for titling applications such as this. You can see that it wouldn't be very readable as body text – although it might be tolerable for very short portions of text such as introductory paragraphs.

But because the characteristics of this face are so extreme, it almost doesn't matter what body text type it's paired with. If a typeface can stand alone in body text, it can stand just fine with this display face. Philosophically, because of Bodoni's strong geometric influence, it would usually pair best with a geometric sans-serif such as Futura.

Table A-1 **All the Fonts You'll Ever Need**

For a PDF of this list, visit www.designforhackers.com

Classification	Font	Letter Structure	Good For	Texture Sample	Pairs With
Serif, old style	Adobe Garamond	Humanist	Print	If so, perhaps that head start, amplified over the last 13,000 years, provides the answer to Yali's question.	Lucida Grande, Gill Sans, Verdana, Tahoma, Trebuchet MS
Serif, old style	Palatino	Humanist	Print, web	If so, perhaps that head start, amplified over the last 13,000 years, provides the answer to Yali's question.	Lucida Grande, Gill Sans, Verdana, Tahoma, Trebuchet MS
Serif, transitional	Baskerville	Realist	Print	If so, perhaps that head start, amplified over the last 13,000 years, provides the answer to Yali's question.	Arial, Helvetica
Serif, transitional	Georgia	Realist	Web	If so, perhaps that head start, amplified over the last 13,000 years, provides the answer to Yali's question.	Arial, Helvetica, Lucida Grande, Tahoma, Verdana, Trebuchet MS
Serif, modern	Bodoni	Geometric, realist	Print	If so, perhaps that head start, amplified over the last 13,000 years, provides the answer to Yali's question.	Futura, Arial, Gill Sans, Helvetica, Lucida Grande, Tahoma, Verdana, Trebuchet MS
Serif, modern (slab-serif)	Rockwell	Geometric	Print	If so, perhaps that head start, amplified over the last 13,000 years, provides the answer to Yali's question.	Futura, Arial, Gill Sans, Helvetica, Tahoma, Verdana
Serif, modern (slab-serif)	Museo Slab	Humanist	Print, web	If so, perhaps that head start, amplified over the last 13,000 years, provides the answer to Yali's question.	Gill Sans, Lucida Grande, Tahoma, Verdana, Trebuchet MS

	Font	Classification	Medium	Sample	Pairings
Sans-serif	Arial	Realist	Web	If so, perhaps that head start, amplified over the last 13,000 years, provides the answer to Yali's question.	Georgia, Baskerville, Bodoni, Rockwell
Sans-serif	Futura	Geometric	Print	If so, perhaps that head start, amplified over the last 13,000 years, provides the answer to Yali's question.	Bodoni, Rockwell
Sans-serif	Gill Sans	Humanist	Print	If so, perhaps that head start, amplified over the last 13,000 years, provides the answer to Yali's question.	Adobe Garamond, Palatino, Georgia, Bodoni, Rockwell, Museo Slab
Sans-serif	Helvetica	Realist	Print	If so, perhaps that head start, amplified over the last 13,000 years, provides the answer to Yali's question.	Baskerville, Georgia, Bodoni, Rockwell
Sans-serif	Lucida Grande	Humanist	Web	If so, perhaps that head start, amplified over the last 13,000 years, provides the answer to Yali's question.	Adobe Garamond, Palatino, Georgia, Bodoni, Museo Slab
Sans-serif	Tahoma	Humanist	Web	If so, perhaps that head start, amplified over the last 13,000 years, provides the answer to Yali's question.	Adobe Garamond, Palatino, Georgia, Bodoni, Rockwell, Museo Slab
Sans-serif	Trebuchet MS	Humanist	Web	If so, perhaps that head start, amplified over the last 13,000 years, provides the answer to Yali's question.	Adobe Garamond, Palatino, Georgia, Bodoni, Museo Slab
Sans-serif	Verdana	Humanist	Web	If so, perhaps that head start, amplified over the last 13,000 years, provides the answer to Yali's question.	Adobe Garamond, Palatino, Georgia, Bodoni, Rockwell, Museo Slab

There are, of course, hundreds of brilliant fonts that aren't included in this table. One glaring omission is Times New Roman, which is a pretty good transitional font. I haven't included it because Georgia is such a superior transitional serif font, specifically designed for the limitations of the screen. A major consideration in the 1931 design of Times New Roman was to save space in the British newspaper, *The Times*. It's a newspaper, so naturally it was cheaper to print it in a font that used less paper. It doesn't seem reasonable that, in the age of the web, where paper use isn't a consideration, we should suffer this consequently narrow font. With this reasoning in mind, if you still want to use Times New Roman, especially as a Georgia fallback face in your CSS font stack, it wouldn't be the end of the world.

Another popular font that you probably used in every paper you wrote in school (because it would automatically make your paper much longer) is Courier New. This is a slab-serif typeface, but it's also monospaced, which means that the font has no kerning tables – in other words, each letter occupies the same amount of horizontal space, instead of being carefully spaced to fit well next to the other letters. Courier New and other monospaced fonts (such as Monaco) create an uneven texture in body copy, so they look awkward and should be avoided for regular text. They're conventionally used for code samples and are, thus, acceptable for that purpose.

appendix **B**

Typographic Etiquette

THE JOURNEY OF language through technology has created a variety of rules and habits, customs and taboos. Knowing which rules are still applicable and which are outdated can be difficult.

In this appendix, I explain some common mistakes that people make when working with type in today's technology. I also outline some typographic "rules" that very few untrained designers are aware of.

You don't need to memorize and follow these rules. My goal is simply to illuminate the principles of clear typographic communication. If you find yourself in a situation that isn't covered in this appendix, just remember these principles:

> **Typography exists to communicate language.** Anything that hinders or interferes with this communication is undesirable.

> **Typographic form is derived from a mixture of medium and language.** The inherent qualities of the medium should always be considered when making typographic decisions.

> **The aim of a typeface is to allow the inherent qualities of the individual letters to shine through, sometimes while conveying a particular mood.** Letterforms should be in harmony with one another, and no particular letter should have qualities that cause it to stand out from its brothers and sisters.

> **The design of a typeface should be respected.** Creating beautiful typefaces takes a lifetime of dedication and careful craftsmanship. Anything that alters the qualities of a typeface compromises its ability to communicate clearly.

> **An even texture is the aim of any block of body text.** Body text is made to be consumed easily, and an evenness of texture is the most direct route to this goal.

> **Visual differentiation between pieces of information should be appropriate to how it is consumed.** In many cases, minimal typographic differentiation is adequate to establish a hierarchy of information. For example, a header and a body may be the same typeface, while the header

is simply a different size or weight and has white space above and below it. Body copy should have minimal typographic differentiation to facilitate the rapid consumption of information.

Here are some general rules that lie within these principles.

Distorting Type: What Not to Do

In early printing, letters had to be carefully cut from steel punches and then cast in lead. This process had to be repeated for every weight and size of a given typeface. Today, anyone with access to a desktop-publishing program can bend, twist, and otherwise distort type however he sees fit. Typefaces have been very carefully crafted, and their gentle forms are no mistake, so these practices should be avoided. Here are some of the most common ways that type is distorted.

Fake bold

Fortunately, simply by designating `font-weight: bold` in CSS, you prompt the browser to select the correct font (if available), but there are many opportunities in desktop-publishing programs to use a fake bold version of a font (such as the Faux Bold button on Photoshop's Character palette). These artificially bolded fonts are essentially just the original version of the font, but with an outline around them. This removes all the subtlety from the forms of the letters and usually closes up small counterforms, reducing the legibility of the font.

As you can see in Figure B-1, fake bold versions of a font are not as gracefully rendered as the authentic bold of a font. Notice how thick and clunky the serifs are and how underwhelming the stroke modulation is in the authentic bold sample as compared to the fake bold sample.

Chubby Bunny Chubby Bunny

"Real" Georgia Bold "Fake" Georgia Bold

FIGURE B-1
The real bold version of a font has more natural forms than the fake bold version.

Fake italic

Again, CSS selects the correct version of a font (if available), when you use the `font-style: italic` property, but some desktop-publishing programs have an Italic button that will create a fake italic of the font. This distortion usually comes in the form of the program simply slanting the font, distorting its letterforms.

Authentic italic versions of many (but not all fonts) have a scriptlike appearance, as shown in Figure B-2 with Georgia.

FIGURE B-2
Some fonts, such as Georgia, have a calligraphic italic which differs from the italic created artificially by software programs.

Tiny Dancer *Tiny Dancer*

"Real" Georgia Italic "Fake" Georgia Italic

Even fonts that don't have scriptlike italic versions are better suited to using the authentic italic (sometimes called *oblique*) version of the font, rather than an artificially slanted incarnation, as you can see in Figure B-3. As Figure B-4 illustrates, the difference is more subtle, but typography is a game of pixels.

FIGURE B-3
Many sans-serif fonts have a custom-drawn slanted italic, which is free from the distortion caused by artificial slanting.

To the Extreme *To the Extreme*

"Real" Helvetica Italic (Oblique) "Fake" Helvetica Italic

FIGURE B-4
Here, the authentic Helvetica Oblique (gray) is superimposed over the software-created italic (pink).

To the Extreme

"Real" Helvetica Italic (Oblique) "Fake" Helvetica Italic

Fake small caps

This typographic blunder is more difficult to avoid than using fake italic or bold versions of a font. When you use the CSS `font-variant: small-caps` property – even if there is an authentic small-caps version available – browsers

will instead create fake small caps by replacing any lowercase letters within the element with smaller versions of capital letters.

But isn't this what small caps are? Actually, no. True small caps are custom-drawn to blend in well (creating an even texture) with the lowercase characters of a typeface. As a result, they will usually be just as tall as the x-height (the height of the lowercase *x*) of the typeface, and be made up of slightly bolder strokes than the capital letters of the typeface, while also standing a little bit wider, as you can see in Figure B-5.

CHOCOLATE RAIN
Simulated Small Caps

CHOCOLATE RAIN
Authentic Small Caps

FIGURE B-5
Authentic small caps more closely match the stroke width of a typeface's capital letters.

You may want to try avoiding using small caps altogether, but they can be a very useful tool in a skilled typographer's arsenal for things like keeping acronyms such as HTML from dominating the text body and interrupting the flow for the reader.

To avoid using these mangy-looking letters, you can use `@font-face` to select a font that actually has authentic small caps, and designate it in CSS without using the `font-variant: small-caps` property, like so:

```
@font-face { font-family: "Adobe Garamond SC"; src:
  local("Adobe Garamond SC"); }
p abbr { font-family: "Adobe Garamond SC"; text-transform:
  lowercase; }
```

The problem with this (as you know if you read Chapter 3) is that Adobe Garamond (and most other fonts that are sophisticated enough to have dedicated small caps) has forms that are a bit too subtle to look readable at

body copy sizes on the web. Web fonts, such as Georgia and Arial, don't have dedicated small-caps versions available.

So, another to solution is to out-fake the fakes. Since the main issue with fake small caps is that their strokes are too thin, you can simply bold the fake small caps to make them look a little more convincing. It also helps to ease up their letter spacing a bit to make the texture more similar to that produced by the standard lowercase letters. Here's what that would look like:

```
abbr, .smallcapssim { font-variant: small-caps; font-weight:
  normal; letter-spacing: .05em; }
acronym, .smallcapssim span { font-weight: bold; }
<p>The acronym <abbr title="HyperText Markup Language">HTML</
  abbr> will blend in with the text better, as will the
  keyboard shortcut <span class="smallcapssim">C<span>trl</
  span> + A<span>lt</span> + D<span>elete</span></span></p>
```

A comparison of raw versus "fixed" CSS small caps can be seen in Figure B-6. Though the hacked fake small caps stand a bit too tall and narrow, they're much less detectable than if they were just left alone.

FIGURE B-6
Somewhat convincing small caps – which more closely match capitals in weight – can be generated with some styling tricks.

PIANO CAT
CSS Small Caps

PIANO CAT
CSS Small Caps "Fixed"

Though generating such markup could be automated through jQuery or a plug-in for your particular web framework or CSS, this is, of course, pretty tedious. Like all matters of design and production, economics comes into play. If you can't justify all the extra work for what is arguably a low-reward payoff, you may choose to pick your poison: Either let acronyms dominate your text body, or put up with emaciated small caps. Just be aware of why fake small caps are technically incorrect.

Stretching type

For various reasons, from time to time, a designer decides that he wants to alter the default nature of a typeface. Sometimes it's because he wants a particular word to fit within a particular space. Other times, he just feels like he's adding some creativity to his design by doing so.

Typefaces are designed with extreme care and skill, following forms that have been established over thousands of years. Stretching or distorting these delicately crafted forms is always a mistake. Always.

As you can see in Figure B-7, the forms of an artificially compressed Helvetica are far different from those of Helvetica Condensed (you may need to look very closely for differences in the samples on the left side), which was actually designed to be narrow. Stretching or compressing a typeface distorts the forms, disrupting the carefully considered stroke modulation.

Snap into it

Helvetica Condensed Bold

Snap into it

Helvetica Bold

Snap into it

Helvetica Bold, distorted to be more narrow

Snap into it

Helvetica Bold, severly distorted

FIGURE B-7
Stretching or condensing type disrupts its carefully considered forms. Use versions that are specially drawn instead.

CSS's `font-stretch` property purportedly allows you to distort type, but, fortunately, there is hardly any browser support for this property.

Outlining type

There are some cases in which a designer may want to outline type. In most cases, it's better to place type on an uninterrupted background that won't interfere with the reader's ability to consume the forms of the letters, but sometimes – such as when labeling a map (see Figure B-8) – providing a high-contrast outline on the type dramatically improves its legibility.

FIGURE B-8
Carefully
outlining type
on busy
backgrounds –
such as in
Google Maps –
makes type
more readable.

Vector-drawing programs such as Adobe Illustrator make it easy for designers to create outlines on type that intrude upon the letterforms, thus hindering their legibility. It's important to choose an option that places the outline just outside the edge of the letterforms. If the outline on the letter straddles the edge of the letterform, it will intrude on the letterform, as you can see in Figure B-9.

FIGURE B-9
If an outline
around letters
intrudes on the
forms, it makes
the text more
difficult to read.
Place outlines
outside the
letterforms
instead.

Get Around Get Around

Helvetica Bold, with an outline that intrudes on the letters Helvetica Bold, with an outline outside of the letters

Type and images or textures

First-year design students are probably more often guilty of this blunder than hackers are. As soon as a beginning design student discovers filters in Photoshop, he is immediately tempted to use those filters as much as possible, even on typography.

Such filters and effects make it very easy to place images or textures directly inside the forms of typography. This is – almost without exception – a bad idea. As you can see in Figure B-10, placing textures or imagery within text forces the edges of letterforms to compete with the value and color changes of the texture or imagery, thus rendering those letterforms illegible.

FIGURE B-10
Placing textures
or images within
text causes the
letterforms to
compete with
value changes in
the texture or
imagery, making
the text hard
to read. Placing
text over a
texture or image
also makes it
difficult to read.

Placing text over images or textures is usually a bad idea as well. If this is necessary, try to pick a portion of the image, or a texture, that is low contrast. But make sure that the type contrasts well with this image or texture. If this is not an option, you may want to try an outline around the type as described in the preceding section.

Setting Body Copy

When setting a block of body text, your main goal should be to create an even texture, so that the actual letters can be read. The typographer's job is to enable the reader to consume the information as smoothly as possible. Both of these goals call for minimal punctuation and visual differentiation within the text.

Indicating a change in paragraphs

Use either an indentation or a space after a paragraph to designate a change in paragraphs – never both. Your sole goal when designating that a new paragraph has begun is simply to indicate that the previous paragraph has ended and that a new one has begun. An indentation *or* some space between the ending of one paragraph and the beginning of the next is all that is necessary to make this designation. Doing both is overkill and creates awkward and irregular chunks of white space.

Not much indentation is needed, usually about 1em (if your font is 12px, then that will amount to about 12px). If you use space after paragraphs instead, a full line break is generally too much. About 0.8em usually is about right.

When indenting paragraphs, you don't need to indent the opening paragraph of a section. The paragraph is the first of that section, so doing so would be redundant.

Allow punctuation and ornamentation, such as quotes or drop caps, to hang into the margin. This compensates for some of the changes in visual weight that would make the bordering part of the text block look broken. As shown in Figure B-11, quotation marks are visually light, so if they don't hang into the margin, it looks as if there is a part of the text missing. When they do hang into the margin, it gives the block of text a crisper look.

FIGURE B-11 Hanging punctuation into the indent makes the edge of a block of text look crisper.

"Today I want to tell you three stories from my life. That's it. No big deal. Just three stories. The first story is about connecting the dots."

"Today I want to tell you three stories from my life. That's it. No big deal. Just three stories. The first story is about connecting the dots."

Hanging punctuation is easy through high-end desktop-publishing programs such as Adobe InDesign, but it's impractical in casual CSS paragraphs. You can easily implement it on `blockquote` elements; doing so gives them a more elegant look.

Drop caps also can be cumbersome to create with CSS, but they can provide a nice visual anchor with which to lead the viewer into the text of an opening paragraph. Because the dropped cap is a larger size than the other text in the block, it tends to have negative spaces that need to be compensated for by gently hanging the edges of the cap into the margins, as shown in Figure B-12.

FIGURE B-12 Drop caps have more presence — and give the text block a crisper border — when they're hung into the margins visually, rather than constrained within an imaginary border.

This was the start in my life. And seventeen years later, I did go to college, but I naïvely chose a college that was almost as expensive as Stanford, and all of my working-class parents' savings were being spent on my college tuition. After six months, I

This was the start in my life. And seventeen years later, I did go to college, but I naïvely chose a college that was almost as expensive as Stanford, and all of my working-class parents' savings were being spent on my college tuition. After six months, I

As with many things in typography, the considerate eye is a better judge of how far to hang punctuation than geometry or rationale.

To create a drop cap (which will work in Firefox, Chrome, and Safari, but not Internet Explorer 9) using CSS3, use the `first-letter` pseudo class, and carefully adjust the size, margins, and line-height so the drop cap is the appropriate size and in the appropriate position. The left side of Figure B-13 is created as follows:

```
p.opening:first-letter {
    display: block;
    float: left;
    font-size: 114px;
    line-height: 80px; /* Note that Firefox 3.x ignores line-
  height; this value is adjusted so that WebKit and Opera
  match Firefox. */
    margin: 8px 5px 0 -6px;
    padding:0;
}
```

Note that the irregular shape of the *D* calls for the first line of the paragraph to be kerned closer to the drop cap, but even if there were a practical way to achieve the proper kerning for this instance, there is no practical way to do this with dynamic content (because you don't always know what letter the drop cap will be). On the right side of Figure B-13, I've shown how closely the letters would be kerned in a perfect world.

Standard HTML/CSS Ideal kerning

FIGURE B-13
Although you can create a drop cap with some careful CSS, the first line won't always be properly kerned with the drop cap (left). If you know exactly which letter the drop cap will be, with a little hacking you may find a way to kern it properly (right).

Avoiding justified type

Many people feel an obsessive need to make the right side of blocks of texts line up, creating text blocks that look as if they were cut by lasers. This habit is more common than it needs to be and should be avoided altogether on the web.

To justify type in a text block of the optimum line length (around 50 to 80 characters, or 8 to 15 words per line), creating enough space to cause the text

to line up, requires some combination of *letter spacing* (altering the space between the letters) and *word spacing* (altering the size of spaces between words). This added white space changes the overall texture of a given line of text. One line may be abnormally loose (because it holds fewer characters) or abnormally tight (because it holds more characters), which causes an uneven texture in body copy.

Because CSS and browsers do not yet have the capability to control hyphenation, this problem is greatly exacerbated on the web. Hyphenation would allow for the number of characters per line to be more consistent from line to line. Instead, as shown on the right side of Figure B-14, the text block is riddled with holes.

FIGURE B-14
Justified type that isn't hyphenated produces a terribly inconsistent texture.

None of this had even a hope of any practical application in my life. But ten years later when we were designing the first Macintosh computer, it all came back to me, and we designed it all into the Mac. It was the first computer with beautiful typography. If I had never dropped in on that single course in college, the Mac would have never had multiple typefaces or proportionally spaced fonts, and since Windows just copied the Mac, it's likely that no personal computer would have them.

Ragged right

None of this had even a hope of any practical application in my life. But ten years later when we were designing the first Macintosh computer, it all came back to me, and we designed it all into the Mac. It was the first computer with beautiful typography. If I had never dropped in on that single course in college, the Mac would have never had multiple typefaces or proportionally spaced fonts, and since Windows just copied the Mac, it's likely that no personal computer would have them.

Justified, without hyphenation

Leaving the right side of type ragged (often called *ragged right* or *flush left*) actually improves readability because the differences in line length make it easier for the reader to distinguish the line she just finished from the one she is about to begin.

Avoiding widows and orphans

Widows – mostly irrelevant on the web – are single words left over from a previous paragraph that appear at the top of a page or column.

Orphans are single words – or a couple of short words – that end the last line of a paragraph. They also can be single lines of a new paragraph that start at the bottom of a page or column.

Both of these phenomena create awkward blocks of white space around the text block.

You can easily prevent orphans by placing a nonbreaking space () instead of a regular space before the final word of a paragraph.

Many web frameworks and content management systems (CMSs) have plug-ins available to prevent widows and orphans.

Tending to Typographic Details

Many small typographic details have been cast aside as technology has changed, and others are just overlooked or highly debated. Giving careful consideration to each of these can produce beautiful typography.

Plug-ins for your particular web framework or CMS can help handle some of this tedium, but ultimately, the decision is up to you whether a particular detail is worth it.

Not all quotes are created equal

The quotation marks that are produced when you type " on your computer are not true quotation marks (unless your word-processing or page-layout program automatically generates otherwise). True quotes are known as *smart quotes,* and the opening and closing quotation marks are different. To open a quotation, use " (“), and to close a quotation, use " (”). For opening single quotes use ' (‘), and for closing single quotes use ' (’).

The " and ' on your keyboard are also often used to designate feet and inches (for example, Steve Jobs is 6'2"). This, too, is technically incorrect. For feet, you should use ' (′), and for inches, " (″). Steve Jobs is, in fact, 6'2".

In Figure B-15, you can see the difference at a greater size. On the right, the "dagger quotes" that are produced by the keyboard are lifeless and do little to express their purpose. The smart apostrophe, and the appropriate use of prime and double prime, give more clarity to what is being conveyed.

FIGURE B-15
The appropriate use of the apostrophe, prime, and double prime (on the left) more clearly differentiates the nature of the information.

she's 5'6" she's 5'6"

Note that many desktop-publishing programs have advanced enough that they will automatically (and inappropriately) insert the smart apostrophes and quotation marks. This can be changed in the program's Preferences, but the quickest way around this is to simply copy and paste from a less sophisticated text editor.

Using dashes dashingly

Most typefaces are equipped with at least three different dashes: a hyphen (-), an en dash (–, which is the width of a lowercase *n*), and an em dash (—, which is one em wide, or the width of a lowercase *m*).

Hyphens are most useful for hyphenating words, but because hyphenation control is absent on the web, this isn't of much concern. You'll most likely use hyphens in compound modifiers such as *fine-tuned*. Some people use hyphens as minus signs, although a longer character available in some fonts is intended for this use; this character more closely resembles an en dash than a hyphen.

At the recommendation of Robert Bringhurst's *Elements of Typographic Style,* the unofficial bible of the modern typographer, dashes used in text should be an en dash flanked by a space on each side. This causes much less visual disruption than an em dash with no spaces (even though the em dash with no spaces is the rule in many editorial style books, including *The Chicago Manual of Style*) because there is less visual tension between the ends of the dash and the characters surrounding it, so it is less of an interruption to a smooth block of text. Additionally, it prevents long strings of characters that will bunch up when they cause a line break.

The practice of using two hyphens (--) for dashes is leftover from typewriters and, besides being visually disruptive to the smooth text block, is unnecessary with the richer character set that is available to the interactive typographer.

The en dash also is used to indicate ranges of numbers – such as 1999–2000 – though it isn't flanked with single spaces in this case.

One space after a period, not two

Very few typographic arguments can match the intensity of that over whether there should be one space or two spaces after periods that end sentences.

This practice is left over from typographers from the Victorian era, which was an unenlightened period in more ways than just typography. Corsets and mutilating anti-masturbatory devices were eventually phased out, but corn flakes and this poor habit have lived on.

For those who are still skeptical, keep in mind that when a sentence ends, there is already a period, an entire space, and a capital letter to signal the end of one sentence, and the beginning of another. The addition of yet another space pokes holes in the text block and interrupts the flow of reading.

The typist may still want to use two spaces after a period, but the typographer does not.

Ligatures bring letters together

When type was still set in lead, the lead slugs on which characters were set made it hard for some character pairs to be set closely enough. For example, in the letter combination *fi,* the top terminal of the *f* stuck out far enough that it couldn't be set closely enough to the *i,* because of the dot on the *i.* So, many fonts (usually classic ones, such as Adobe Garamond) have ligatures for some pairings that actually meld the letterforms together. Some more modern fonts (such as Helvetica) also have ligatures, though no one will notice if you don't use them.

In Figure B-16, you can see that the need for ligatures is more dire in some typefaces than in others. The left side shows type set without ligatures; the right side shows type set with ligatures. The visual tension is especially noticeable in the *fi* and *fl* pairings of Adobe Garamond and Georgia; although Helvetica is equipped with ligatures, there is no perceptible difference between them and type that has been set without ligatures. Georgia does not have ligatures for the *ff, ffi,* or *ffl* groupings.

Obviously, it's impractical to type ligatures whenever they may apply, and even if you did, you would run the risk of the content eventually being displayed with a font that isn't equipped with the appropriate characters. So, plug-ins such as jQuery's Ligature.js can automatically insert the most commonly supported ligatures where appropriate. But, be careful: Even if the proper characters are available, you may make it difficult for your users to use the Find command in

their browsers. At the time of this writing, Internet Explorer and WebKit-based browsers such as Chrome and Safari recognize ligatures as their corresponding letter pair when the Find command is used (that is, if a user is searching for the word *fig* within the text of your page), whereas Firefox does not.

CSS3's `font-variant-ligatures` property displays the proper ligatures while not interfering with the actual HTML code of a page, thus retaining use of any browser's Find command. Internet Explorer, Chrome, and Safari do not currently support this property, while Firefox does.

FIGURE B-16
Ligatures are more necessary in some typefaces than in others. The groupings containing *ff* for Adobe Garamond are remnants of the typeface's original incarnation as metal type.

fish fish
flounder flounder
offer offer
affinity affinity
affluenza affluenza

Adobe Garamond

fish fish
flounder flounder
offer

Georgia

fish fish

Without ligatures Helvetica With ligatures

So, if you choose to apply ligatures on the content layer, your Firefox users won't be able to use their Find command; if you choose to use `font-variant-ligatures`, only your Firefox users will see ligatures. Because of the spotty browser support for ligatures, it wouldn't be unreasonable to ignore ligatures altogether in body copy. Failure to use ligatures in large titles or headers may be more obvious, however; so, it may be worth picking your poison to support ligatures.

Index